Jannis Kounellis

ITINERARIES offers in-depth studies of contemporary artists and their work. Outstanding writers provide fresh assessments of key figures from the recent past, some of them unduly neglected until now, and of the most important members of the new generation.

ITINERARIES books will be indispensable to current debates in the visual arts.

Series editors: Lynne Cooke and Michael Newman

Jannis Kounellis

Stephen Bann

REAKTION BOOKS

Published by Reaktion Books Ltd
79 Farringdon Road, London ECIM 3JU, UK

www.reaktionbooks.co.uk

First published 2003

Printed and bound by CS Graphics

British Library Cataloguing in Publication Data
Bann, Stephen
 Jannis Kounellis. – (Itineraries)
 1. Kounellis, Jannis, 1936– – Criticism and interpretation
 2. Sculpture – Greece 3. Installations (Art) – Greece
 I. Title
 709.2

ISBN 1 86189 1520

Contents

FOREWORD 12

1 Memory, Space and Place 21

Da inventare sul posto 26
Mnemosyne 50

2 A Mediterranean Art 63

Starting from the Studio 68
Arte Povera: The Public Face 80
Discoveries in a Private Space 84
Emblem, Connotation, Fragment 92
Contemporaries and Moderns 99

3 Alternative Histories of Art 121
Materials and the Limits of Representation 131
Theory of the Cloud 138
Ponderation 147
Installation, Painting or Sculpture? 158

4 Conclusion: 'A Visible Language' 181

REFERENCES 200
SELECT BIBLIOGRAPHY 205
PHOTOGRAPHIC ACKNOWLEDGEMENTS 206
ARTIST'S CHRONOLOGY 207

1 Exhibition at the Galleria Nazionale d'Arte Moderna, Rome, Summer 2002

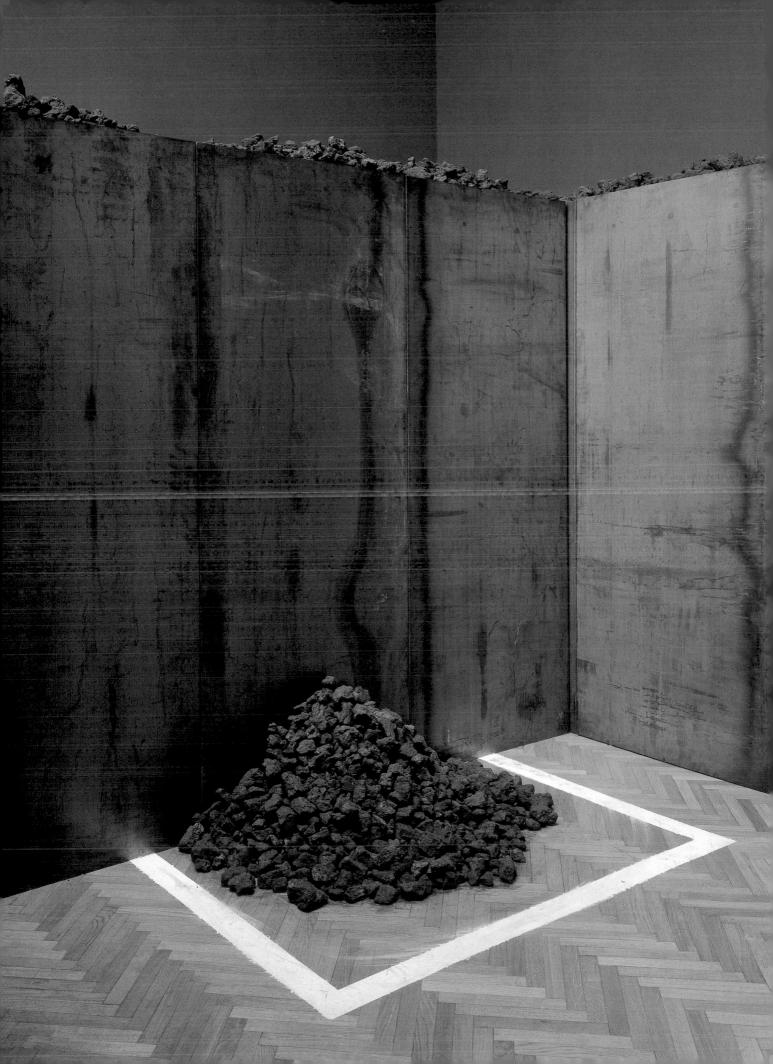

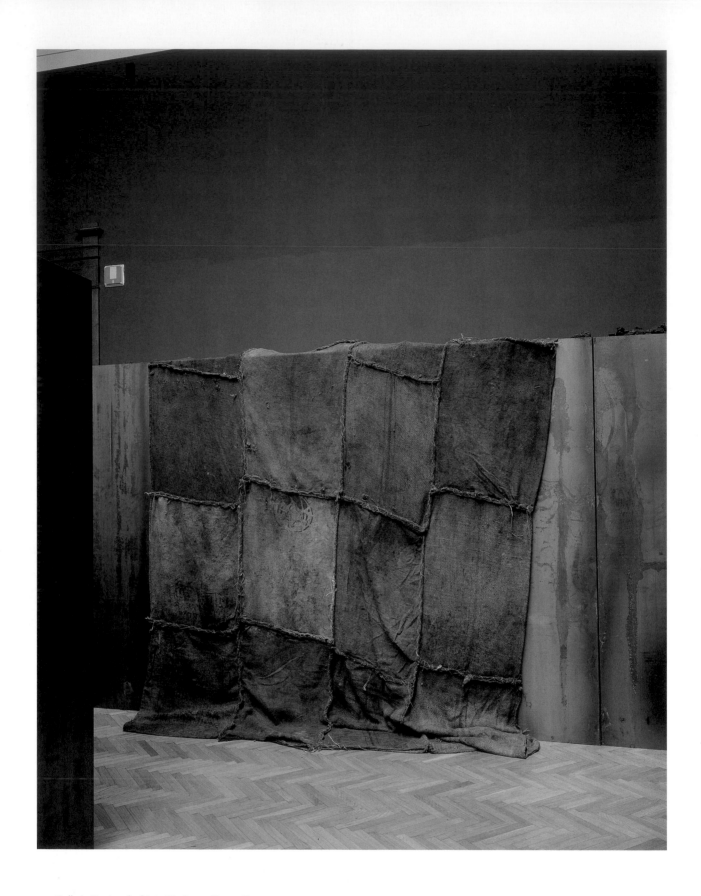

2, 3 Galleria Nazionale d'Arte Moderna, Rome, Summer 2002

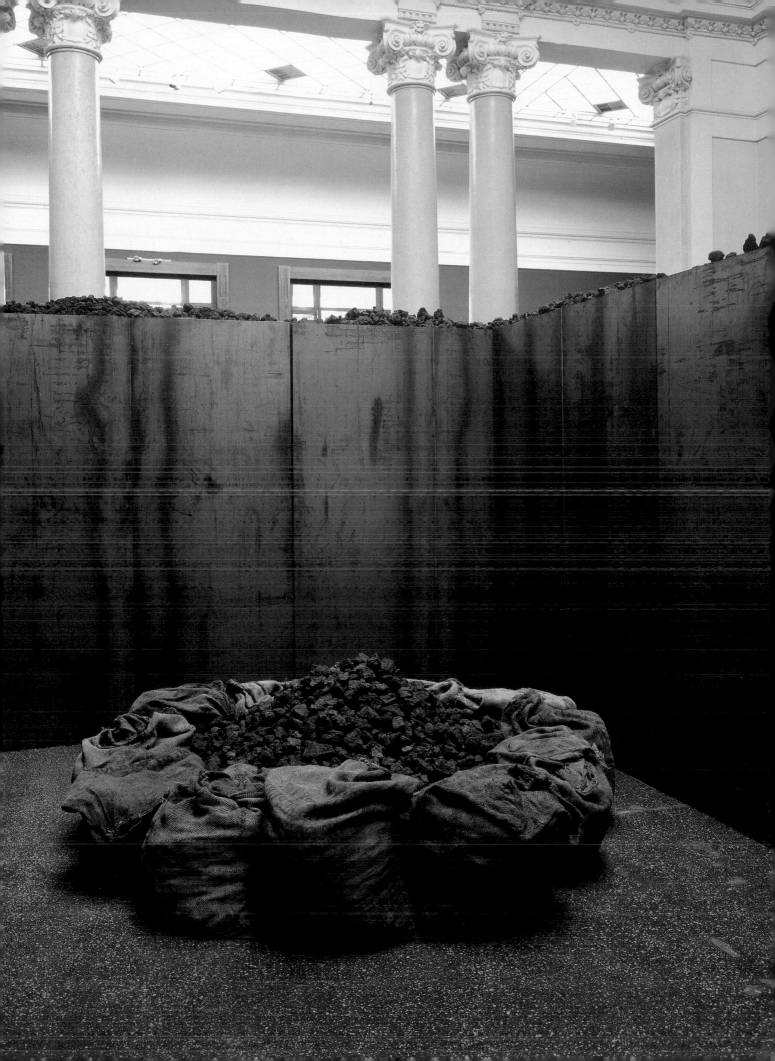

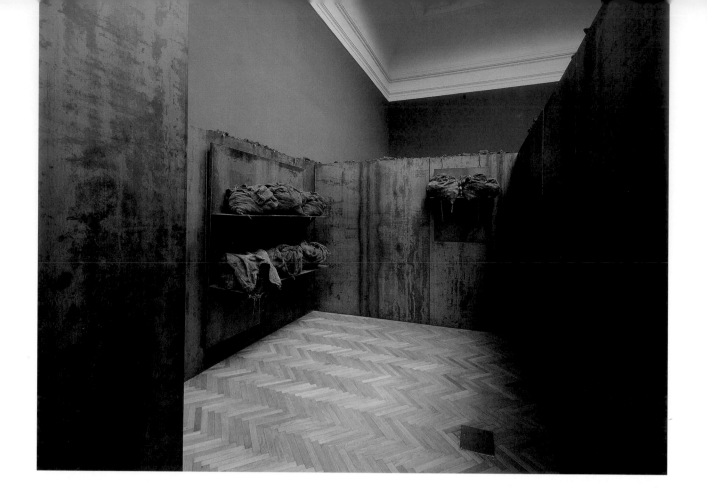

4–6 Galleria Nazionale d'Arte Moderna, Rome, Summer 2002

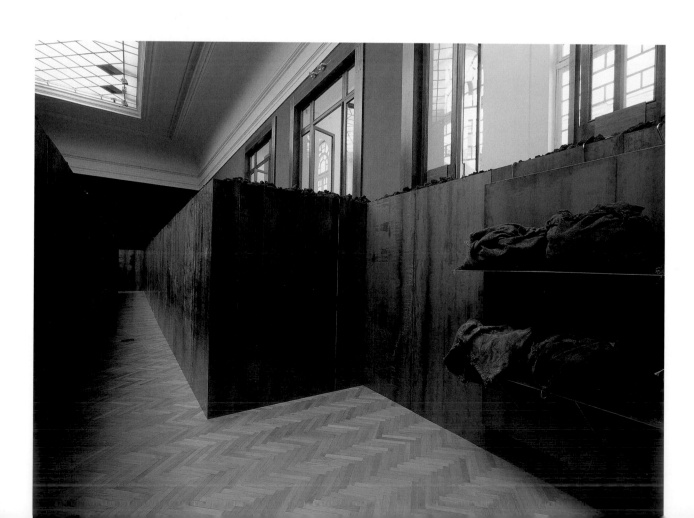

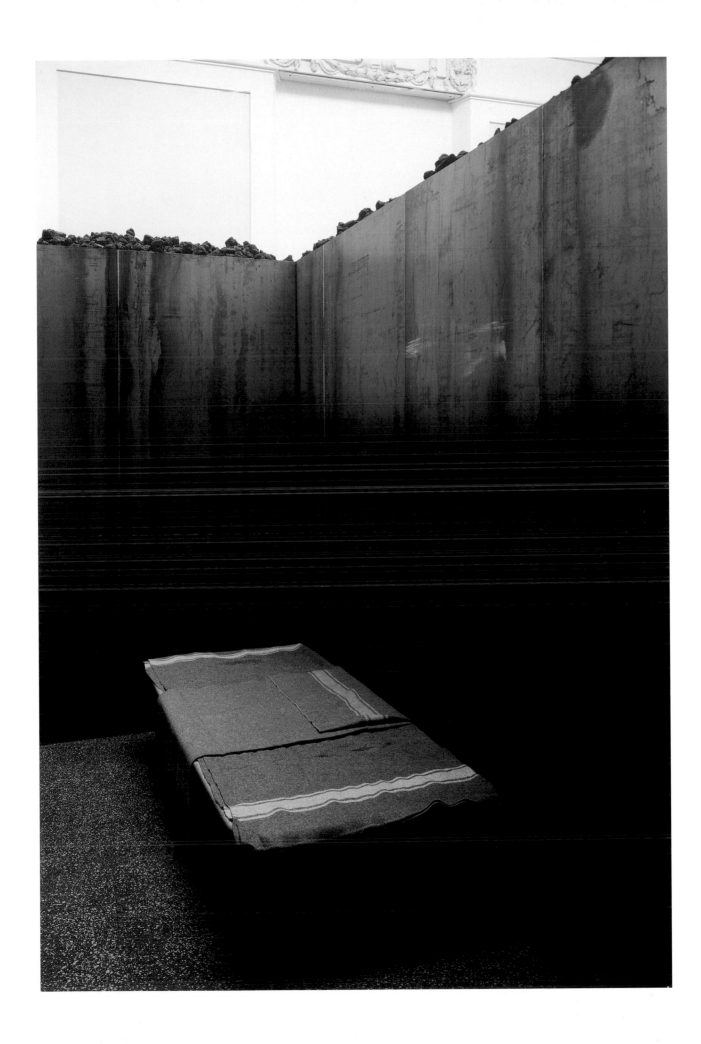

Foreword

Writing about a contemporary artist involves the combination of two different, and potentially divergent, approaches. It requires that careful attention should be paid to the existing documentation of that artist's career, represented by the various texts and photographic records that have been produced over the years. But it should also take into account the direct responses of the critic who is writing, whether they be confined to a few exhibitions or arise from a broader field of knowledge accumulated over a lengthy period. This dual focus can be hard to sustain. It is not always easy to avoid privileging the appearance of a work as it has been documented in a catalogue, backed up by published writings and statements, over the recollection (maybe a dim and distorted one) deposited in the memory by that same work a number of years back.

This may appear an obvious point, and indeed it indicates a concern that will in practice usually be dismissed as too fastidious. But as I begin to write about the career and works of Jannis Kounellis, I have to admit that it bulks very large. This is because his method of working is always intimately involved with memory and repetition. Yet at the same time he insists upon the specificity, in time and place, of each instance of a work's appearance. A seemingly endless sequence of works labelled Untitled awaits the writer who wishes to take a comprehensive overview of Kounellis's copious production. Each of these has the date of a year to qualify it, but since there are often many more works than one in any single year, the identification of a particular piece requires the exact knowledge of its dimensions and its materials. It can be appreciated that even this degree of specification is sometimes helpful only to a limited extent, if it is a question of identifying pieces that are close together in time, or share the same material constituents.

Yet this method of working is not just an exercise in mystification on the artist's part. In fact, the procedure follows logically from the distinctive way that Kounellis progressively came to adopt of presenting his work, in particular from the early 1980s onwards. Since that period, most of his major exhibitions have been, in effect, successive retrospectives in which earlier works share the given space with more recent ones. Yet these are not really retrospective shows in the conventional sense of the term. For the dominant concern in most cases has been to adapt the wide range of works selected to the distinctive characteristics of the museum building or other type of exhibition space. Over several months at a time, then, a large area of a public building is entirely taken over by a set of works which are

not presented to be viewed in terms of their chronological development, but because they have been made to fit together, syntactically, within the given space.

This implies almost an inversion in Kounellis's case of what has come to be the conventional strategy of the 'monumental' sculptor. Rarely is it possible to see, in a museum's sculpture park or in a busy public space out of doors, one of Kounellis's works that is destined to remain in place for an indefinite period of time. What does persist as a feature of the 'permanent collection' of the museum or gallery, after the temporary exhibition has come and gone, is more often than not a newly installed variant piece from Kounellis's repertory – one that may well signal, since it bears the traces of an evanescent deposit like candle smoke, the fact of having been recreated on the spot, after the departure of the rest of the work.

Meanwhile, outside the museum, Kounellis has incessantly tried to colonize unconventional kinds of exhibition space, from a simple hotel bedroom in his early period to outstanding public buildings such as royal castles, historic warehouses and modern factories. In fact a good proportion of the museums and galleries where his shows have left their mark prove themselves to be buildings imaginatively converted from an earlier use. These have been, in innumerable inventive ways, resuscitated by Kounellis so that they seem to enhance the features of an earlier existence – courtly, liturgical or commercial as it may have been, or simply artistic in accordance with more timid conventions of exhibition and display.

What is the point of this unusual and yet quite consistent way of working? In the first place, I believe that it encourages us to look back at the whole recent history of exhibition practice, and particularly at the structures that were developed, by the Academy, over the two centuries or so preceding the rise of Modernism. Kounellis's methods of exhibition may appear unusual. But this is only in respect of the exhibiting conventions developed over the period, which stipulated individual titling and dating for art works classified according to genre. On one level, therefore, Kounellis appears to be breaking polemically with the traditional academic structures and systems that were carried over wholesale into the newly founded generic museums of modern and contemporary art. But it would be a mistake to conclude that he is simply endorsing the strategies of the avant-garde artists of his generation, many of whom have also chosen to confine themselves to the category of the 'Untitled' work.

In effect, Kounellis's practice hardly ever seems to qualify as avant-garde protest. If he is not content to lie down peaceably in the disciplinary environment of the 'White Cube', he is even less inclined to indulge in the kind of transgressive strategies that only serve to reaffirm its dominance. To a certain degree, he seems to be aiming to evoke a much earlier and long superseded mode of exhibition, one related to what are now historically remote conceptions of identity and recollection. His exhibition installations recall, for one thing, what was known in the early modern period as a 'theatre of memory': that is to say, an arrangement of objects designed to recall and perpetuate the remembrance of things. What is it then that Kounellis would have us remember? His writings and interviews make it evident that, though he eschews the grandiose mythological titles used by many postmodern artists, he is continually bringing to mind specific recollections of the great artists and great works of the past. It is as if he wished the matt metal plates that form the ground for so many of his recent works to reverberate with the multiple messages of Classical and Christian culture.

At the same time, there is a more ancient and no doubt more familiar field of reference that his mode of exhibition has recently called to mind. His last major show at the time of writing was an installation at the Galleria Nazionale d'Arte Moderna in Rome, which took the form of a labyrinth. This exhibition, which opened in May 2002 and was prolonged throughout the summer, was a genuine homecoming for Kounellis, in that it was the first occasion when his work had been on show in a major public museum in the city where he had made his home for over forty years. But in choosing to site the labyrinth 'like an octopus' (in his own words) curving through the renovated halls of Rome's newly restored gallery, Kounellis also achieved a spectacular effect of displacement (illus. 1–6). The works so redolent of his earlier career that greeted visitors in their passage through the labyrinth seemed to emanate not just from his own history, but from a collective history of the Roman and Mediterranean world. I interpret in this way the extremely strong impact that the show exercised on people who had no special knowledge either of his work, or of contemporary art in general.

This effect is the one that Kounellis tries to achieve. And perhaps the final objective is not as quixotic as this brief description might make it seem. My argument in this study will be that Kounellis does indeed call to mind many fruitful connections with the overall historical development of

Western art. These are not just asserted dogmatically, but made sensuously present in the concrete experience of the works that he has placed on show. He may not fit very well, admittedly, into any putative grand narrative of Western art history. But there can now be found alternative, less imperialistic histories, that clarify the working out of particular sequences and developments in the visual arts in ways that seem much more relevant to his artistic terms of reference. What will be offered here is certainly not a single narrative capable of connecting Kounellis, or any contemporary artist, to the mainstream of Renaissance art. It is a compound of convergent ideas, and draws heavily upon a number of invaluable writers and theorists who have given the same close attention to the works of the present day as they give to the art of the past. The conviction that such a dual focus is possible, and indeed necessary, will inform this study.

I would like to express special thanks to Wolfgang Kemp and the Aby Warburg Stiftung, who invited me to spend three months on a project of my own devising in the comfort and tranquillity of their institute. Hamburg proved to be just the right location for more reasons than one. Jannis Kounellis and Michelle Coudray generously welcomed my decision to choose this assignment and, together with Elisabetta Campolongo, provided indispensable help in locating the many illustrations used here.

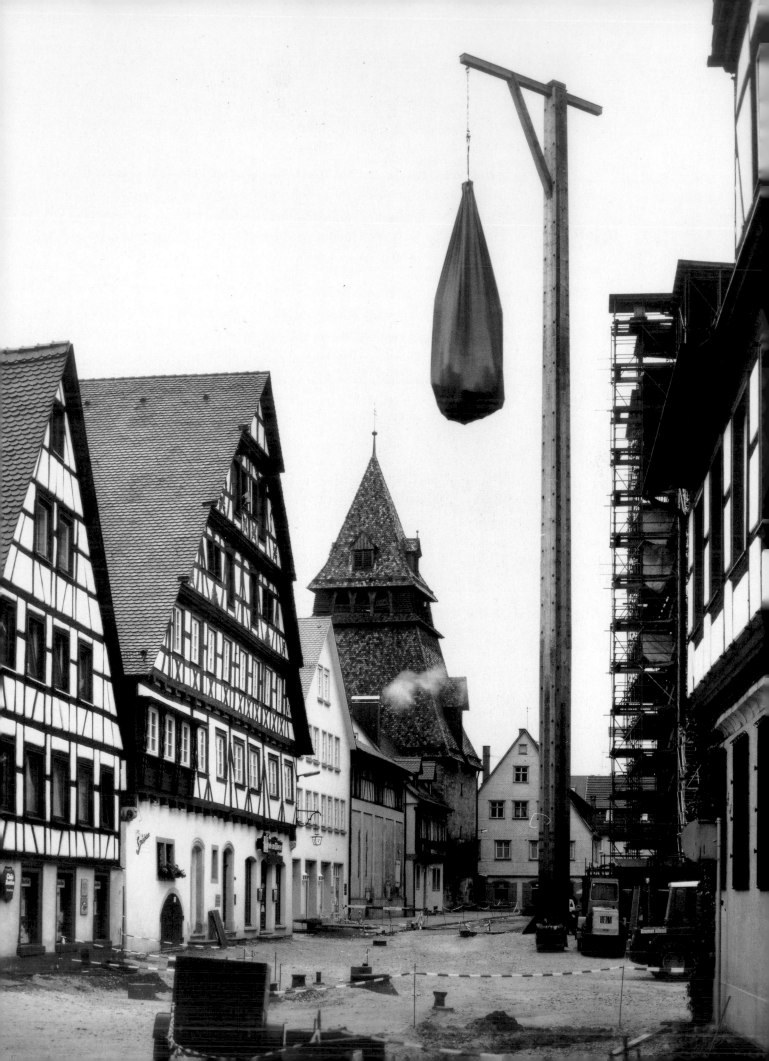

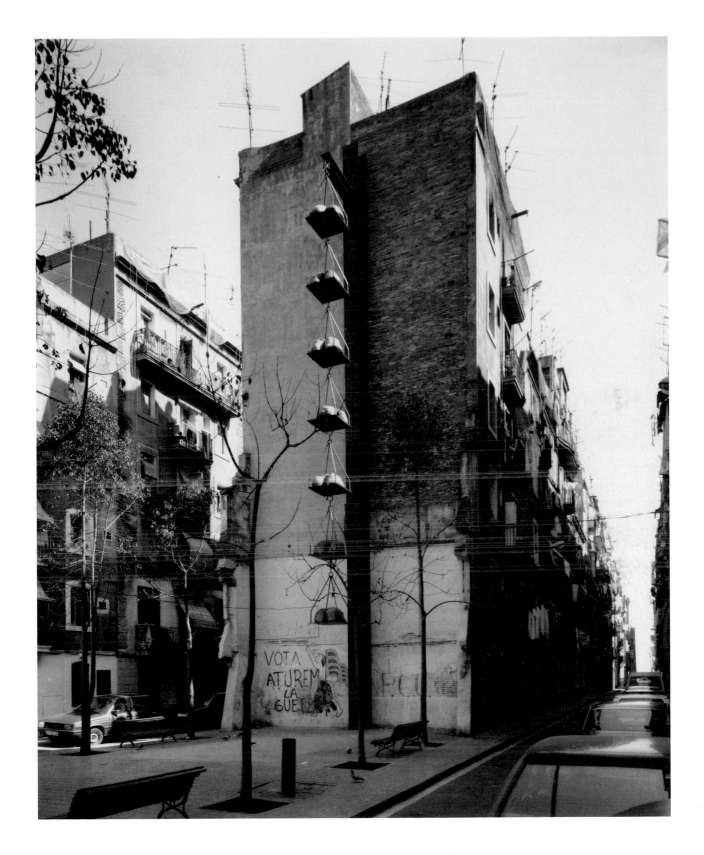

7 *Untitled*, 1992. Wood and iron construction, cloth bag and old furniture. Height approximately
3,600 cm. Exhibition: 'Platzverführung', Schwäbisch-Gmund, 1992

8 *Untitled*, 1992. Vertical iron structure, iron scales, jute sacks, coffee. Total height 1,860 cm.
Owned by the City of Barcelona. Exhibition 'Configuraciones Urbanas', Carrer Baluard,
Barcelona, 1992

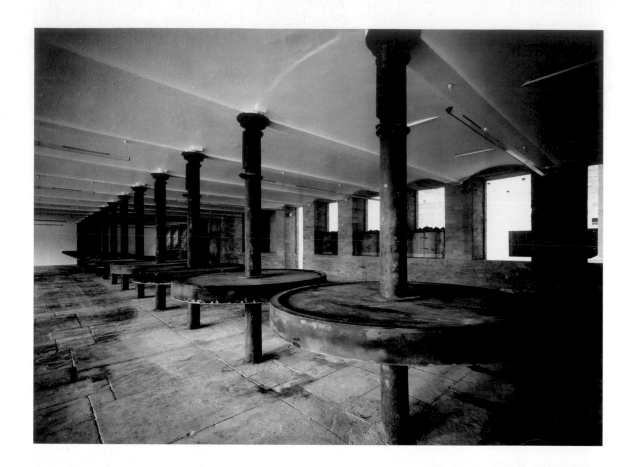

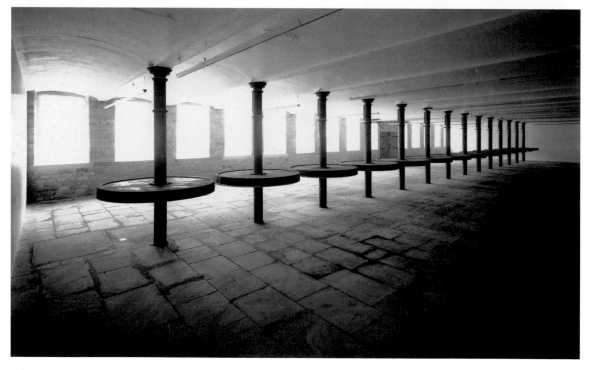

9 Exhibition at The Henry Moore Sculpture Trust Studio at Dean Clough, Halifax, West Yorkshire, 1991

10 Exhibition at Dean Clough, 1991

11 Exhibition at Museum Ludwig in der Halle Kalk, Cologne, 1997

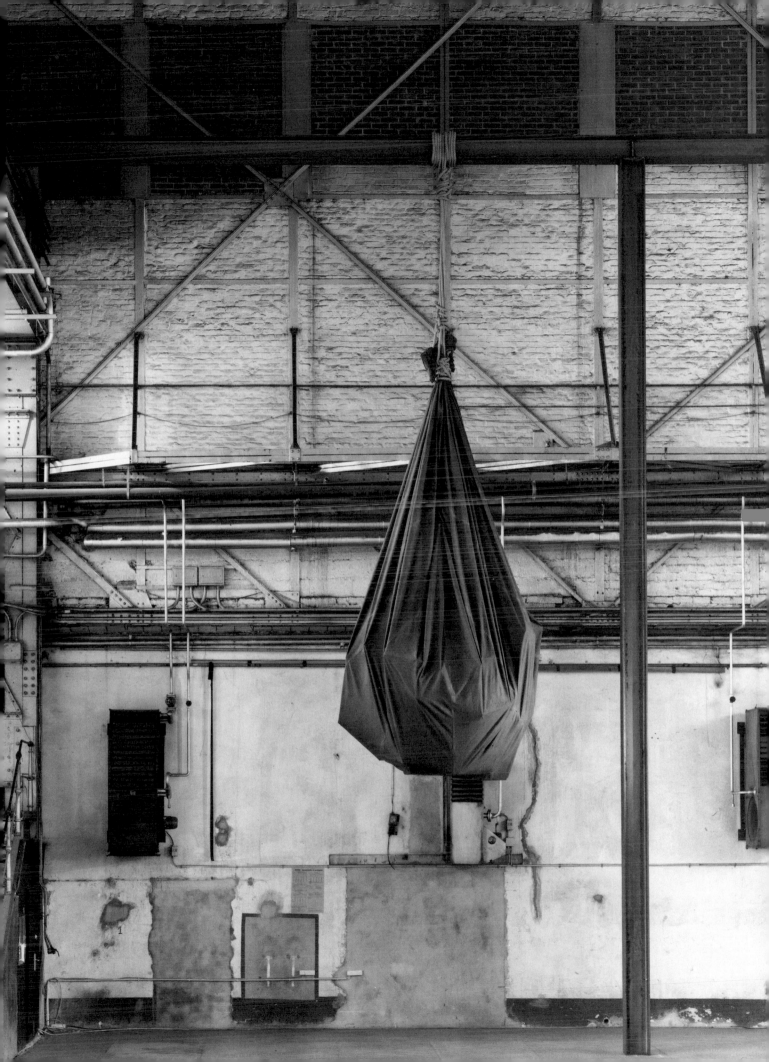

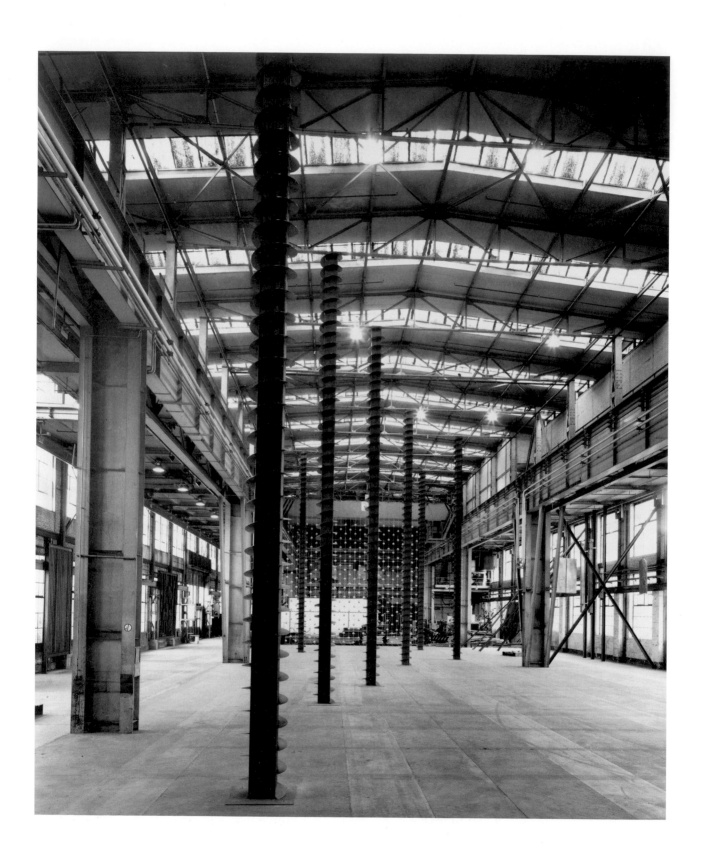

1 Memory, Space and Place

Kounellis's Roman labyrinth is an attempt to recreate place through investing a space with memory. This has to be seen in some degree as a response to the alienating effect of the processing of images in the contemporary world. It sometimes appears as if artists of the present day bear the accumulating visual evidence of their past work as a snail carries its shell. New deposits of images are added to the existing structure, and this both repeats and preserves the record of earlier patterns of growth. Yet it may also seem as if this process is being arrested and petrified by the sumptuous and extensive catalogues that have become the hallmark of retrospective exhibitions. Everything is gathered in, and all is recorded photographically, so that the most recent catalogue comes to seem like a palimpsest of exhibiting moments, whose origins in time have been virtually effaced.

It is worth taking a historical view of this phenomenon, and remembering that it is a comparatively recent development. Before photography, no artist could take for granted such an equivocal assurance of immortality. By the end of the second quarter of the nineteenth century, the new technologies of visual communication ensured that, for the first time, Western artists could envisage the prospect of worldwide fame during their own life-span.[1] But, far from offering consolation, this new situation at first created considerable anxiety about the unprecedented opportunities that might be missed. Such renowned artists as Ingres and Delaroche were invariably preoccupied with the future fortunes of their most cherished works. They knew from bitter experience that sporadic political revolutions had a tendency to end in iconoclasm. They were only too well aware that a painting which had entranced the public for a few months at the annual Salon would frequently disappear afterwards into the intimate recesses of an aristocratic collection or the mouldy seclusion of a provincial cathedral. They trusted to the skills of the reproductive engravers of their time to multiply, and sometimes indeed refine, their most important compositions. But such engravings inevitably took an inordinate amount of time – not infrequently, more than ten years – to complete. As a consequence, it was not always possible to find the means of financing these long-term investments in an image's immortality.

Notwithstanding these concerns, such artists did indeed stand at the beginning of a new era of reproductive technology, which would end with the creation of what André Malraux baptised the 'musée imaginaire'. In 1851, Ingres' pupil, Albert Magimel, brought out a 'general and chrono-

12 Cologne, 1997

21

logical collection' of the master's works, which consisted of delicate line engravings of the most significant pictures from his career to date. Ingres took the opportunity to revise some of these in the process of publication, so that the ideal repertory was also a highly fallible record. But only seven years later, Delaroche's pupil, Jules Goddé, commemorated the occasion of the painter's death by editing the first comprehensive photographic record of any visual artist's entire work, compiled by the first practitioner to perfect the technique of photographing paintings, drawings and engravings: the Englishman Robert Jefferson Bingham. This unprecedented form of publication was made possible by the fact that, in 1857, the majority of Delaroche's best-known works had been assembled in Paris for the first major retrospective exhibition anywhere of a recently deceased artist.

For an artist of Jannis Kounellis's generation, this context may seem very distant, but its historical logic has indeed been fulfilled in more recent developments. Over the four decades when Kounellis's works have been exhibited in public, the illustrated catalogue has metamorphosed from being a discrete, ancillary product of an ephemeral event, into a compendium offering the promise (however endlessly deferred) of totality. The process goes hand in hand, of course, with the growing tendency of the exhibitions in themselves to offer not just an assembly of new works, but the digest of an entire career. In the mid-nineteenth century, it was very perilous to entrust fragile canvases to lengthy journeys over land and sea. But the artist of the present day succeeded in mastering the strategies of ubiquity, keenly adapting to the requirements of international biennales and worldwide gallery connections. In these new circumstances, a record of exhibitions held is likely to cover a truly global network, and the catalogue's illustrative material inevitably becomes a bewildering congeries of innumerable different sites.

This study of Kounellis cannot, of course, claim to be an exception to the rule. Its illustrations show, as they have to show, an astonishing variety of works as they have appeared in many different locations (illus. 7–12). But I hope nonetheless to demonstrate the highly distinctive ways in which Kounellis has adapted to these contemporary circumstances. To go one stage further, I would propose from the outset that he has conceived his methods of display and production in such a way as to counteract the effects of dispersal and proliferation that arise from the diffuseness of the exhibiting system. Ingres in his period was seemingly both attracted and intimidated by the prospect of having his life's work tabulated and placed

between two covers, and reacted by modifying some of his compositions. By comparison, Kounellis's lengthy sequences of kindred works, individually dated but identified by the neutral designation of *Untitled*, indicate a ceaseless process of revision and reincorporation of earlier motifs. His large exhibitions also provide the occasion to show earlier and more recent works together in new combinations. But the goal is never to attain an ideal totality in a single exhibition. Always it is a question of responding directly to the special challenge offered by the individual site, to its unrepeatable blend of atmosphere, surface and space.

For this reason, I must also emphasize that this study endeavours to respect the specificity of Kounellis's working methods, to the extent that they find their fulfilment in the spectator's direct experience of the altered sites and spaces. My account does rely unavoidably on the thorough photographic documentation that has been built up over the decades, much of it by the photographer Claudio Abate, in whose family home Kounellis lodged on his arrival in Rome as a student (illus. 13–15). But it is

13 Jannis Kounellis, Rome, *c.* 1967

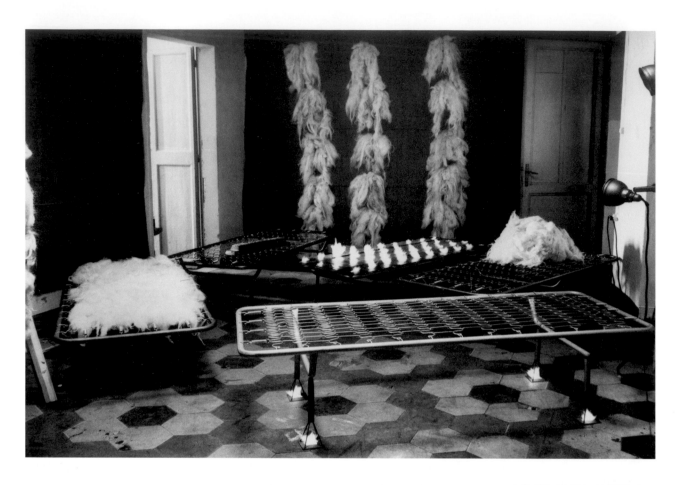

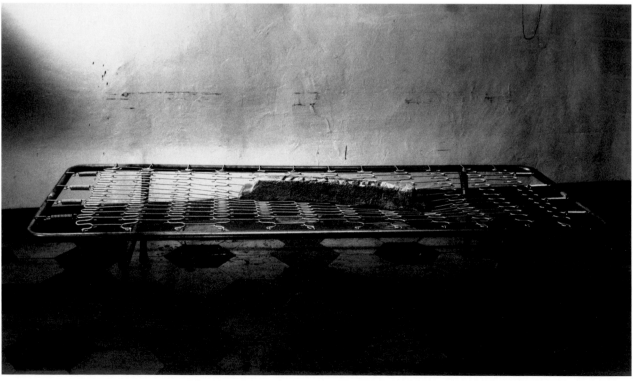

14 The artist's studio, Rome, 1967

15 *Untitled*, 1969. Steel bed-frame, lead bars, 33 x 190 x 80 cm. Photographed in the artist's studio, Rome, 1969

also rooted in my personal experience of the work of Kounellis over a long period – one that is inevitably patchy, but extends all the same over thirty years. From my first acquaintance with his installations, at the 5th Kassel Documenta of 1972, up to more recent occasions like the large retrospective show at Prato in 2001, I have taken the opportunity to see, and commit to memory, his achievements. This has been a steady, cumulative development of acquaintanceship, not only in the obvious sense that I have observed the first appearance of some new works, but also because I have noted recombinations of previous motifs in new situations, bringing memory to bear on the relationship between the earlier context and the new one.

The trick of the photographic catalogue is to offer us a kind of prosthetic memory – an artificial optic through which all the heterogeneous instances captured by the photograph are reduced to a common forum and format. But memory, despite having tricks of its own, provides a fund that cannot be dispensed with. This study of Kounellis is part of a series dedicated to Itineraries, that is to say to the various paths that contemporary artists have taken, in a geographical as well as a figurative sense. But it is also, inevitably, about the itineraries taken by contemporary critics and historians in their successive encounters with the art of the present.

No one today can expect to recapture the nineteenth-century experience of visiting the annual exhibitions of the different Academies. Yet the current interest in recreating at least some of the major physical circumstances of such past occasions (as with the authentic period hang of the Great Room at Somerset House undertaken for the exhibition 'On the Line' in Autumn 2001) is not merely nostalgic. Such displays demonstrate, at the very least, an increasing interest in the concrete representation of the conditions under which such well-known works were originally shown[2]. From another point of view, however, this phenomenon could be seen as the other side of the coin to the universal presence in contemporary museums of what is imprecisely known as installation art. Despite its immediate roots in the avant-garde, so-called installation art could plausibly be viewed as a nostalgic reversion to an earlier state of affairs, where the display of art works was integrally associated with the design and location of specific rooms, rather than being realized through projection into a notionally unblemished, neutral space.[3]

It goes without saying that this 'reversion' is not a simple matter. The logic of deterritorialization is no less powerful than it was, and it is easy to

treat a concern with the historical circumstances of display as no more than an idiosyncracy. But that is precisely why it is important for a contemporary artist to prove the contrary. Kounellis's work obviously has transverse connections with many aspects of contemporary and specifically postmodern styles of artistic expression. But it also possesses, in my view, a unique explanatory power. It resonates in our consciousness, and creatively reactivates the past.

DA INVENTARE SUL POSTO

The English critic William Hazlitt may have been the first person to inveigle his readers into a discussion of a group of paintings by way of a description of the journey that he had taken to view them. Hazlitt's description of the collection of the Soane Gallery at Dulwich is prefaced by a vivid evocation of the journey on foot from central London to this then idyllic village site. My first opportunity to see a work by Kounellis came at the 5th Kassel Documenta in the late summer of 1972. As with the two previous international shows under this title that I had attended, Documenta 5 was broadly distributed between two buildings overlooking open spaces in the centre of the city: the eighteenth-century Museum Fridericianum which ranks as the earliest specifically designed public museum in Germany, and the more recently built Neue Galerie. I can revisit in my recollection the mounting sense of discovery while I climbed the winding stairs in the furthest corner of the Fridericianum, up into a turret-like excrescence or belvedere that stands proud of the formal and symmetrical neo-classical facades of the building. On the opposite wall of the highest room in the turret was a large painting, with a coloured ground and a few bands of musical notation inscribed in black upon it. A music stand was placed close by, with an indication that, at some recent point in time, a performance involving a young ballerina had taken place. The title of the work was: *Da inventare sul posto* – to be made up on the spot (illus. 16).

It is difficult to speculate why the recollection of that little spectacle has stayed in my mind, almost to the exclusion of the many other works that I saw on that visit to the Documenta. Perhaps it was precisely because I had not arrived at the right moment, and the experience left a lingering regret at missing an event that had already taken place. Yet this memory did not consist exclusively in a regret for missing the performance. The poignant record of the unplayed music – hardly more than a few bars –

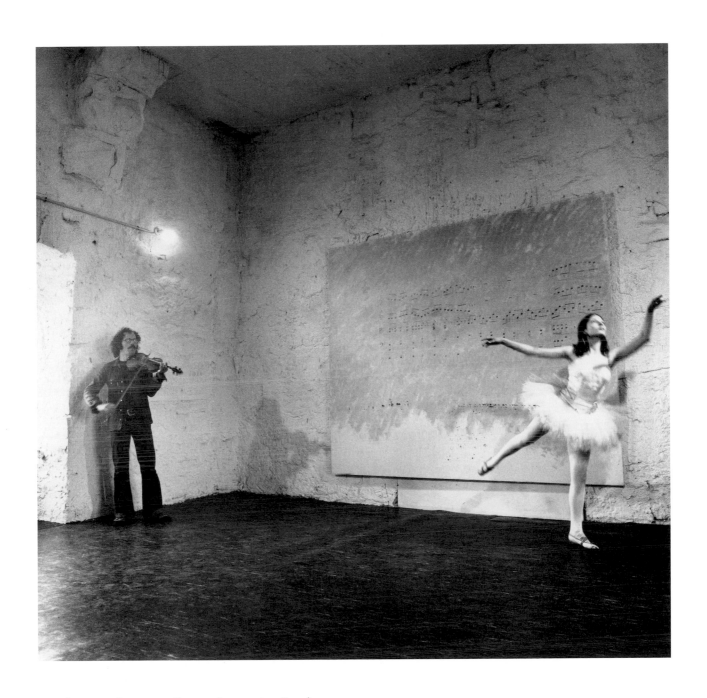

16 *Da inventare sul posto*, 1971. Shown at Documenta 5, Kassel, 1972

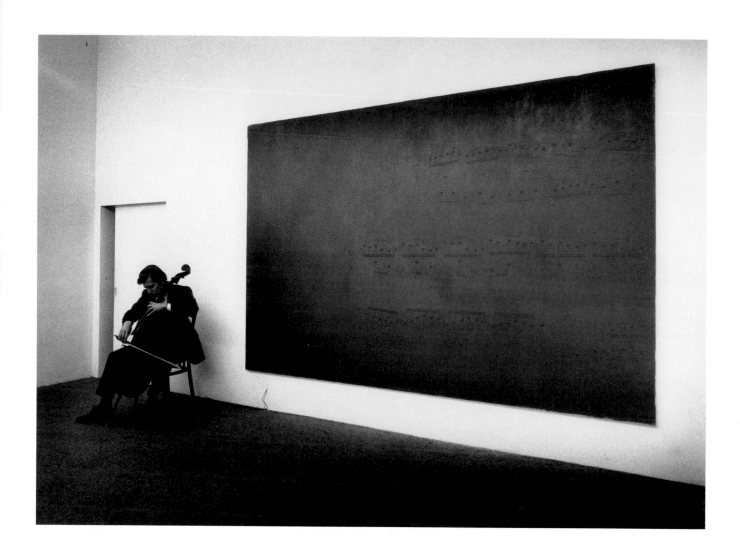

17 *Untitled*, 1971. Cellist playing a fragment of Bach's *Passion According to St John* in front of a
green painting of musical notes Painting: oil on canvas, 200 x 300 cm. Private collection.
Performed at Modern Art Agency, Naples, 1971

was there to be seen on the canvas, recalling no doubt the Cubist deployment of the graphic signs for clefs, bars, minims and crotchets in Braque's *Homages to J.S. Bach*. But Kounellis seemed to have no intention of manipulating the graphic language of music in order to create a fluctuating field of ambiguous signs, as did Braque in his relatively small, almost monochrome, paintings. His notations on the canvas were demonstrably part of a score to be played, and his large painting asserted its visual presence not in spite of, but in view of the missed performance. Other works from this period, incorporating fragments of musical scores, have been photographed with performers beside them (illus. 17). Yet they have generally been exhibited on their own, as with *Untitled* (1971), whose resonant dark green ground I recall very clearly, having seen it on several occasions at the recent '*Arte Povera*' exhibition (Tate Modern, 2001).

The catalogue of Documenta 5 is of very little use in providing anything informative about the circumstances of *Da inventare sul posto*. In its overblown, by now irritatingly informal presentation, with punched holes designed to fit a binder that libraries have long since decided to convert into a sprawling volume, it does not even specify Kounellis's placing in the turret room, as part of the section mysteriously labelled 'Prozesse', which he shares with fellow Italian artists like Giovanni Anselmo, Pier Paolo Calzolari and Mario Merz. Perhaps the installation of that part of the exhibition was indeed required to be improvised – *To be made up on the spot*? Worth noting, however, in Kounellis's catalogue entry is the listing of his foregoing one-man exhibitions that describes, in general terms, the character of the works that were shown at each: for his first exhibition at the Galleria La Tartaruga in Rome (May 1960), paintings with letters and numerals; for his third, at the Galleria L'Attico (March 1967), paintings with artificial flowers and bird-cage frames (illus. 18); for his fourth, at the Galleria Iolas, Milan (1968), trolleys with stones, sacks, a parrot (illus. 19–29); for his fifth, at the Galleria L'Attico (January 1969), horses; for his seventh, at the Gallerie Iolas, Paris (May–June 1969), smoke – and fire (illus. 21–22).

This incongruous list of materials and media provides a skeletal outline of Kounellis's early career, to which I return with a more detailed consideration in the following section. But it is accompanied by a list of no less significant occasions, when Kounellis made a contribution to joint exhibitions, both in groupings involving fellow Italian artists of his generation (such as the '*Arte Povera*' show at Genoa in 1968), and at

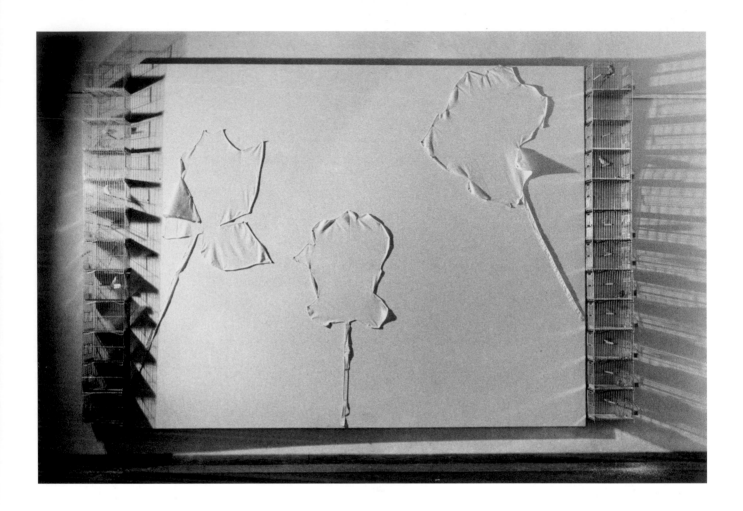

18 *Untitled*, 1967. Cotton mounted on
canvas and bird-cages with live birds,
380 x 280 cm. Photographed as installed
in the artist's studio. Also in exhibition
'Il Giardino i Giochi' at Galleria L'Attico,
March 1967

19, 20 Exhibition at Galleria Iolas, Milan, 1968

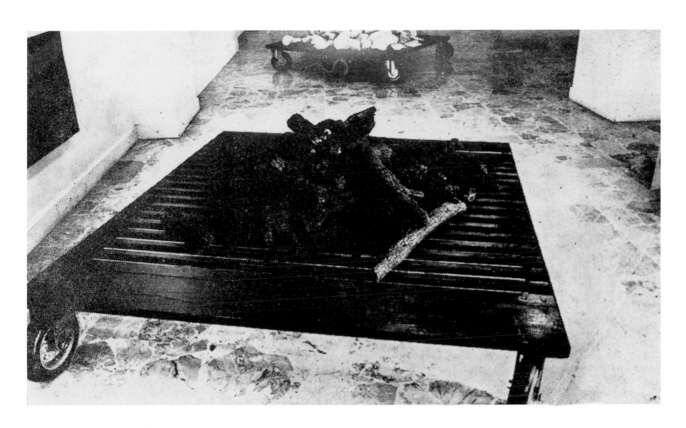

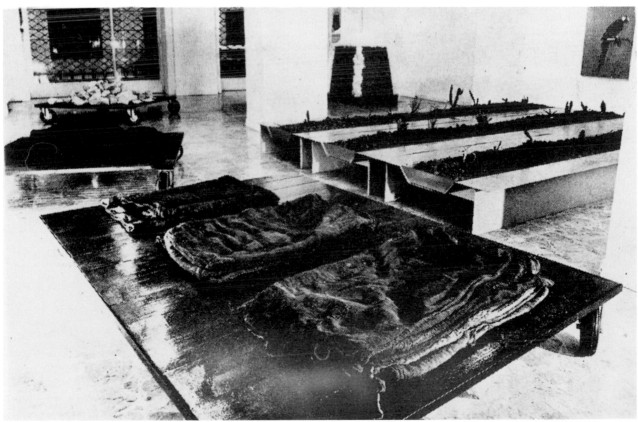

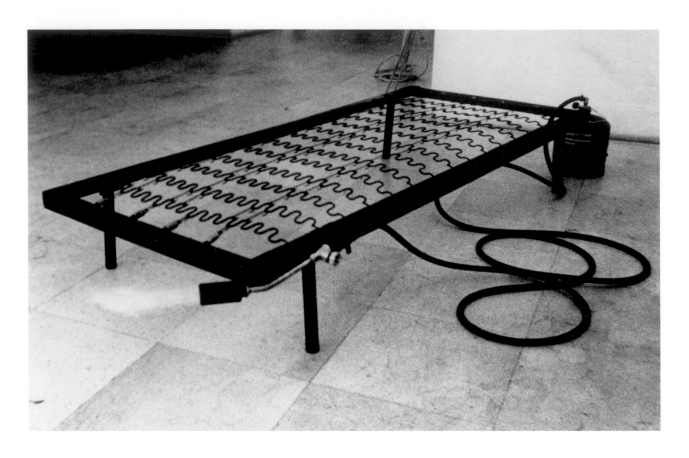

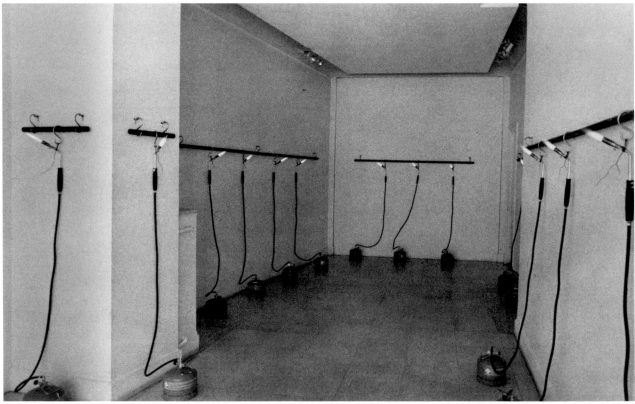

21 *Untitled*, 1969. Steel bed-frame with burning flame, propane gas bottle on the floor. Exhibition at Galerie Iolas, Paris, May–June 1969

international forums like the 6th Paris Biennale (1967) and the Institute of Contemporary Art, Boston (1968). If these listings could be expanded in the same way as the details of the works included in the one-man shows, they would reiterate much the same message: that Kounellis's exhibitions over the 1960s were characterized by an extraordinary, indeed bewildering, diversification of materials – comprising vegetable and mineral, the natural and the artificial, the dead and the alive. I could also have realized, had I checked these catalogue entries carefully in 1972, that *Da inventare sul posto* was a not unexpected development of Kounellis's dialectical strategy of incorporating elements of performance into the exhibited work. As it was, I experienced the work as something between a vivid experience and a promise unfulfilled. I have never since climbed the winding staircase to the turret room at subsequent Documentas – most recently in 2002 – without feeling a strange mixture of incomplete reminiscence and unsatisfied curiosity.

Viewing Kounellis's Whitechapel Gallery Exhibition of 1981, nearly a decade later, partially fulfilled the expectations of his work that had been generated by *Da inventare sul posto*. Here it is important to comment briefly on the special role that this gallery in the East End of London had played in expanding the awareness of contemporary art in post-war Britain, especially from the time of the appointment of Bryan Robertson as Director. The long, luminous main room, leading straight off the crowded High Street, had welcomed the works of Franz Kline, Jasper Johns and Robert Rauschenberg (among many others) in the 1960s. The Gallery then entered a new phase in the early 1970s with the appointment as Director of Nicholas Serota. Kounellis's exhibition took place in a setting that had undergone a complete architectural renovation, which however rendered all the more conspicuous the fine detailing of the original Art Nouveau building. My memories of visiting the show itself have now been condensed into the documentary evidence of one or two very striking photographs, each of which marks a recognizable corner of the gallery with the temporary imprint of a work. Continuing the use of smoke as a material, which he had begun to develop in 1968, is Kounellis's *Untitled* (1980), which consists of a series of iron shelves fixed vertically above one another on the white wall, the first four with plaster cast fragments wrapped in wool blankets, and the topmost drawing our attention to the adjacent dark smoke stains (illus. 23). The counterpoint between the formal, elegant setting of the gallery and this mysterious carbon trace

22 *Untitled*, 1969. Burning flames hanging by means of hooks from metal tubes, propane gas bottles on the floor. Exhibition at Galerie Iolas, Paris, May–June 1969

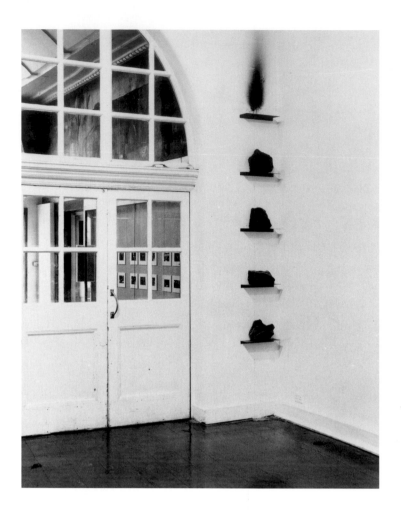

23 *Untitled*, 1980 Five iron shelves, four with plaster cast fragments wrapped in wool blankets; the top shelf has smoke stains on the wall, 40 x 13 cm each shelf; 300 cm high. Exhibition at the Whitechapel Gallery, London, 1982

with no apparent origin is perhaps what enables even the photographic record to conserve a disquieting energy.

There is no lack of art-historical antecedents for Kounellis's use of such primary materials as carbon deposits derived from smoke. He has himself acknowledged his interest in Yves Klein, in particular, as regards the artistic use of fire and its secondary effects. I think, however, of the half-artisanal, half-entrepreneurial activity of Daguerre in the 1820s, when he baffled his collaborator Niépce with examples of his *dessins-fumée*, pictures whose velvety tones used to indicate depth of shadow were the result of the direct application of candle-smoke.[4] As Daguerre showed in these little works, smoke traces possess a particularly strong indexical charge, only to be surpassed after further experimentation in his case by the hallucinatory image faithfully recreated by fumes of mercury on the surface of the daguerreotype. A photograph of Kounellis's smoke-based works thus possesses a strangely auto-referential character, when it highlights the effect of the smoky black deposit left behind by the living flame.

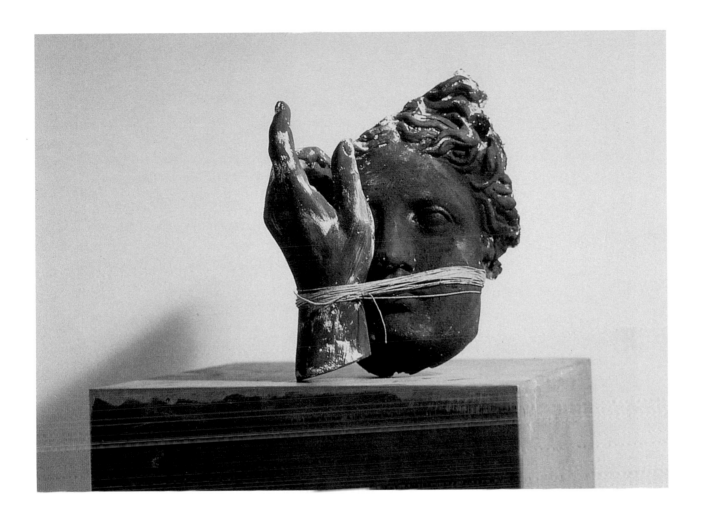

24 *Untitled*, 1978. Fragments of
plaster casts bound with twine, head
painted black and hand painted
violet. Collection of Professor Jung,
Aachen, Germany. On loan to the
Kunsthalle, Hamburg

No less eloquent than this work in its multiple references, however,
was the *Untitled* (1978) that I saw in 1981 for the first time (illus. 24). Only
quite recently has it been deemed interesting to discover the iconographic
identity of the two fragments of plaster casts that are bound together, with
a few rows of rough string, to form this composite exhibit. The damaged
head is derived from the head of the Apollo Belvedere, while the hand that
points is the hand of the Farnese Hermes.[5] I have had the opportunity to
examine the work more closely in the recent past, while it has been on
loan to the Hamburg Kunsthalle. The two fragments turn out quite
surprisingly to be painted very roughly in different colours, violet for the
pointing hand of Hermes, and black for the head of Apollo. Yet, because
I have already illustrated this work once before, and returned to the black
and white photograph many times between 1981 and the present, it has
become, in an irreversible way, a piece that cannot be summed up by the
mere description of its physical state and location. The cultural back-
ground to this continued resonance needs to be recalled here.

Over the second half of the twentieth century, a surprising revaluation of the plaster casts so reviled by an earlier generation took place in museums throughout the West. This seems to present something of a paradox. Why should it be interesting to look at plaster casts from the antique when genuine antique statues were now abundantly available to tourists, not to mention their handy portable replicas in the form of postcard photographs? The answer must surely be that the cast came to be seen not simply as a replica but as embodying an added cultural value, and not one restricted to the meagre art-historical interest implied in the fact that such copies were the major resource for the study of the antique before the rise of photography. As Michaela Unterdörfer has clearly shown, a whole generation of contemporary Italian artists began to incorporate elements of classical casts, in one way or another, into their works of the 1960s and 1970s.[6] The practice can be seen as directly connoting – and perhaps exemplifying – the postmodern strategy followed by many of these artists. The plaster fragment after the antique marks a strong yet at the same time an undisguisedly flawed identification with the past. The psychological, as well as the aesthetic, implications of such a strategy cannot be taken further here. But they will be considered in the later part of this study.

The Whitechapel exhibition of 1981, initially shown at the Stedelijk-Van Abbé Museum, Eindhoven, and ably supervised by its director, Rudi Fuchs, clearly signals the emergence of Kounellis as a major artist, with a satisfying range of important works already to his credit. In contrast to the frenetic documentation of the 1972 Documenta catalogue, one might single out for praise the joint publication by the two galleries of one of the best (though not the first) individual catalogues that cast a retrospective eye on Kounellis's achievement. In its sober brown-paper wrapper – evoking just the same revaluation of *poor* materials that is achieved so markedly in the works themselves – the Stedelijk/Whitechapel catalogue features a wide range of recent objects and installations. But it also makes available for the first time substantial English translations selected from Kounellis's own writings. These fascinatingly heterogeneous texts, which will be quoted later, are neither descriptions of the works themselves, nor (in any conventional sense) journals recording the artist's life – though they may sometimes be presented as such. They are perhaps best thought of as intermittent meditations that speculate on the existence of a world of manifold cultural interconnections: a world that is criss-crossed by the tracks left by earlier artists, and indeed not only by visual artists, since

poets, novelists and composers are also prominently featured. This is the chosen itinerary along which Kounellis moves in fantasy, profiling his own schemes against such rich associative textures, and inviting the reader to follow in his steps.

Yet I must come back to my main concern in this section, which deals with the traces that individual works leave behind, and the track that memory takes, in part independently of the prompts supplied by catalogues and photographs. It is necessary to insist on this emphasis, if only because it corresponds to Kounellis's own increasing focus on bringing out the special character of a site, whether it be a closed gallery space or a more public, open, situation. During the 1980s, the insistence on the wholesale transformation of given sites became so integral a feature of Kounellis's artistic practice that, at the end of the decade, Gloria Moure decided to commemorate his show at the Espai Poblenou at Barcelona with a volume that did not simply retrace the course of his career to date chronologically, but focused specifically on the documentation of three major recent exhibitions: those at the CAPC, Bordeaux (1985: illus. 25–27) and the Museum of Contemporary Art, Chicago (1986: illus. 28), together with the one that she herself was holding at Barcelona.

This recognition of the importance of the exhibition site has, from my own point of view, produced an odd subsidiary effect. I did not see any of these three notable exhibitions. But the outstanding photographic record of the Bordeaux show, in particular, has left a strong impression precisely because I have made so many other visits to the Entrepôt Lainé – the former warehouse by the Bordeaux quayside, which had then recently been converted into a superb exhibition space for contemporary art. One or two notable works by Kounellis have remained behind, on loan to the CAPC collection, and these have continued to provide a vivid testimony of how astutely he interprets the character of the massive industrial building. But the effect of these still surviving installations is retrospectively enhanced for me by the testimony of the earlier photographic record, which demonstrates how Kounellis's astute lighting and choice of simple primary materials entirely transformed this imposing space. In a comparable way, I am touched by the two photographs of *Untitled* (1977: illus. 29–30), not because I ever saw Kounellis's miniature electric train running around a circlet of iron affixed to a pillar in the Cloisters of Santa Maria Novella, but because, having often stopped off at the railway station in Florence precisely to revisit these nearby tranquil cloisters,

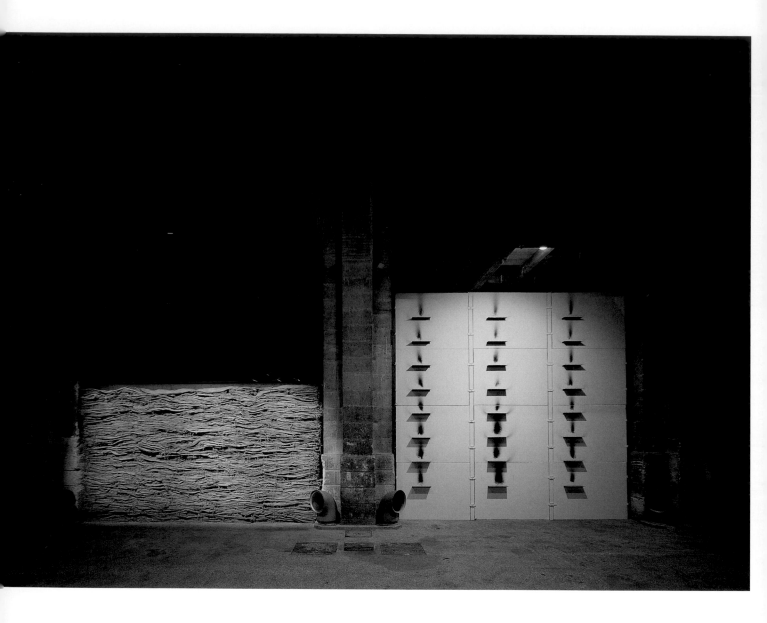

25 *Untitled*, 1985. Arch 1, jute sacks, double iron beams; Arch 2, white painted iron plates,
consoles, traces of soot. Width of arch 500 cm. Exhibition at CAPC, Bordeaux, 1985

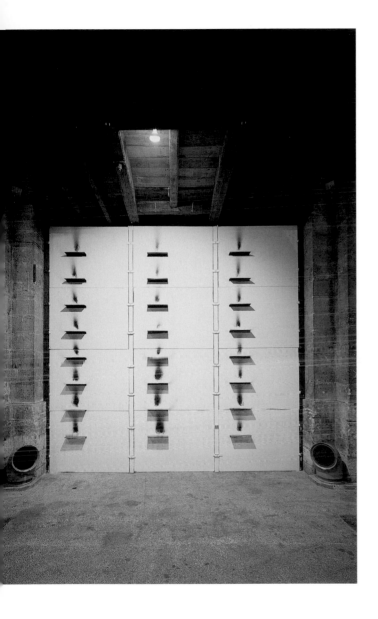

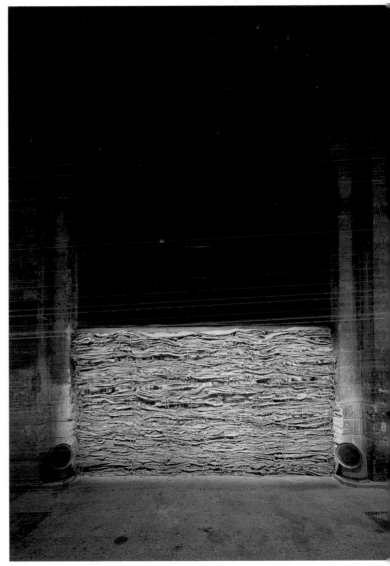

26 Detail of *Untitled*, 1985

27 Detail of *Untitled*, 1985

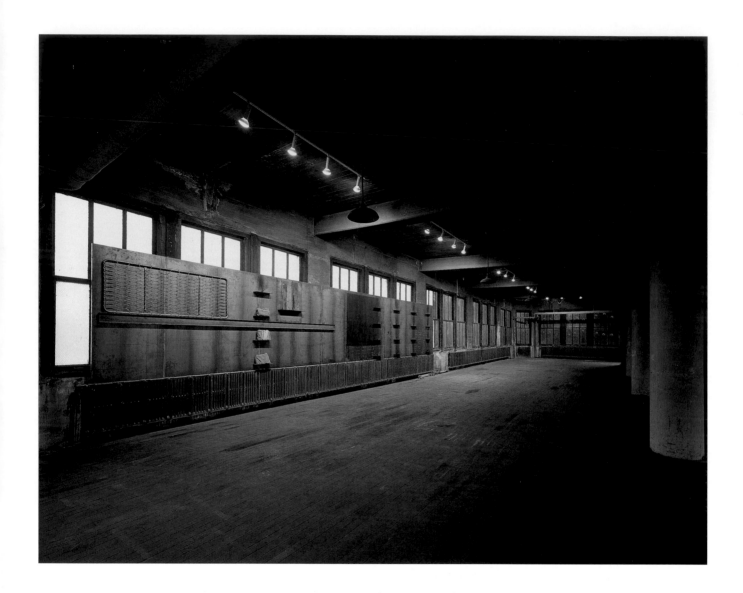

28 *Untitled*, 1986. Iron panel with a spring mattress, four shelves, the top one with smoke stains and the others with fragments of wood wrapped in blankets, one shelf with fragments of wood placed along the length of an iron beam; black painted square and sixteen shelves with smoke stains on the panel: in the background, windows walled in with lead, incisions in the metal. Exhibition at West Jackson Boulevard, Chicago, 1986

I can reinvest the image with the sensuous quality of the cool refuge from midday heat that I experience there.

The Bordeaux show of 1985 marked an irreversible advance in Kounellis's ambitious project of transforming large-scale exhibition spaces through installing a comprehensive array of his major works to date. It formed, as Bruno Corà remarked at the time 'the greatest sequence of images ever produced by his linguistically subversive repertory'.[7] In this respect, it has set the pattern for a sequence of more recent major retrospectives, in which he has once again energetically taken on the task of adapting an entire building to his demanding brief.

I recall, for example, Kounellis's second one-man show at the Stedelijk Museum, Amsterdam, which took place early in 1990. This incongruously staid, brick-built epitome of Dutch nineteenth-century civic architecture has often enhanced the shock value of contemporary work on display by the demure cleanliness of its galleries, with their carefully crafted (and slightly creaking) wooden parquet floors. Through an odd neglect of the principle of direct access (which is evident in other major Amsterdam galleries like the Rijksmuseum), both the building itself and the main exhibition space on the first floor are reached by steep flights of steps. In 1990, Kounellis took the bold decision to surround this central staircase-hall with his characteristic panels of steel, hung close to the cornice and just above the line of blank arcades which decorates the interior walls of the building. Along the full length of these panels, thin gas-pipes protruded, each bearing at its tip a guttering jet of flame. The whole hall resonated with the fierce hissing of these gas jets, and their sound could be heard echoing through the adjacent exhibition galleries (illus. 31–32).

A contrasting achievement in almost every respect was the show at the Centro per l'Arte Contemporanea Luigi Pecci in Prato, which I visited on its last day, 9 September 2001. This large and ungainly specimen of postmodern architecture sits by the side of a surprisingly ugly street on the outskirts of the medieval town, with as much grace as a beached blue whale. Its stridently coloured exterior claddings seem designed precisely to repudiate the Renaissance refinement of the town centre, where there are notable works by Donatello and Fra Lippo Lippi on view. The shoddy plasterwork of the interior of the recently built exhibition space seems already to be crumbling in places, so that its huge, barn-like interiors have taken on a melancholy, unloved air.

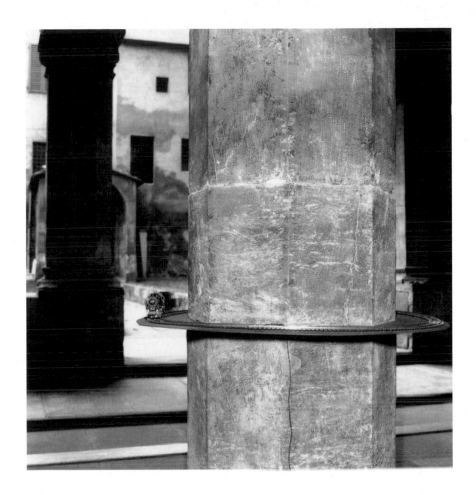

29 *Untitled*, 1977. Miniature electric train on a circle of iron fixed to a column. Installed in the Cloisters of S Maria Novella, Florence, 1977

30 Detail of *Untitled*, 1977

Kounellis's recipe for this embarrassing attempt at a place worked like a shot of adrenalin. More than forty of his works were shown, as usual covering the period from the late 1950s to the present time. Each of the large, connected rooms was brought to life by a dynamically counterbalanced, non-chronological selection of works, with the early paintings (an example from the 1960s hung very low on the wall) sharing the vast area with intricately assembled composite works: panels incorporating huge aquariums that contained live fish, and heavy piles of old cloth-bound books stacked up in metallic frames. Directly reminiscent of *Da inventare sul posto* was the presence in one room of a grand piano, marking the occasion of an earlier performance of *Untitled* (1970) – the playing of a fragment from Verdi's *Nabucco* (illus. 33).[8] As in 1972, one could assume that the performance had already taken place.

There was no lack of opportunity at Prato to focus on the many visible interconnections existing between these works, drawn as they were from a time-span of over forty years. Individual features could be picked out here and there which gave a specific identity to the mass effect of the different

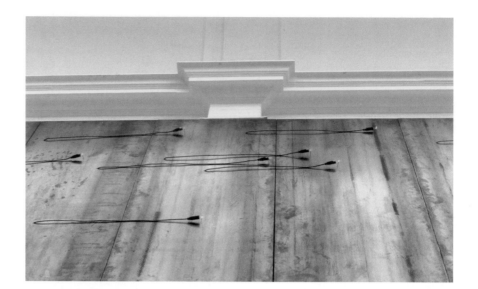

31 Exhibition at the Stedelijk Museum, Amsterdam, 1990

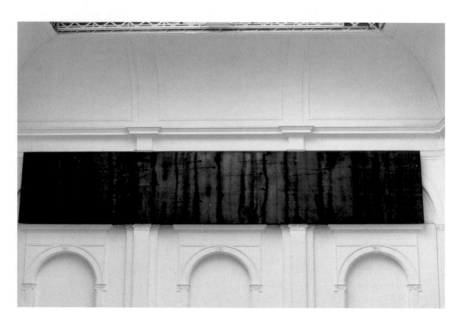

32 Stedelijk Museum, Amsterdam, 1990

installations. Such was the opportunity to observe a single date, AD 1783, printed in blue glazed lettering on no more than one of the grouped Mediterranean amphoras in *Untitled* (1989: illus. 34), or the glimpse of a small goldfish, seemingly transfixed by its own reflection in a knife that lay motionless in a bowl of water (illus. 35).

In these major retrospective shows of recent years, Kounellis invariably performs, one could say, with his full orchestra. But this rapid summary of my recollections of his work over four decades would not be complete without account being taken of more casual, and sometimes accidental occasions for viewing it. A chance visit to Bologna in the

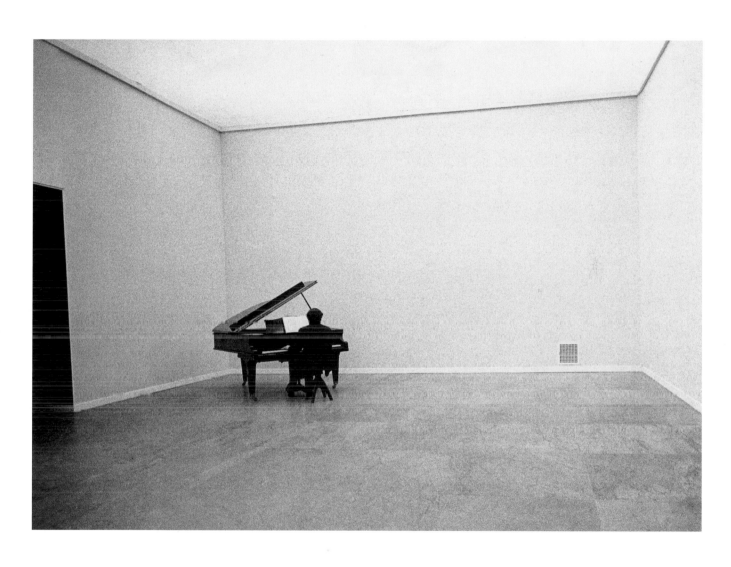

33 *Untitled*, 1970. The pianist Frederich Rzewsky plays a fragment of 'Va pensiero sull'ali dorate' from Verdi's *Nabucco*. Exhibition, Palazzo della Quadriennale, Rome, 1970

34 *Untitled*, 1989. Work consisting of two elements: iron panels, sacks of coal hanging from metal rods; amphorae full of seawater except one, which is full of blood. Exhibition at Museo di Capodimonte, Naples, 1989–90

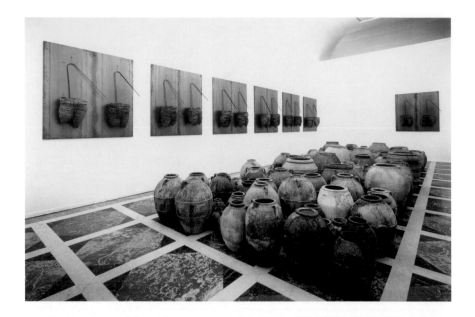

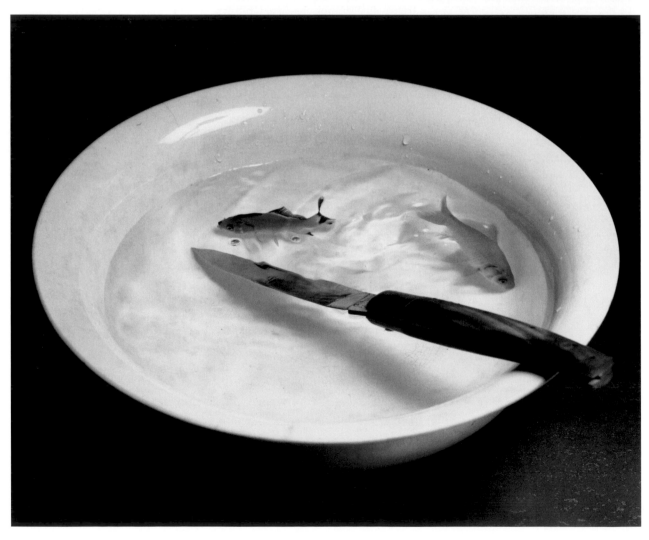

summer of 1995 enabled me to see what striking new use he had made of the medieval Salara, a polygonal brick building on several floors which was at the time left empty, pending a project to devote the site (close by the former city walls) to a visual arts centre. The building itself had been stripped to its bare bones, with wooden beams and columns outlined starkly against the unplastered walls. Kounellis had installed, in the upper room with its intricate structure of wooden roof supports, a series of heavy boulders attached to the roof beams which underlined the forces of gravity and, in the lower room, a set of steel panels duplicating the rhythms of window and wall (illus. 36–39). This was, however, more than a mere exercise in applied mechanics. As I shall argue presently, Kounellis is never so engaged in the physical balancing of weights and forces as to obliterate the effect of the forms and their representational function.

Very few of Kounellis's works have been designed to occupy a permanent architectural home and this, once again, will be an issue extended further in the later part of this study. I discovered one apparent exception to the rule on a visit to Padua a few years ago, during which I was searching for the historic Anatomy Theatre in one of the central university buildings. In the courtyard of the old palazzo, which pullulated with milling students, and in a position symmetrically opposite to a large marble panel covered with commemorative inscriptions to the war dead, there was a comparable large work by Kounellis. This was a monument to three professors of the university who had died under the Fascist regime. Layered horizontally with packed paper and card materials that filled the entire wall space, it was both solemn in its emphatic presence, and democratically open to different interpretations.

Most intense, perhaps, of all these memories of chance encounters remains my visit to the Venice Biennale of 1993, when the question at the forefront of my mind was the gathering of materials for an essay on Kounellis's contemporary, Giulio Paolini. In the intense summer heat, the dusty alleys of the Giardini were more than usually tedious to negotiate. Paolini's work was fixed, in an elegant yet quite unobtrusive fashion, on the actual facade of the Italian pavilion, with the result that I missed it completely on my first entry, and had to try and locate it in the labyrinth of exhibition rooms. Intermittently, I regretted the absence, from the major galleries on the ground floor, of the spectacular installation by Kounellis that I had first noticed at the 1988 Biennale and viewed again, when it had been newly adjusted to the very different spatial conditions, in the

35 *Untitled*, 1991. Bowl of water with gold-fish and knife. Originally a poster for an exhibition at Synagogue Stommeln, Pulheim, 1991

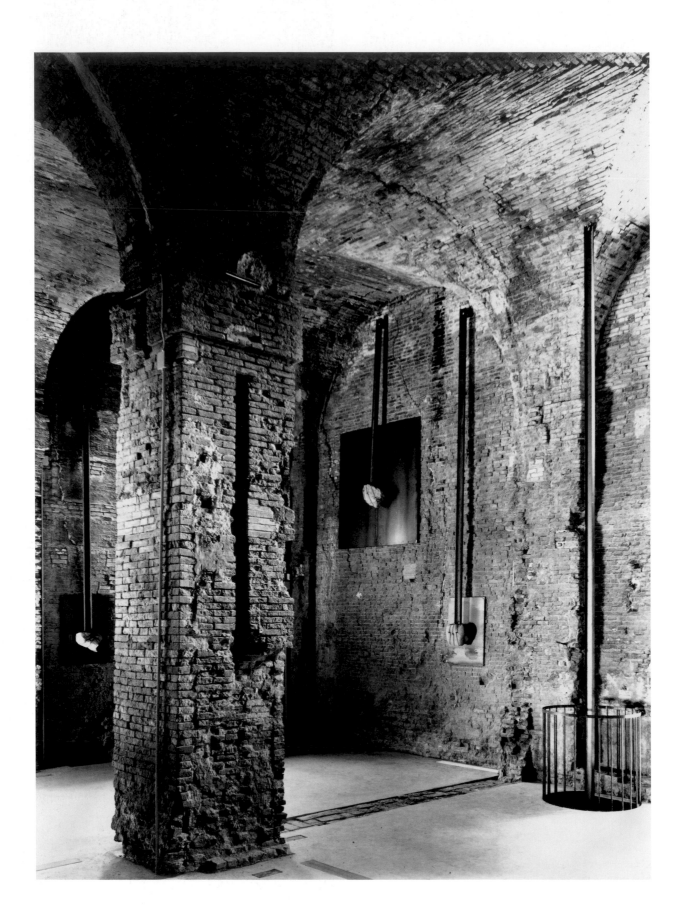

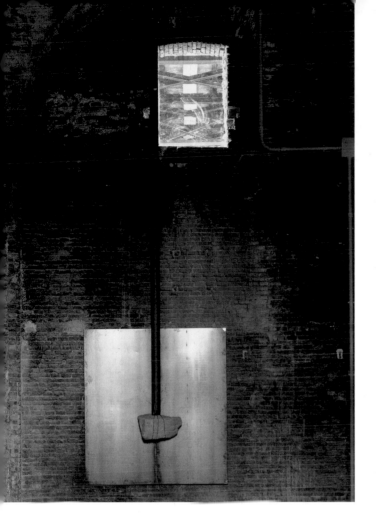

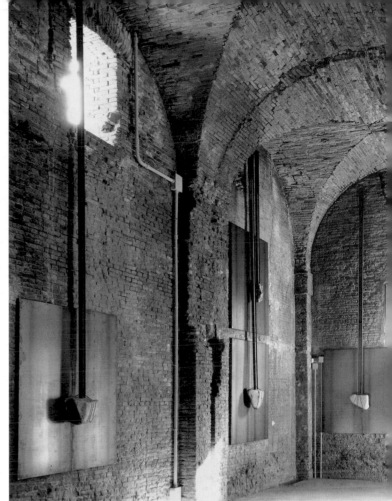

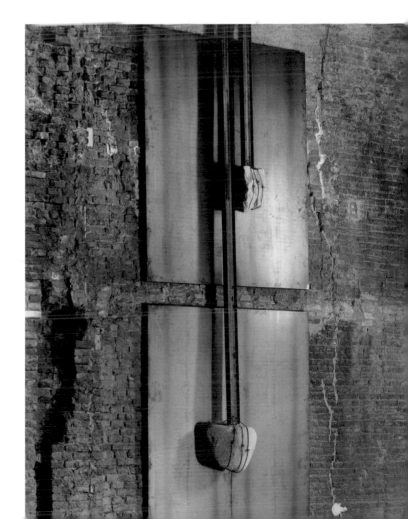

36–39 Exhibition at the Galleria d'Arte
Moderna 'La Salara', Bologna, 1995

Stedelijk exhibition of 1990. Yet this vivid recollection was superseded after a short while. Just adjacent to the small lateral canal that cuts across the Giardini, with its door open to let in a pleasant current of cool air, there was a single room that Kounellis had filled with the canvas sails of Adriatic fishing boats (illus. 40). Floating just below the ceiling, these were by no means new sails, but had been visibly roughened, toughened and discoloured by many years of use. Just one of the sails carried a token of an original dedication, in the form of a crucifix, and the whole array was billowing gently in the afternoon breeze.

MNEMOSYNE

I am starting to write this study of Kounellis as a guest of the Aby Warburg-Stiftung, in the very building where this pioneer of a broader cultural approach to art history first established his library in 1926. Each time that I enter the building, I pass beneath the stone lintel that bears the engraved inscription, in letters of gold: MNEMOSYNE. This powerful evocation of the Greek word for memory recalls Warburg's life-long dedication to the task of tracing the afterlife of the Classical tradition. The Warburg-Stiftung may seem an unlikely context in which to write about the work of Kounellis, who once declared forthrightly: 'There aren't any art historians. History is of use only to artists and poets.'[9] Yet precisely because Warburg himself problematized the issues of history and memory as applied to the understanding of works of art, it is possible to think of his example as a point of reference. Warburg was concerned to make explicit problems that had been conveniently elided in the narrative procedures of mainstream historiography. Not content with hazy notions of succession and influence, he addressed some of the fundamental questions underlying the concept of tradition. What is it that is carried over from one art work to another in a historical sequence? What do we need to know in order to identify this process when and as it occurs? How can we locate it securely in art works that appear to be very remote indeed from the cultures that the historian has previously been committed to studying?

One of the terms that became central to any discussion of these questions, by Warburg and those who learned from him, is 'iconography'. From the early modern period onwards, collections such as Cesare Ripa's *Iconologia* had codified the visual symbols found in emblems and devices,

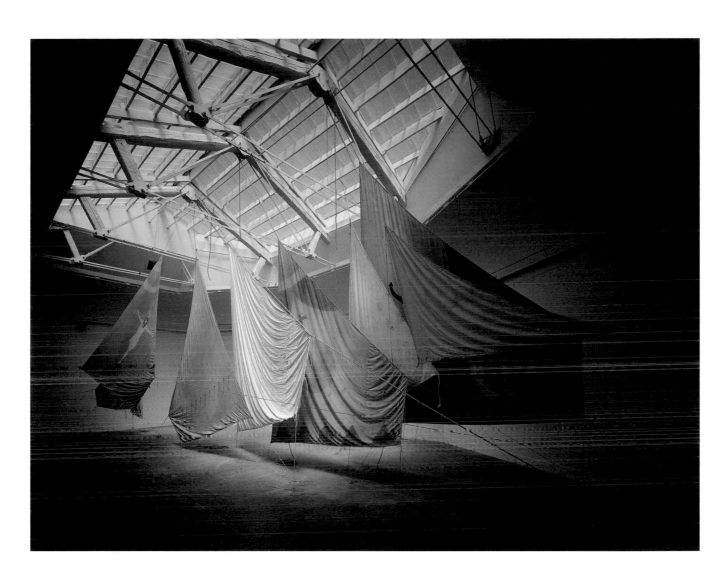

40 *Untitled*, 1993. Old sails from Venetian fishing-boats. Collection Galerie Christine König,
Vienna. Exhibition at XLV Venice Biennale, 1993

besides the entire range of paintings, sculpture and architecture. Warburg brought to the study of iconography a vast learning and an unusually open mind. Some of the fruits of his thinking were embodied in the remarkable montages of associated images (the so-called *Bilderatlas*, or picture atlas) to which he gave the overall title *Mnemosyne*. In one of these montages, a print after Raphael by Marcantonio Raimondi holds the centre space, while Delacroix's *Massacre of Chios* and Manet's *Déjeuner sur l'herbe* can be found in the group of images adjoining.[10] We are invited to imagine the resonance, at the very brink of modernity, of Raphael's lost *Judgement of Paris*, saved from oblivion by Raimondi and so nimbly plagiarized by Manet. Warburg believed intensely in the power of certain images to perpetuate their message across time, and he often mused on the significance of two complementary figures that seemed to condense the abiding memory of the antique: these were respectively the emblems of the active and the contemplative life: the 'ecstatic nymph' and the 'dreaming river God'.[11]

Of course the concrete effect of Warburg's juxtaposition of images in *Mnemosyne* brings a major reservation to the fore.[12] The Raimondi print is without any doubt dominant in this particular constellation of images. It is, for one thing, almost as large as all the other images put together. It has an 'absolute' size, being at the very scale that it has maintained as a re-edition of Raimondi's original print, while the other images are completely out of scale in absolute terms, having been arbitrarily cut down following the requirements of photographic illustration. This may seem to be a quibble. But let us imagine that Warburg had been capable of juxtaposing the Raimondi print with the actual painting of Manet's *Déjeuner*, or indeed the reduced version (by the master's hand) that is in the Courtauld Institute Gallery. Would not this change in relative scale alter our perceptions very considerably? Instead of recognizing the unchallenged authority of the Renaissance print, confronting a range of rather indifferent photographic reductions, we would see the Raimondi being challenged by the virtuoso brilliance of Manet's brushwork, and by the undoubted prestige of what must be the modernist painting *par excellence*.

This hypothetical experiment is suggested as an initial response to Kounellis's judgement: 'There aren't any art historians.' We could rephrase the point in a more diplomatic way by saying that the demonstration of Manet's relationship to Raimondi, and indeed to Raphael, is only fully meaningful if the materiality of all the referents is taken into account. Or, to put it another way, the kind of connection that can be made from an

exclusively iconographic analysis is likely to privilege the earlier of the two referents, especially when it is closer to the original form of the representation. Even when the playing field is levelled, and the images are reduced to a common medium, the older work will usually speak more powerfully to the memory. The *ecstatic nymph* and *dreaming river God* evoked by Warburg are creatures of the classical tradition and not of Modernism, even though Manet has managed to transmogrify the latter into a comfortably reclining contemporary French bohemian. We have to acknowledge that the Renaissance as a historiographical category was created by, and in terms of, the historical sensibility of the nineteenth century. It may look as if Warburg is just reflecting the commonly held view that the Renaissance embodied a revivification of the classical past, without convincing us that it had secured an indefinite lease of life in the process . What is Manet's stake in this fund of memory, we might ask, if his forms have done nothing more than trigger a process of recognition?

A partial answer to this objection is that Warburg is indeed more than anxious to detect the life of the past in the forms of the present. In this respect, he anticipates the ways in which a range of contemporary art historians have tried to articulate the relationship of modernist art to earlier achievements. It has been demonstrated with conspicuous success that we need no longer regard the 1860s as a definitive break in the Western tradition of visual art. With regard to Manet, in particular, Michael Fried (whose early work on this artist in the 1960s pioneered this type of approach) has argued convincingly for a series of multiple connections between High Modernism and the traditions of the Italian, French, Spanish and Dutch schools. He has coined the term 'repetition-structures' for these omnipresent recurrences that may have been only occasionally noted by critics at the time, but on closer study prove to be incontrovertible.[13]

Quite explicitly, Fried's searching analysis is not confined simply to noting the repetition of iconographic motifs. Wherever such repetition can be identified, the wider question of what purpose it might serve comes to the fore, and the primacy of Manet's pictorial sensibility is taken for granted in assessing its significance. The sub-title to Fried's monograph on Manet, *The Face of Painting in the 1860's*, expresses synecdochically the point that this is not just a literal concern with 'faces' (such as the averted face of the unclothed 'nymph' who derives from Raimondi in the *Déjeuner*), but with the pictorial effect of 'facingness': that is, a distinctive

flatness of surface which does not completely relinquish spatial depth, but still confronts the viewer in an unprecedentedly direct fashion. Fried does not take 'facingness' for granted, as if it were synonymous with the literal flatness of some contemporary abstract paintings. He shows how Manet works to secure this address to the spectator through all the diverse mechanisms of his art.

This example perhaps indicates a way in which Kounellis's reservations about art history can be deflected. There is no cause to dispute the point that conventional art history often puts a premium on the earlier work, when a close relationship between two works is being claimed. No purely iconographic analysis will adequately account for what it may be, in the later work, that requires and validates such a 'repetition'. But a more productive approach lies in apprehending and understanding what it is that distinctively characterizes the more modern work, and in projecting that analysis back upon the earlier forms which may well, in effect, be entirely reinterpreted as a consequence. Artists have indeed understood this point better than most art historians. Indeed, one of Kounellis's most admired predecessors, Van Gogh, showed an acute awareness of the ways in which 'influence' can be said to work backwards, from the present to the past. As he put it in a letter to his brother Theo from July 1880: there is 'something of Rembrandt in Shakespeare'.[14]

It may perhaps appear more difficult to sustain this point if the modern work has (by contrast with Van Gogh or Manet) no clear iconographic content, and no element of figuration and narrative content such as can be seen to function – however vestigially – in a work like the *Déjeuner*. What Kounellis strives to obtain in his art is a relationship to the art of the past which seems almost to bypass, and render completely irrelevant, such concepts of iconography, figuration and narrative. But this economy of means is a strategy of securing its connection to the past on what could be a no less fundamental level. Kounellis's insistence on the use of the term 'Untitled', which has already been mentioned, denotes among other things a determination not to foreclose interpretation with crude literary or anecdotal readings. But, as I hope to show in what follows, these works manifest in their scale, their materials, and indeed all their physical attributes, their rootedness in the structural procedures of Western art. Here again, the value that an art historian like Fried attaches to the concept of 'facingness' seems very relevant. Kounellis's work does not 'face' us in the same way that Manet's *Déjeuner* does. But Manet, and

41 Exhibition at CAPC, Bordeaux, 1985

42 *Untitled*, 1985. Stones covered in jute sacks. Width of arch
500 cm. Exhibition at CAPC, Bordeaux, 1985

43 Detail of illus. 41

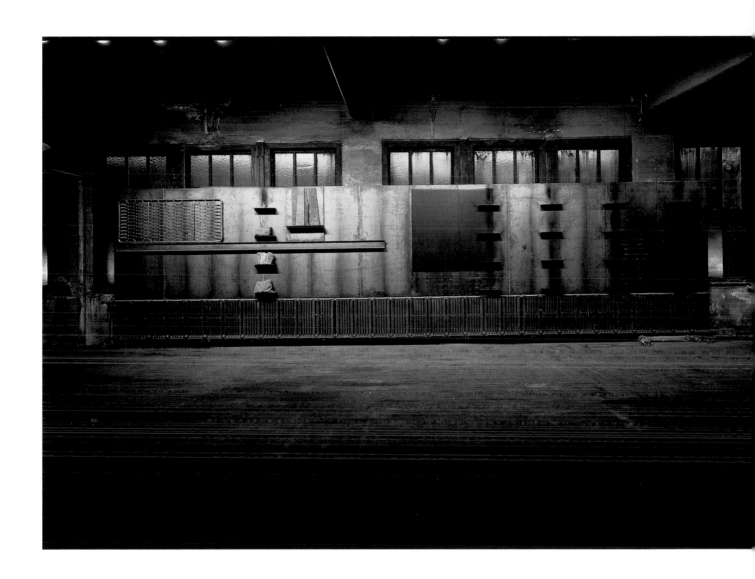

44 *Untitled*, 1986. Exhibition at Sam's Liquors, 740–52 West North Avenue, Chicago, 1986

indeed Masaccio before him, may help us to understand how Kounellis has engineered his own style of confrontation, his own 'facingness', as a form of address to the spectator, and as a material equivalent to the evocation of historical depth (illus. 41–44).

The simple answer to the point that there are no art historians is therefore that there are art historians, but they must be carefully selected. Those who will later be quoted in my section on 'Alternative Art Histories' are by no means a homogeneous group. But they have in common the capacity to analyse the art of the past in such a way that their judgements can inform (and be informed by) the art of the present. And, as Warburg has been used to introduce this discussion, it is appropriate to mention here one of the channels through which his preoccupations have been brought up to date: namely, a recent study that radically updates the image of the 'ecstatic nymph' that Warburg tracked so remorselessly. Georges Didi-Huberman's eloquent *Ninfa Moderna* begins with the sculptures of antiquity and the Venuses of Renaissance painting, takes an excursion in the direction of the Baroque sculptor Stefano Maderno's *Saint Cecilia*, and then plunges us without ado into the gutters of Paris.[15] The bundles of rags traditionally placed there in order to canalize water from the drains have attracted the attention of photographers from Atget and Moholy-Nagy to the new British artist Steve McQueen. But over the same period they have no doubt come to be looked at with new eyes, in part owing to the reclamation of rubbishy materials effected by the *Arte Povera* artists and their predecessors (illus. 45–47). Through the deployment and analysis of an abundant photographic iconography, Didi-Huberman alerts us to the reappearance in such an abject but compelling guise of Warburg's draped and gesturing nymph.

So MNEMOSYNE can still preside over the process of interpretation, after all. But it is not just a matter of adding the stock of Kounellis's motifs to an encyclopedic collection of preexisting motifs, where every new arrival has to suffer the indignity (or abide the irony) of being the furthest from the source. A study like *Ninfa Moderna* focuses precisely on the way in which such 'poor' materials reactivate memory not in spite of, but because of, the disquieting pathos that they embody. This is a lesson that applies, no doubt, to the whole phenomenon of *Arte Povera*. It is through an unostentatious negativity – an avoidance of the visual exuberance of the Renaissance tradition – that these artists secure their right to be incorporated in it. But MNEMOSYNE must also be, in the context of this study, the

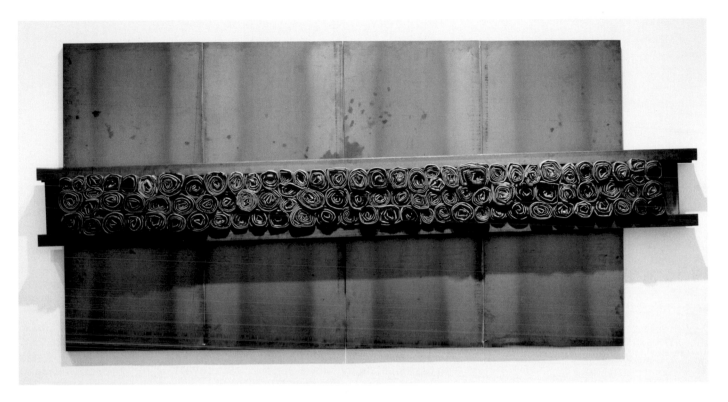

45 *Untitled*, 1998. Cast-iron plate, double iron beams, lead casters, clothes; 200 x 420 cm. Exhibition at Ace Gallery, New York, 1998

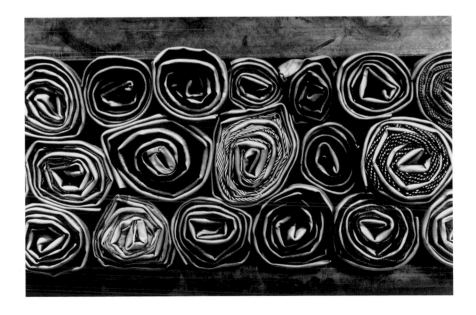

46 Detail of *Untitled*, 1998 (illus. 45)

emblem of memory in its most direct and personal sense. What I recall of Kounellis's work, after observing particular pieces and revisiting them over the years, can be transmitted – in the way that I have already begun to do here – through the description of some of the striking features of his major exhibitions. This brings to a conclusion the process, begun some time ago, of making notes about the works at the time when they were first seen, with the intention of jogging the memory at some later date. Yet on one of the most recent occasions when I was able to see a substantial collection of Kounellis's works – at the '*Arte Povera*' exhibition at Tate Modern (Autumn 2001) – I decided not to make any further lists of 'Untitleds' that I could only identify in note form by their dates and their specified materials, and I paid scant attention to the official catalogue. What seemed apt instead was to make a pen sketch of each work that took my attention, very rapidly and inexpertly, so that a record would remain not just of the objects themselves, but of the moment at which some of their motifs and properties had particularly caught my attention: a bar with the treble clef inscribed on a coloured canvas leaning against the wall, an uneven row of sober sacks, a mass of gleaming coals on a trolley. This proved no less valuable than having received, as a result of a fellow visitor's foresight, an informal photographic record of many of the works in the Stedelijk Museum show of 1990, taken on the spot at the time.

MNEMOSYNE – the inscription at the entrance to the Warburg library – calls out, however, for a wider historical perspective. It will be argued that the 'repetition-structures' occurring throughout Kounellis's work are not confined to one genre or medium. Their very heterogeneity obliges the critic and historian to reopen long-standing debates regarding the distinction between painting and sculpture, the relationship of plastic art to performance and theatricality, and indeed the overarching question of architecture as the summation of the arts. My first obligation in the section that follows will be to set Kounellis's achievement in a contemporary historical context. But in this very process some of these further issues will need to be identified, and to some extent disentangled, so that recognition can be given to the wider tradition to which he lays claim.

47 Detail of *Untitled*, 1998 (illus. 45, 46)

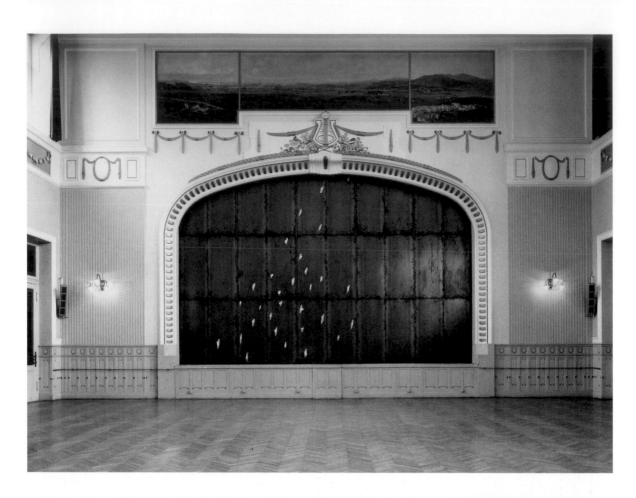

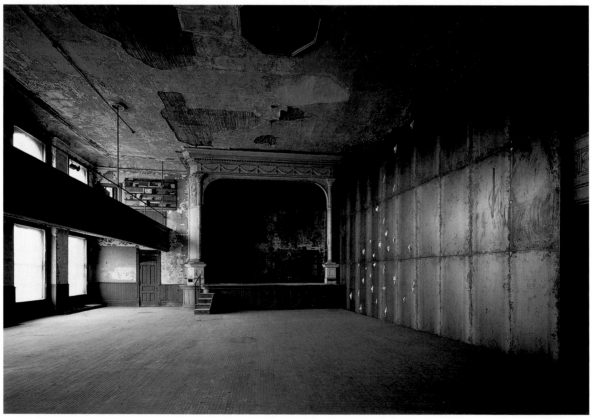

2 A Mediterranean Art

48 *Untitled*, 1986. Proscenium arch walled in with 30 iron panels, some with incisions faced with lead and fragments of plaster casts. Installed at the Theater am Steinhof, Vienna, 1986

Jannis Kounellis was born in Piraeus, the ancient harbour serving the city of Athens, in 1936. At the age of nineteen he emigrated to Rome where he began to study at the Accademia di Belle Arti, and held his first exhibition in 1960 while still a student. On his arrival in Italy, he took the decision to speak Italian, rather than Greek, forthwith. In a later interview, he referred to the effect of this decision as a 'trauma', which left a psychological wound.[1] Yet we can surely also see the shock of this displacement as a prelude to Kounellis's abidingly creative preoccupation with language, and his insistence on the need for the plastic artist to think through his project in quasi-linguistic terms. In discussion in 1985 with Beuys, Kiefer and Cucchi, he emphasized in a phrase that will resonate particularly at the conclusion of this study: 'The construction of the cathedral is the construction of a visible language.'[2]

Since Kounellis made his home in Italy from 1956 onwards, there can be little point in regarding him as a Greek artist in any exclusive sense. Until quite recently, his work does not appear to have been at all well known in Greece – indeed it has been portrayed as something between a mystery and an imposture by at least one native-born critic.[3] There is little doubt that his work can be understood as bearing a significant relationship to Greek religious art, and to the visual traditions of the Orthodox Church in general.[4] But this should in no way be regarded as an exclusive affiliation. Kounellis has used in conversation with me the telling phrase 'the tyranny of the icon', which indicates a sure need to preserve his distance. Gloria Moure is right to underline, when she discusses his borrowings from the antecedent cultural legacy of Greek paganism, that this has no connection with being 'of Greek origin'. On the contrary, Greek nationality is, for Kounellis, 'a fact from which he himself has tried to extirpate any provincial connotations, transposing it into the broader, collective patrimony of all Westerners'.[5]

Yet it remains true, for Kounellis, that Western culture means essentially European culture, and its centre of gravity lies for him in the South, rather than the North of Europe. In the course of the lengthy discussion at Basel in 1985, he expressed one consequence of this position unambiguously from the start: 'America does not exist on its own. It is a projection. For me the best America is always Kafka's . . . America has no culture.'[6] This sentiment was not directly challenged at the time by any of the group of European artists who were conducting this frank exchange of views. Yet Kounellis, for his part, would never have subscribed to the no less

49 *Untitled*, 1986. Thirty iron panels, some with incisions faced with lead and fragments of plaster casts. Installed in a disused theatre, Chicago, 1986

forthright statement made by Beuys at the conclusion of one of these discussions: 'The heart of Europe lies in Germany.'[7] For Beuys, it transpires in these exchanges, the value placed upon nomadism as a pattern for the artist's life, and the attention given to the culture of small, distinctive peoples like the Basques, does not avert the fact that, for him, European culture finds its deepest roots in the German experience. Kounellis's position is a symmetrically opposed one, and different on many levels from that of Beuys. For him, to be rooted in the many-layered culture of the Roman world is not an obstruction, indeed it is a complement, to the 'Mediterranean' overview.

It is one of the most interesting and unexpected aspects of late twentieth-century European art that this concept of a 'Mediterranean' dimension, in historical and visual terms, has reinstated itself over a few decades, despite (or perhaps because of) being somewhat at odds with the urban, internationalist emphasis of Modernism. Picasso has been, to a certain extent, repatriated from the banks of the Seine to figure as a Catalan artist, beside other Catalans. As early as 1935 Adrian Stokes elaborated in *Stones of Rimini* the argument that Renaissance painting sprang from the observation of Mediterranean light on limestone, and defended contemporary British artists like Nicholson and Hepworth on the basis that they had reestablished contact with the Mediterranean tradition of Piero della Francesca and Agostino di Duccio. In his magisterial history published in the 1950s, Fernand Braudel powerfully underpinned these intermittent visions of a pan-Mediterranean culture when he viewed the whole interconnected maritime zone from the perspective of a *longue durée*, which caught in one frame the contemporary Greek fisherman sitting at his café table and the legendary exploits of Ulysses.

Most vivid, perhaps, among specifically pictorial references of this type has been Roland Barthes's coining of the phrase 'a kind of Mediterranean effect', to describe the paintings of the American artist, Cy Twombly.[8] This was echoed, aptly enough, in Richard Howard's essay on Twombly's recent major series of paintings, *The Battle of Lepanto*, shown at the Venice Biennale of 2001. Twombly is, like Kounellis, a foreign artist, who left his native country and made his home in Rome from the 1960s onwards, and for several reasons his continental change of locations suggests interesting parallels with the shorter journey of Kounellis. In the synoptic 'Art of the 20th century' exhibition, held in the Berlin Gropiusbau in 1997, the last set of galleries in the chronological sequence featured a

large painting by Twombly in memorable juxtaposition with Kounellis's *Untitled* (1986), an assemblage of 30 iron panels originally installed within a proscenium arch at the Theater am Steinhof, Vienna, and also shown to striking effect in a disused theatre in Chicago (illus. 48–9). It hardly needs emphasizing that any comparison between the 'Mediterranean' values of these two Roman exiles exposes significant differences in almost every aspect of their working practices. What they do arguably have in common, however, is a determination to wrest inherited meanings and traditional symbols out of the domain of sterile, repetitive iconography, and to imbue the old rhetoric with a raw, contemporary enunciation.

Kounellis's Mediterranean identity is expressed first and foremost in his kinship with the vessels that sail and steam across its length and breadth. These are not the mythic warships of the *Battle of Lepanto* series, tinted blood-red and gold, but the heavy iron-clad cargo vessels that ply laboriously from port to port. For the poster of his show at Barcelona in 1989, Gloria Moure chose to use a photograph by Eugenio Forcano of a vessel loading rusty iron drums in the port of the city, with the tautness of the rigging offsetting the visible tension of ship's cables and chains. All that Kounellis found it necessary to add was a 'signing' of this image, partly through the superimposition of his name in red letters, and partly through the intrusion of his own hand, grasping a burning oil lamp, against the ground of the photograph. Twenty years earlier, in another poster advertising an exhibition at the Modern Art Agency in Naples, dating from 1969, he had initiated this theme with a work that was simply a photograph of himself far out at sea on the deck of a boat (illus. 50).

In the early 1990s this figurative connection with the world of ships acquired a new and impressive material dimension. At the massive Metropolis exhibition, shown at the Gropiusbau in Berlin in 1991, he exhibited a Roman fishing boat, carefully dissected or, one might say, carved up into component parts (illus. 51). When he finally agreed to return to his birthplace of Piraeus for a one-man exhibition of his work in 1994, he decided to hold it within the hull of the freighter *Ionion*, docked in the harbour (cf. illus. 52–3). Much of the special character of Kounellis's Mediterranean vision can be summed up in the fact that this show did not take place in the city of Athens, but afloat on board ship in the ancient port.

This close identification with the sea and shipping is not, of course, simply a mode of autobiographical allusion. On the one hand, the cargo boat or barge can be envisaged as a perfectly self-enclosed world, and

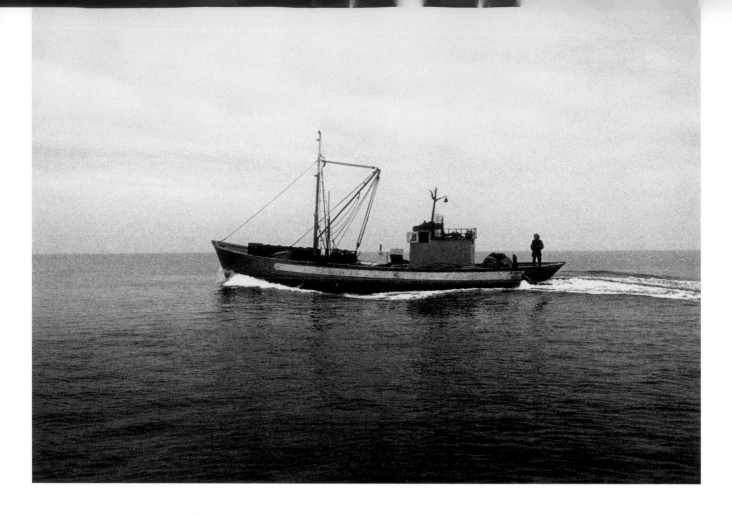

50 *Untitled*, 1969. Photograph of the artist on the deck of a boat, 1969

51 *Untitled*, 1991. Dissected Roman fishing-boat. 'Metropolis' exhibition at Gropiusbau, Berlin, 1991

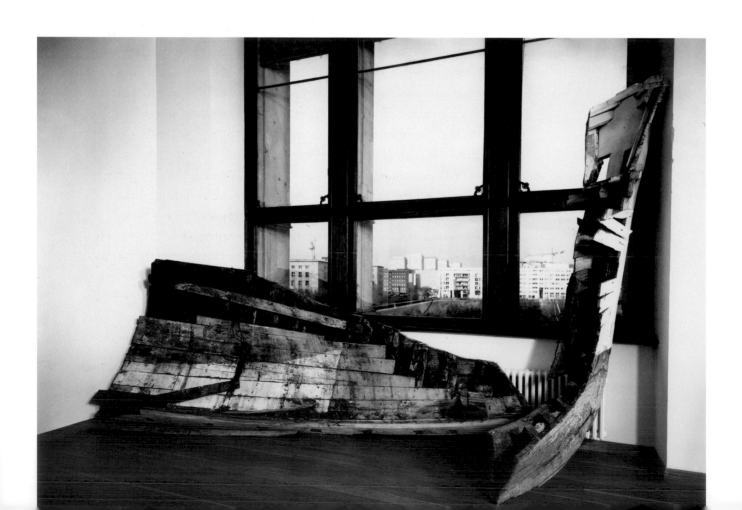

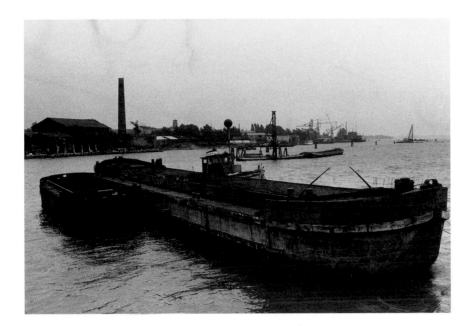 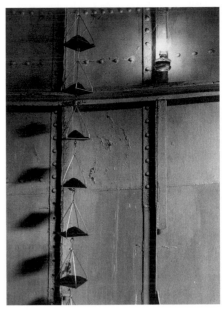

52 *Untitled*, 1974. Photograph showing the exterior of a barge on one of Venice's canals: inside, iron scales with ground coffee and burning oil lamps. Exhibition at the xxxvi Venice Biennale, 1974

53 Interior view of *Untitled*, 1974 (illus. 52). Iron scales with ground coffee and burning oil lamp. 12 x 12 cm, each pair of scales; 228 cm total height, 1974

therefore as a self-contained environment in which to introduce his own personal inflections. Kounellis entirely respects the functional character of such an environment, and does not attempt to change it. As with the lighted oil lamps that illuminate so many of his installations, he aspires to modify the existing scene only to the extent of bringing out its existing visual dynamics. As has already been noted, he seems invariably to prefer working with 'impure' locations to inhabiting the neutral blankness of the White Cube, and indeed his work thrives on the possibilities of interaction with a strongly marked locale. At the same time, the boat is a specially relevant point of reference because it is the privileged centre for an incessant circulation of materials – a regulated and directed movement of masses and commodities. Thus the boat as container emblematically duplicates the central aim of Kounellis's art, and perhaps of aesthetic communication in general.

The French philosopher Michel Serres, himself a practised mariner, analysed in a revealing essay on Turner the huge significance which contemporary developments in shipping over the early years of the nineteenth century held for the British painter. According to Serres, the fully rigged sailing ship represented for Turner the world of classical mechanics, with every mast and pulley adapted to the task of transforming the force of the wind into a strictly governed motion. But, as Turner well recognized, this world was vanishing fast in the course of his own lifetime, giving place to the squat and ugly form of the steam-barge, which expressed the powerful new forces of the scientific and industrial revolution. Hence, according to this suggestive reinterpretation of Turner,

the painting of *The Old Temeraire Towed to its Last Resting Place* has a mythic and elegiac quality. The steam barge is sounding the knell for the beautiful warship that fought at Trafalgar, and simultaneously proclaiming its own Promethean strength through the glow of red pigment that signals an inner fire.

For Kounellis, when he evokes the sea and ships, the note is not elegiac in this sense. Nor is there any intimation of the world-historical critique to which Turner frequently reverts when he infuses images of the fallen maritime empires of Carthage and Venice with his own concern for the future of the British Empire. The beauty of the cargo boat for Kounellis lies, more exclusively, in its role as a perfectly functioning machine, which can also be seen (still today, in spite of Turner) as a poetic essay in the circulation of materials, inciting the artist to emulation. Yet I would not try to exclude the possibility that Kounellis's vision might be connected with a new movement of marine-based cosmopolitanism. It was remarkable to note how many of the exhibits at the Kassel Documenta of 2002 made use of the environment of the sea-port and the ocean-going vessel. These ranged from the extensive photographic and sociologically conceived surveys of Alan Sekula to many kinds of occasional and less overdetermined references. Though they support no sociological thesis, Kounellis's boats certainly appear to be emblematic of the material and cultural exchange that created the Mediterranean world. From a pan-European point of view, indeed, such an exchange might well extend beyond the Mediterranean to the outlying trade routes of the Atlantic Ocean. For an exhibition in Pescara on the Adriatic coast in 1975, Kounellis put on display a lead panel engraved with the outlines of shipping docked in the port of Antwerp, where he had made landfall on the return journey from his first trip to the United States. The deep window embrasure giving on to the Mediterranean port was blocked by this foreign vision. North and South of Europe were brought into a fleeting contact.

STARTING FROM THE STUDIO

Kounellis's first dated work was completed in 1958, just two years after his arrival in Rome. His first exhibition, also in Rome, came shortly afterwards, in 1960. Retrospectively, these very early works can be seen to have an intimate and continuing connection with those that he continued to

produce in the later stages of his career. They are frequently evoked, and often exhibited, in his large, partly retrospective shows. At his exhibition in the Hamburg Kunsthalle in 1995, two works from the last years of the 1950s were included in a 'retrospective' section that complemented the large new installation in the central rotunda of the building. A helpful catalogue essay by Ortrud Westheider legitimately placed these works from Kounellis's early career within a broad international context.[9] However the detailing of this context for the work does not, in any degree, dissipate its originality. In a real sense, these striking and distinctive early paintings appear to have erupted, fully fledged, on to the scene of contemporary art. And yet, from another point of view, they seem to have been, at the time of their first appearance, private and almost hermetic in their significance, not least to Kounellis himself.[10]

Giuliano Briganti, who admits to not having seen a work by Kounellis before 1976, speaks of the 1960 exhibition of 'the Kounellis Alphabet' at a small gallery looking out over the Piazza del Popolo in Rome as 'no doubt a revelation'. He then makes an interesting attempt to reconstruct its original significance, albeit with all the advantages of three decades of hindsight:

> Today Kounellis has thirty years of work behind him. That many have passed since his first exhibition at the Tartaruga Gallery where he showed those white canvases with large numbers, letters or simple black signs which had no other meaning than the meaning inherent in them which intended to demonstrate the 'recognizable' in its most elementary expression and thus establish in the most immediate and obvious way a real contact with the surrounding world. This was a break with the past, a provocative action. In fact, the new avant-garde felt a particular need at that time to move away from the pure formalism of the Abstract and the informal and out of the closed rooms of their aestheticizing hermeticism. It was undoubtedly meant to be a challenge, that encounter between plastic forms and conceptual discourse, but it was also as if Kounellis wanted to mark the departure point of his journey into the real world.[11]

This description has its own historical resonance, surely, in so far as it evokes the classic beginnings of High Modern art. It calls to mind that crucial moment in the history of Cubism when, early in 1912, Picasso and Braque decided to 'change their tune'. Over a few months, both artists together abandoned the hermetic strategies of Analytic Cubism, and

began to welcome the intrusive signs of everyday reality into their compositions: a rough cord did duty for the expected gilt frame moulding, and sundry cut-out fragments of newspaper, with their gross block capitals, infringed the sacrosanct domain of the picture plane.

In spite of this connection, it is not difficult to imagine the charge of novelty that these early works by Kounellis would have possessed – all the more so as the effect has not yet been dissipated. *Untitled* (1958) – the earliest work that he has consistently used to illustrate his catalogues – still seems to possess a special, inaugural character. The contemporary photograph of it, which has been published several times, gives up roughly half its extent to the floor space of the studio, with its distinctive polygonal tiles (illus. 54). Fixed to the far wall, a long wooden panel presents layers of printed writing that float ambiguously in space, with a fainter and smaller text ACETO OLIO (Vinegar Oil) receding behind the larger and blacker OLIO.

54 *Untitled*, 1958. Photographed in the artist's studio, Rome

55 *Untitled*, 1959–60. Tempera and paste on squared paper mounted on canvas, 136 x 256 cm. Collection Karsten Greve, Cologne

On the other side, Kounellis has mentioned, there is a further word indicating a basic commodity: TABACCHI (Tobacco). We also see a sharply defined black hand symbol that points downwards in the direction of the floor.

Kounellis has taken care to explain the process behind the production of this work, and those that immediately succeeded it. His account both supplements and, in a certain sense, amends the evidence of the photographic record with its inevitable distancing effect – accentuated as it is by the framing and isolation of the work. In a conversation with Germano Celant that dates from 1992, Kounellis emphasizes in particular the way in which the work 'OLIO' (as he calls it) occupied the given space, with its 'hermetic and mysterious writing'. He explains at the same time: 'The writing of the letters created rhythms, since space is always rhythmic.'[12] This emphasis on the 'rhythmic' character of space acquires a further significance if we also take into account the process by which all the immediately subsequent works, such as *Untitled* (1959–60; illus. 55), were subsequently produced. Kounellis is quite ready to cast doubt on the autonomous status of all these early works as pictures (*quadri*), and prefers instead to put all his emphasis on the working process and the environment that supported it:

> They were not pictures as such, all the canvases derived from the measurements of the house, in which I lived. They referred to the wall. In fact, I used to stretch the canvas or the sheet, right up to the limits of the corners of the wall, the painting ended there . . . It was like taking off a fresco, since the canvases or sheets had the form and breadth of the walls of the room . . . The letters or painted signs, they came however from forms which I prepared out of hard cardboard. They were printed, not calligraphic but structural.[13]

That this sense of a working process can still be discerned in the phenom-
enological effect of the work – despite the intervention of the photograph –
is attested in the case of *Untitled* (1959–60), identified in catalogues as
being made of 'Tempera and paste on squared paper mounted on canvas'
(illus. 55). The individual pieces of mounted paper certainly seem to stand
out as separate components of the visual field, having their own material-
ity in relation to the barely visible support. Once again the numbers, bars,
arrows and other signs do indeed prove to be 'structural', in the sense that
they set up a different, so to speak contrapuntal, rhythm, that cuts across
the regular spacing of the individual sheets of paper. Kounellis appears to
have set up this system of counterpoint in a long sequence of related
works, before he began to vary the recipe by painting directly on canvas
(illus. 56–60).

This may be the reason why there is no perceived anomaly when
Kounellis continues to show works of the earlier type in conjunction with
his more recent metal constructions, whether in exhibitions (such as the
2001 retrospective at Prato), or simply on the adjacent pages of a cata-
logue. *Untitled* (1988) consists of an array of iron panels mounted on a
larger iron ground, four metres high and six metres long, and it almost
seems to fill the entire wall space of the gallery in the photograph chosen
for the Barcelona catalogue of 1990 (illus. 61). Rhythm is supplied first of
all by the backing panel itself, with its faint indications of internal welding,
and then especially by the effect of the five brilliantly white paper-covered
panels that are superimposed upon it. Three sacks of coal (held in place
with iron beams) provide a secondary level of punctuation. Opposite this
work, in the 1990 catalogue, comes the previously discussed *Untitled*
(1959–60: illus. 55). If we can disregard the vast differences in size and
materials between these two works separated by nearly thirty years, there
remains a great deal held in common. Both are designed in order to set up
a dynamic relationship with their immediate environment, by creating a
substitute for the surface of the wall and animating it through rhythmic
accents that derive from successive, clearly differentiated structural
planes. Kounellis's use of paper in the 1988 work might, indeed, be
regarded as a specific strategy for bringing such comparisons with the
earlier period clearly into view.

One rare photograph survives from the early period of Kounellis's life
in Rome to illuminate the distinctive process through which his first
works were produced. It was taken by the photographer Claudio Abate,

already his most faithful documentarist, and shows the artist at work, draped in a canvas on which the characteristic numbers and signs have already been stencilled. He stands right up against the studio wall, which is covered with another prepared canvas. But his face is not visible, and there is no sign of an audience, apart from the implicit presence of the photographer. On the other hand, reasonable prominence is given to the tins of paint and varnish in the left-hand corner of the image. That this scene could be classed as a 'happening', in the sense that the term was then acquiring in the art world, is perhaps misleading. No more helpful is the suggestion that this is an image referring to the contemporary ideology of the 'artist at work', as popularized in the concept of 'action painting' that derived from Harold Rosenberg's reading of American Abstract Expressionism. It would be anomalous to title it, in the manner of several articles appearing at that time in the American art press: 'Kounellis paints a picture'. Much more relevant, surely, is the point that he is actually wearing one of the canvases that he has previously measured against the studio wall. He recalls that he saw them all in terms of 'membranes from a fresco'.

Yet Ortrud Westheider is entirely justified in bring into the debate the many other historical connections implied by this foregrounding of the artist's performance. She is also right to bring out the probable allusions in Kounellis's early practice to recent events in the Roman art world. The Galleria La Tartaruga had, in 1959, hosted an exhibition of the work of Robert Rauschenberg. This was advertised by a striking exhibition card showing his name in large block letters, with an indicative pointing hand closely paralleling the indexical symbol in Kounellis's 'OLIO' of 1958. Both Rauschenberg and Kounellis would, moreover, have been aware of the pointing hand that appears in Marcel Duchamp's notorious farewell to the act of painting, the enigmatic *Tu m'* (1918). This was a work commissioned by Katherine Dreyer for a space over a door in her library, and so would have chimed in with Kounellis's prescriptions for a work adjusted to a specific domestic space.

Kounellis's own invitation card for the 1960 exhibition has more than an echo of Rauschenberg's randomized typography, but it operates on a different scale. Instead of stressing the block letters, he disperses his own name and the basic informative details relating to the show amid a hail of bewilderingly disparate letters and signs.[14] We know, from Kounellis's later tribute to his friend and fellow artist, Pino Pascali, that Pascali at least

56 *Untitled*, 1959. Oil on canvas,
200 x 200 cm. Collection Goetz, Munich

57 *Untitled*, 1960. Tempera on paper,
143 x 300 cm. Collection Reiner Speck,
Cologne

58 *Untitled*, 1960. Enamel on canvas,
approx. 140 x 300 cm. Private collection

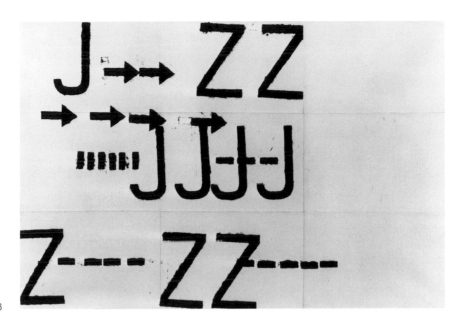

59 *Untitled*, 1961. Tempera on paper,
approx. 200 x 400 cm. Private collection

60 *Untitled*, 1959. Oil on canvas,
200 x 200 cm. Private collection.
Exhibition at Palazzo Fabroni, Pistoia, 1993

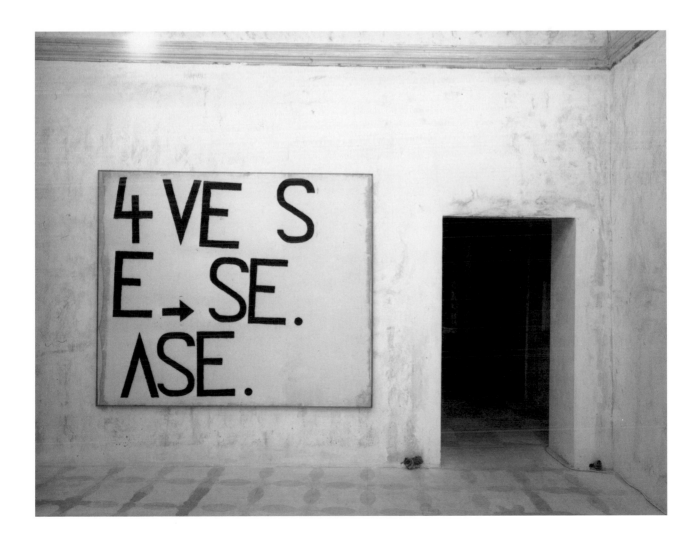

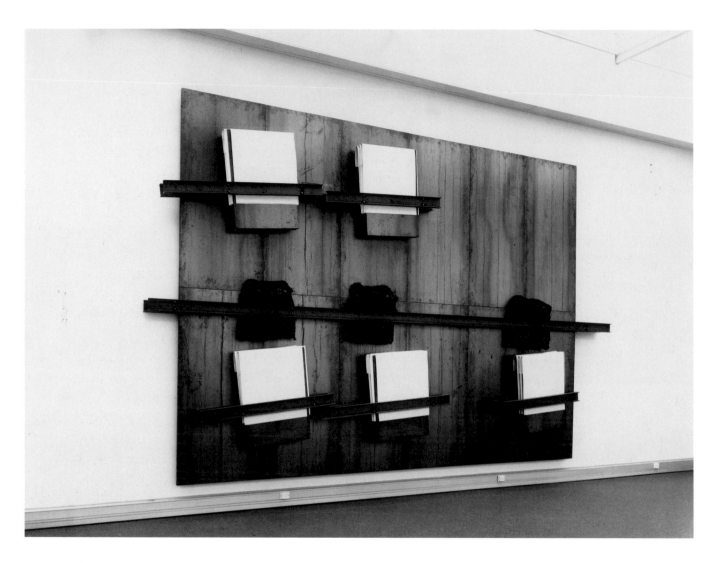

61 *Untitled*, 1988. Iron panel, superimposition of five iron panels covered in paper and three
sacks of coal, held in place by iron beams. Cast-iron plates, jute, coal, 400 x 600 x 60 cm.
Collection Anthony d'Offay, London. Exhibition at Palazzo Reale, Milan, 1988

was extremely interested in the American artists of the Black Mountain School.[15] Both Pascali and Kounellis must have been well aware, by this stage, of the exciting atmosphere of avant-garde music and performance which Rauschenberg and his fellow artist Jasper Johns had soaked up through their connections with figures like John Cage and Martha Graham at Black Mountain College. But Kounellis must also have known of the historical predecents for this type of avant-garde performance activity in the Dada movement. As Ortrud Westheider points out, the curious combination of enveloping cloak and paper crown that he wears in the studio photograph of 1960 bears quite a close comparison with the famous image of Hugo Ball declaiming his sound poetry at the Cabaret Voltaire in Zürich.[16] Kounellis may well have been thinking of this earlier precedent, as well as recording his participation in the revival of this feature of the historic avant-garde, when he later commented on this phase of his work: 'I sang my pictures . . . it was my first performance.'[17]

As will be shown later, this element of 'performance' continues to be integral to Kounellis's work from this stage onward. It can be seen as one side of the dialectical transformation that he seeks to achieve by constant interaction between the self and the work. Nevertheless these early *Untitled* pieces have now, inevitably, begun to acquire the patina of age. As Mary McCarthy remarked of the ideology of 'action painting', so clamorously defended in the 1950s: 'You cannot hang an event on a wall, only a picture.' In the same way, Kounellis's early paintings, by whatever means they were originally produced, have now inevitably come to acquire a generic significance, one that may indeed connect them to the seafaring themes evoked in the foregoing section. Their arrows, impossible now to take as arbitrary signs, appear to imply direction and circulation, while the letters mimic the bold marks of identification on transport vessels and their packaged cargo. The idiosyncrasies of the sign system – figures repeated and overlapping, letters the right way round and also in reverse – create a complex fugue of superimposed rhythms and movements, one that is appropriate to the atmosphere of a crowded port.

Ruskin conjectured that Turner was moved, as a child, by the 'forest of masts' that he witnessed in the port of London below London Bridge. The phrase is apt, since it implies not just a banal residue in the memory, but a metamorphosis, whereby the wooden masts become suggestive *en masse* of the common condition of nature from which they came. Kounellis's stencilled letters betoken a 'real contact' with the world, in so far as they

represent primary signs for identifying size, weight and direction, concretely expressed and structurally arranged. They disappear from his work in the early 1960s, but they are often recalled whenever his later choice of materials incorporates explicit markings of material and destination. In *Untitled* (1988), shown at the Prato retrospective, the sacking used in conjunction with the large iron sheets bore a number of such random yet suggestive indicators of substance and place: TRIESTE, MADAGASCAR, ROBUSTO and most noticeably CAMEROUN (illus. 62).

The immediate outcome of these early works was a period in which Kounellis developed and broadened his skill as a painter, while still keeping in train the element of performance that had dominated his former activities. The show which he held at Galleria Arco d'Alibert, Rome, in October 1966, comprised watercolours as well as large canvases. In contrast to the majority of the large works, which were confined strictly to black and white, these small sheets bearing similar motifs were often intensely or delicately coloured. They seem to anticipate the pleasure that Kounellis has experienced throughout his later career in making rapid and fluent coloured sketches, usually in close relation to the large constructions and installations being developed at the time.[18]

Something of this spontaneity already spills over into the charming transitional painting *Untitled* (*Petite*) of 1964, a precursor of the series of canvases bearing musical markings which extends up to and beyond *Da inventare sul posto*. The few bars of notes relate conceptually to the performance that has taken place, or is maybe yet to come. In addition, it seems, they raise to a different level the principle of rhythmic scansion that governed all the earlier works involving letters and numbers. But in this case, it is particularly the yellow-painted word that introduces a distinctively new type of inflection. The adjective 'petite', with a feminine ending reminiscent of the Cubist use of a word like 'Jolie', is painted as if it had been stencilled (maybe it was). Its idiosyncratic yet careful typography, with no dot on the i, and a capitalized P, seems to take its origin from an idiosyncratic, old-fashioned repertory of signs. At the same time, the crafting of each of the letters seems designed to give the impression that they are produced by a series of broad brush-strokes (with added bars for the two ts, and no dot upon the i).

Within a year of the appearance of this work, the Scottish poet Ian Hamilton Finlay had published his first major collection of concrete works, *Rapel* (1963), sub-titled 'Fauve and Suprematist poems'. Kounellis's

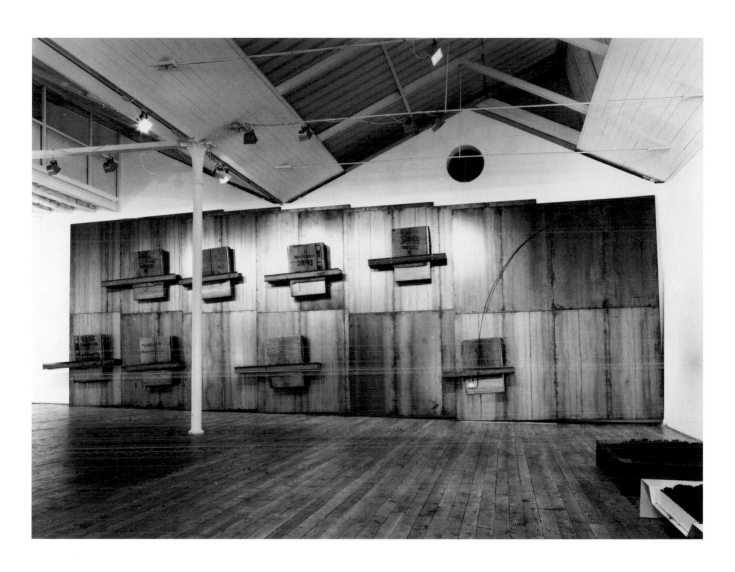

62 *Untitled*, 1988. Wall partially covered with iron panels; superimposition of eight iron panels covered in turn with burlap sacks held in place by iron beams; burning oil lamp suspended from a metal rod, 415 x 1249 x 65 cm. Exhibition at Galleria Christian Stein, Milan, 1988

Untitled (*Petite*) instantly recalls Finlay's homage to the modernist tradition, and his colourful use of typography. This is not to imply that these two artists at opposite ends of Europe were in any degree of contact, but simply that these types of work suggest an affectionate distance from the classic avant-garde of the Cubist period. In terms of Finlay's antithesis, we can say that Kounellis's earlier black and white works were indeed intended to be Suprematist in spirit. But *Untitled* (*Petite*) struck a contrasting note that was unquestionably Fauve.

ARTE POVERA: THE PUBLIC FACE

Kounellis's later work from the 1960s is inevitably seen from the perspective of his incorporation in the group of younger Italian artists who started to acquire celebrity in their own country over this period, and rapidly developed an international currency. He participated in the '*Arte Povera*' exhibition at the Galleria La Bertesca in Genoa, September–October 1968, and in several subsequent group shows, in the course of which the membership of this loose affiliation began to acquire greater consistency. Germano Celant, who was responsible for establishing the brand image for this new generation of Italian artists, never claimed to present them as a homogenous group subscribing to a common programme. To a great extent, indeed, his highly successful proselytizing on their behalf should be seen not as a matter of proclaiming their identity as a group, but rather as a mean of securing a strong Italian presence in the new wave of international movements that came onto the scene after the complex political and cultural transformation of the late 1960s.

*Arte Povera w*as thus given equal billing with Conceptual Art and Land Art in the large group exhibition at the Galleria Civica d'Arte Moderna, Turin, in 1970.[19] By this stage, young Italian artists (including Kounellis) had already gained representation in the broad cross-section of conceptual tendencies that made up the influential exhibition 'When Attitudes Become Form', inaugurated by Harald Szeeman at the Bern Kunsthalle in 1969, and later shown at the ICA, London. By the time of the Kassel Documenta of 1972, many artists within the grouping were well enough established to feature prominently in this unique international showcase. In the 'Prozesse' section, Kounellis was joined by Giovanni Anselmo (b. 1934), Pier Paolo Calzolari (b. 1943), Mario Merz (b. 1925) and Gilberto

Zorio (b. 1944). In addition, Alighieri Boetti (b. 1940), Luciano Fabro (b. 1936) and Giulio Paolini (b. 1940), all of whom had also shown in early *Arte Povera* exhibitions, were included in the adjacent section of 'Individuelle Mythologien'.

For obvious reasons, then, it is not the main purpose of this study to trace the development of *Arte Povera* as a totality, either within this early period or in all its subsequent ramifications. Some general points can nonetheless be emphasized at this stage. First of all, Celant's role as critic, commentator and curator was by any standards an outstandingly effective one. By comparison with the subsequent *Transavanguardia* grouping, organized in a comparable way by the critic Achille Bonito Oliva, it more successfully and enduringly placed the advanced Italian art of one genera-tion in the public eye, and gave it an international presence that young French contemporaries, for example, signally failed to achieve. No doubt this was as much as could reasonably be expected from a label of this type. The second point to be reemphasized, however, is that the *Arte Povera* artists were from the start diverse in their approaches, and became even more so as time went on. Already at Kassel in 1972, the curatorial division of the grouping into 'Processes' and 'Individual Mythologies' suggested that foreign critics had their own views on their varying orientations. One clear, and wholly objective, distinction between them arises from the fact that artists born and/or living in Turin – Boetti, Fabro, Paolini, Anselmo, Merz and Zorio – far outnumbered the rest. Kounellis was and remained the only artist of non-Italian origin, and the only one living and working in Rome.

The recent appearance of a major *Arte Povera* show in Britain (Tate Modern, 2001) has made it possible to pass an interim judgement both on the enduring interest of the works themselves, and on the validity of the original grouping. One point can be made straightaway. Many, if not most of the works on display (selected with a terminal date of 1972) had a markedly conceptual character, whether this implied a move towards the ironic reinterpretation of the gallery space, or the desire to create ideal and utopian models. In the ironic camp, one could place Boetti's *Nothing to See, Nothing to Hide* (1969), an iron-framed glass 'window on the world' that leaned against the wall, or Fabro's subtle inflections of the rectangular space by means of light metal strips, to create such elegantly redundant structures as *Tautology* (1967) and *Cross* (1965). In the utopian camp, one would have to put Merz's *Fibonacci Igloo* (1970), which functions both as

an 'ideal organic form' based on mathematical progressions observable in nature, and as a basic structure comparable to those that were constructed by ancient nomadic cultures.

In this context, Kounellis stood out by virtue of the fact that his work appeared neither ironic nor utopian, and the difference came across in terms of a sense of unease in manipulating the pre-existing space of the gallery. His *Untitled* (1969), remade specially for this occasion, was presented at Tate Modern as a piling of large stones within a recess in the gallery wall. In its original context, at the 8th Biennale of Contemporary Art at San Benedetto del Tronto on the Adriatic coast, this work had been specifically identified as a 'Door walled in with stones', and the exhibition at the Galleria L'Attico in the following year repeated the formula. A subsequent, closely related work by Kounellis (*Untitled*, 1969/82) was described as a 'Spanish-style cupboard walled in with stones'. Photographs of these exhibits indicate (though of course they cannot satisfactorily prove) that in the first case, the stones are rudely blocking expected exits from the room and, in the third, the occupation of the semi-private cupboard space must have been strikingly invasive (illus. 63–4). Yet the gleaming white walls of the Tate Modern, themselves designed to offer no real sense of mass and substance, could put up no such resistance to the intrusion, and consequently reduced the possibility of a tense interaction.

Much better adapted to showing off the ironic and utopian works of *Arte Povera*, the display spaces of the Tate Modern seemed to come into their own especially in the unique case where visitors were not admitted to the gallery, and had to be content with viewing the installation from the outside. This was Paolini's *Apotheosis of Homer* (1970–71), which brought together music stands, photographs and spoken texts to celebrate a pantheon of artists, poets, patrons, adventurers, saints, sinners and scientists. Some knowledge of Ingres' more rigorously selective grouping of heroes in the painting of the same name is surely important in the viewing of this work, since it epitomizes Paolini's concern to align his own fastidious postmodern strategies up against the anxious neoclassicism of the French painter. Paolini's relentless drive toward the ideal purity of the concept is indeed summed up in the phrase with which he offers this new *Apotheosis of Homer* to the public: 'Before and after this illusion of eternity, little remains for observation, nothing at all for analysis.'

The greater part of the difference between Kounellis and Paolini (and this goes for the other *Arte Povera* artists, though not to the same extent)

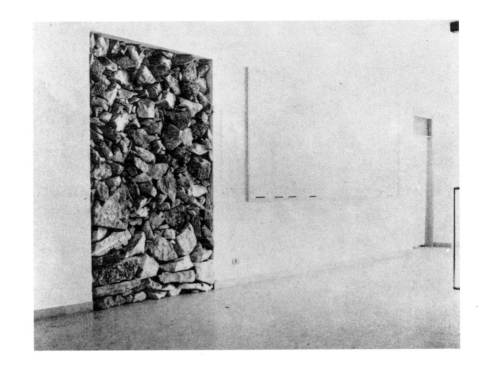

63 *Untitled*, 1969. Door walled in with stones. Exhibition at 8th Biennale of Contemporary Art, San Benedetto del Tronto, 1969

64 *Untitled*, 1969/82. Spanish-style cupboard walled in with stones, 170 x 150 cm. Exhibition at Whitechapel Gallery, London, 1982

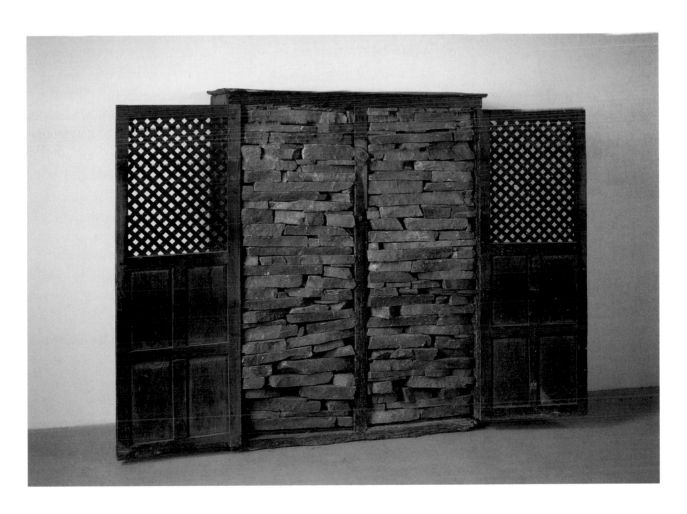

can be summed up in this mismatch over their abilities to adapt to defined types of display space. It is certainly not true that Paolini can only show his work in contemporary versions of the White Cube. His fine retrospective exhibition at the new Gallery of Contemporary Art at Verona (Summer 2001) showed how astutely he could utilize the charming period style of the small salons in what was still to all intents and purposes the eighteenth-century Palazzo Forti. Yet Paolini plays with visual geometry; he mimes the effects of perspective in order to float images and project illusory spaces that are designedly without mass and substance. If this is a learned extension of Western art, based implicitly in the history of perspective science from Alberti onwards, it is also a project that is deliberately neglectful of the Renaissance preoccupation with suggesting volume and weight. At a later point in my argument, there will be a chance to look more carefully at the degree to which Kounellis can be viewed as inheriting this particular concern. At present, just one work (on display at the Tate exhibition as at many previous ones) can be used to encapsulate the difference. Kounellis is certainly aware of the pictorial feature of the famous egg that appears, suspended on high, in Piero della Francesca's *Madonna con Santi* in the Brera Gallery, Milan.[20] His own *Untitled* (1969) quite simply places an egg on a metal shelf that protrudes from an iron panel. There is, it seems, no allegory involved, and no secondary meaning like the possible interpretations endlessly debated by Renaissance art historians who contemplate Piero's audacious simile. But the egg is there, in its actual substance as it is defined visually by light and shadow, inviting us to experience a calm interval while pondering its form, and not just for form's sake (illus. 65).

DISCOVERIES IN A PRIVATE SPACE

In an interview with the American critic Robin White, first published in 1979, Kounellis gave a very specific answer to the question of whether '"arte povera" was the European equivalent of American minimal art'.[21] It was, he explained, created in a wholly different historical and social context. Only after the shock effect of the political events of 1968 in Europe did it become retrospectively identified with a new and specifically European socio-cultural development, which ensured that it would later be taken into account in the initial critical analyses of minimalism. If we look

65 *Untitled*, 1969. Cast-iron plate, console, egg, 100 x 70 cm. Collection Giulio Rornieri, Milan

back to the development of Kounellis's work in this early period, it does indeed appear that the decisive break that qualified him to be included in this new orientation happened a few years earlier, not in the public sphere but in an intimate and personal context. It was a factor of his experience of living as a recently arrived young artist in Rome. The successful series of works involving letters and numbers was brought to its conclusion around 1962/3, at the point 'when people began to see it as a style' (as he later remarked).[22] The next three or so years were mainly taken up with working on a series of 'marine paintings' (to borrow his own term). These were shown at the Tartaruga, but seemed to him to have reached a dead end.[23] It was within his own living and working space that the conditions for further development appeared to be most propitious.

Already, with the performance mode that gave rise to the letter and number paintings, the form of Kounellis's room had begun to play an integral role in the conception and creation of new work. Bruno Corà has written of two decisive moments in his early years, the first before 1960 when he began to adjust his compositions structurally to the wall space, and the second, in 1967, which Corà describes as amounting to the

'discovery of a quintal of charcoal'.[24] The literal context for this 'discovery' can be rediscovered, happily, in the precious series of early photographs that Claudio Abate continued taking in the studio throughout all these years. Such documents appear to confirm the development over time of a continuing dialectic in the use of wall space and floor space, between the materials hanging on the wall, and those that are disposed, according to their specific mass and weight, on the floor. The interweaving of horizontal and vertical emphases thus begins to generate its own special tensions and cross-overs, as can be seen.

The dramatically lit photograph of *Untitled* (1966) is presumably one of the first in chronological order. Instead of applying the squares of paper, with their stencilled letter and number forms, to the wall-hung canvas, Kounellis has here sewn together burlap sacks, with their own stencilled letter inscriptions, in such a way that they form a large sheet, which droops heavily from the wall, creating deep areas of shadow as well as manifesting the rough woven texture (illus. 66). Just to the left, in this photograph, is a partial glimpse of another work, whose zone is delimited by broad white lines on the studio floor. To observe this work more closely, we have to turn to another of Claudio Abate's photographs, where it is taken head on from a lower angle and without the strong patches of reflected light that cast it into shadow in the earlier image (illus. 67). Whether this shift from the periphery to the centre is an intentional ploy or not, it effectively reenacts Corà's notion of the 'discovery of a quintal of charcoal'.

How then does one *discover* a certain material, with particular reference to the experience of Kounellis's work? For any casual viewer, the answer is bound to seem a relatively simple one, from the phenomenological point of view. Among the works that have been on view at the Hamburg Kunsthalle is *Untitled* (1984), which consists of a wooden trolley with wheels, heaped with a pile of charcoal logs. The work lies low on the floor, and so can only be seen adequately if one approaches it closely, and views it from above. The trolley is both a support and also, because it is made of noticeably weathered wood, appears reminiscent of the functional purpose that it once presumably served. The charcoal, which is also a material connoting a functional role (not least as an artist's drawing tool), is presented in the middle of the trolley in much the same way as a painting is framed by its wooden support. That is to say, we look to the framing effect of the trolley to concentrate and focus our attention on the special

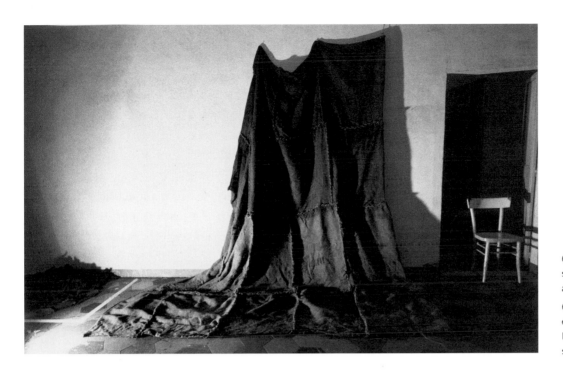

66 *Untitled*, 1966. Burlap sacks. Photographed in the artist's studio, 1966

67 *Untitled*, 1967. Coal and enamel on floor, 110 x 140 cm. Photographed in the artist's studio, 1967

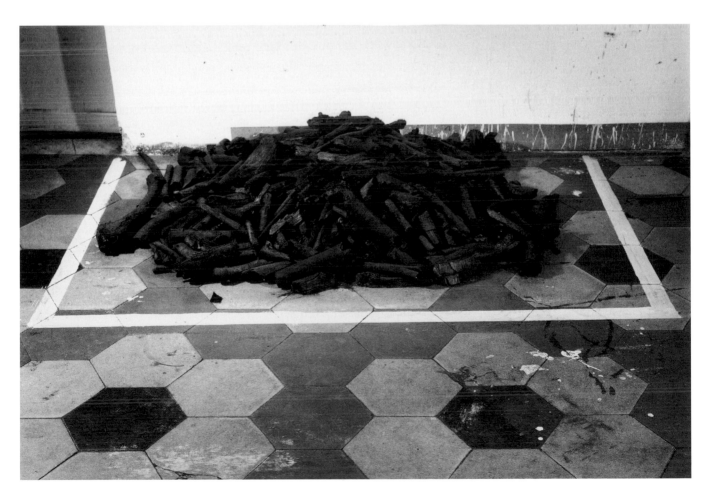

material properties of the charcoal: this appears to be quite light in weight by comparison with the denser material of coal (we know this in the light of our former experience), silvery black in colour, matt in texture, and perhaps still capable of conveying the faintest odour of burning wood to our nostrils.

Yet the artist's own original discovery that such a spectator experience would prove viable, set within the context of an artistic representation, would inevitably have been different in character from the viewer's process of revelation. Looking at *Untitled* (1967: illus. 67), we can imagine the lengthy process of self-criticism that led Kounellis, stage by stage, from the letter paintings to the hung sack structure, and from the sack structure to the adjoining charcoal heap, at that stage designated as a work simply by the broad enamel band that demarcated it from the other parts of the tiled floor. We can bring to our imagining of this process the knowledge that we share with Kounellis of the 'ready-mades' of Duchamp, and perhaps of the so-called 'institutional theory of art' discussed by the American philosopher Arthur Danto: the argument being that art is constitutively nothing but that which is brought into a space of display and publicly acknowledged as such. But in this case (and perhaps here we have another instance where Kounellis would stress his Europeanness, against the appropriative strategies of a Warhol) the act of designation has nothing arbitrary about it. The material newly designated as art is not surprising by virtue of its displacement from a former commercial or technical context. It possesses neither the semi-aesthetic, surreally provocative form of a urinal or bottle-rack, nor the bland consumer-directed information of a Brillo box. When Kounellis repeated his gesture of demarcation several years later, in a work exhibited at the CAPC in Bordeaux, the white band around what was, in this case, a heap of coal, did appear to designate what is an institutional limit, comparable to the crush barriers in neighbouring galleries, or the notices saying: Do not touch. But, in the case of *Untitled* (1967), as originally photographed in the artist's studio, there was no need for crowd control. This was purely and simply the record of an enunciation: I, the artist, designate this material a work.

This evidence that the studio was being experimentally tested as a matrix for developing a range of possible works can also be gleaned from a number of other photographs of the same period. *Untitled* (1967–68), a work now destroyed, is a structure of wood, with a piece of white cloth hanging from the lower bar, and a lighted acetylene lamp fixed to the

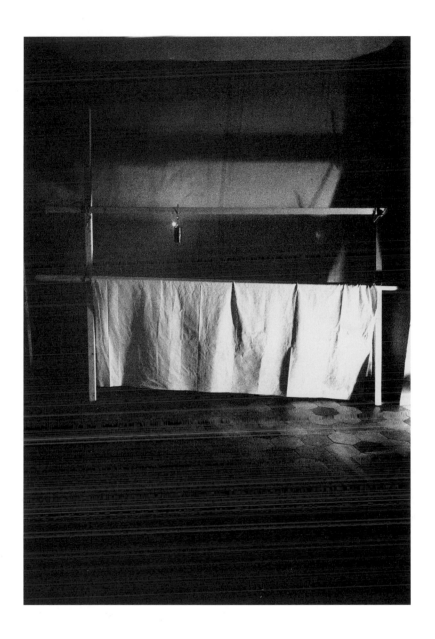

68 *Untitled*, 1967/68. Structure of wood, white cloth and lighted acetylene lamp. Approx. 400 x 480 cm. No longer in existence. Photographed in the artist's studio, 1968

upper one (illus. 68). Here the intersection between natural light and shade, and the artificial lighting source, later to be deployed so effectively in *Civil Tragedy* (1975), is tested, perhaps on one of the first such occasions. We can then see most of the studio space in Claudio Abate's photograph from 1968, which shows the same configuration of the burlap sacks hanging and the charcoal heap along the right-hand wall, and Kounellis himself in the foreground, posed arms akimbo beside the large wooden sticks festooned with wool that would be reassembled again for *Untitled* (1968). Then there is a later, remarkably revealing glimpse of Kounellis standing at the threshold of the studio space in 1969, with three wool sticks lying against the back wall, incorporated into the ground of burlap, and the floor

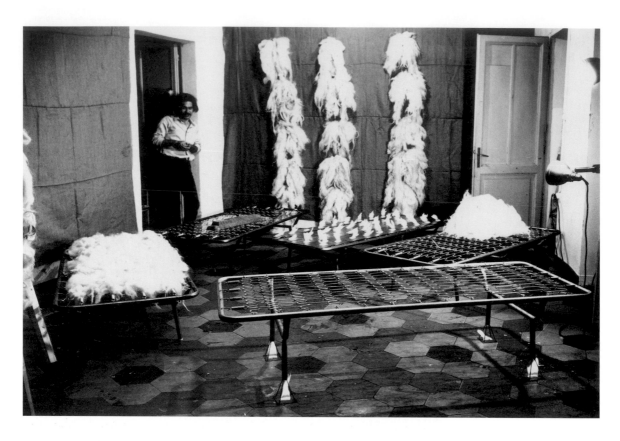

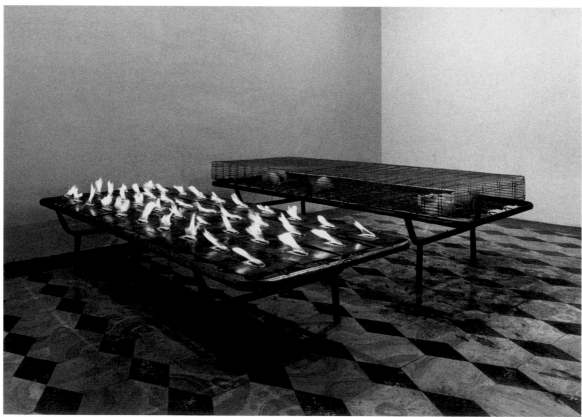

area almost completely occupied by works based on bedsteads stripped to their springs (illus. 69). Other photographs from this period show works of the latter type in pairs and in isolation, sometimes covered with burning tablets of solid fuel, and sometimes with solid fuel burners attached to the bedstead's four feet (illus. 70).

By this date, the *Arte Povera* grouping had become well established, and Kounellis had seized the opportunity to participate in several group exhibitions that challenged him to use new ways of articulating his art in public. The show at the Galleria L'Attico in 1967, which took as its title '*Lo spazio degli elementi: Fuoco immagine acqua terra*' (Smoke image water earth), was one of the first to call for an expanded vocabulary of material effects. As will be seen shortly, the drive to expand the possibilities of what could be done in a public gallery would inevitably prove more stimulating after a short while than the continued exploration of the narrow limits of the studio space. Nonetheless, it seems clear that the special intensity retained by many of these early works by Kounellis derives from the partly domestic, partly experimental context in which they originated. Although the pattern of revelation has to be repeated again and again, the excitement of discovery is never completely lost.

This feature, once again, was what singled out Kounellis in the company of the *Arte Povera* artists at the Tate Modern show of 2001 (and maybe created the sense of his work being more than a little uncomfortably housed there). *Untitled* (1968) is a conjunction of horizontal and vertical emphases: a sewn structure of burlap sacks placed within a steel bed frame, leaning up against the wall. *Untitled (The Coal Trolley)* (1967) is a work echoing the 'discovery' of the heap of charcoal, which presents the once functional trolley with its flanking metal borders as an apt frame for the gleaming chunks of coal (illus. 71). In such a neutral space as the Tate Modern, with the flawless white walls offering (as stated before) no sense of material resistance to Kounellis's invasive mass of piled stones, these other works also appeared to be a little adrift in the gallery, as if having cast off their moorings in space. Kounellis's engaging, and occasionally uncanny, equivocation between the domestic and the public was, however, caught perfectly by the effect of at least one installation: *Untitled* (1969), which consists of small sacks of coffee, lentils, beans, rice and lentils in a quietly casual sequence. Laid low-down along the floor, they lean replete along the length of the white wall, like cargo boats at a quayside (illus. 72).

69 Photograph of the artist with works in his studio, 1969

70 *Untitled*, 1969. Two bedsteads, one with metal plates supporting burning tablets of solid fuel, the other with rats in a cage, 33 x 190 x 90 cm. Collection of the artist, Rome. Photographed in the artist's studio, 1969

Foremost among the criticisms directed against Kounellis's work, and *Arte Povera* in general, has been the claim that it attempts to provide the viewer with an unmediated experience. In confronting us with the 'real', so the argument goes, it takes improper advantage of us, and allows a sentimental naturalism to stand in the place of the aesthetic emotion, which must inevitably entail a certain distance. This objection is akin to the accusation of 'literalism' directed against minimalist sculpture by Michael Fried in his essay, 'Art and Objecthood'.[25] But in Kounellis's case, surely, such a claim cannot pass without challenge. In the first place, the spatial organization of such works bears little relation to the structures of identical repetition, reminiscent of the assembly line, that are found in minimalist work. The relationship to the surrounding space is always a

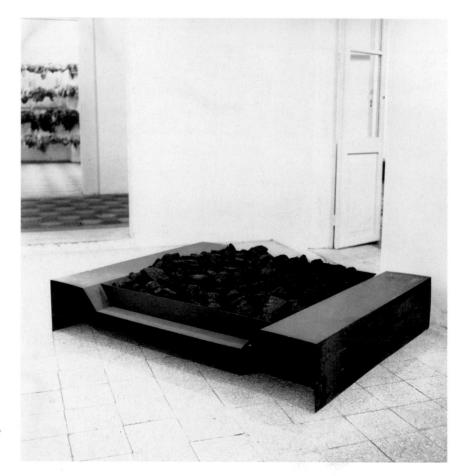

71 *Untitled* ('The Coal Trolley'), 1967. Iron structure with coal, 28 x 155 x 125 cm. Exhibition at Galleria L'Attico, Rome, 1971

72 *Untitled*, 1969. Seven burlap sacks with red and white beans, coffee, maize, lentils, peas and rice. Exhibition at Kunsthalle, Bern, 1969

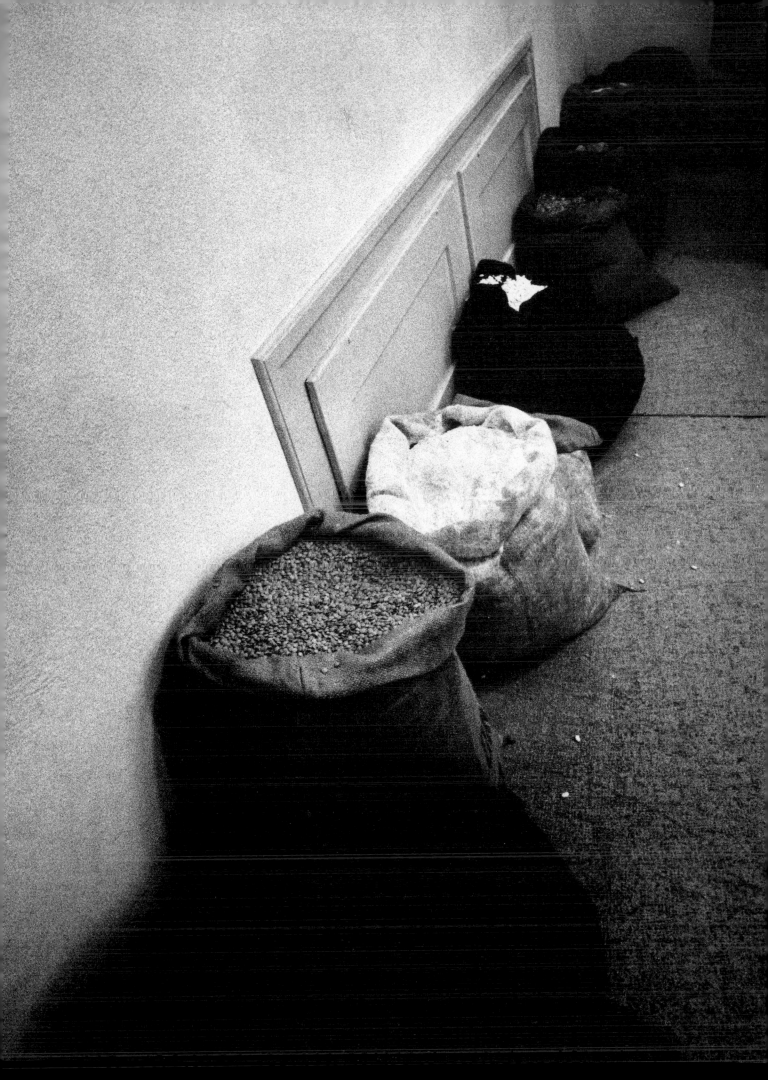

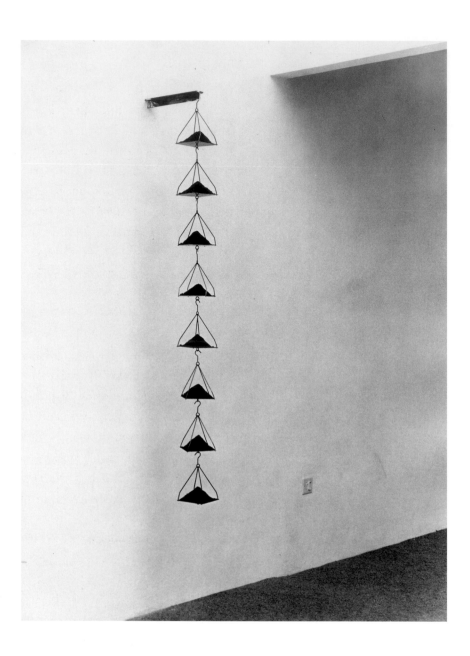

73 *Untitled*, 1969. Eight metal scales, coffee powder, 12 x 12 x 285 cm. Total height 228 cm. Exhibition at Galleria Lucio Amelio, Naples, 1969

precisely structured one, with wall and floor being demarcated to receive the lines, stretchers, ledges and other supports that contain or present the materials. But there is also a high degree of asymmetry and complexity in the forms, which evoke not so much new-minted freshness as subtle connotations of ageing and previous use. In this sense, the general appearance, texture and imagined weight of the materials acquire visual interest, precisely in the degree to which the object has been recuperated from its functional purpose. This is the ground of the aesthetic experience.

Indeed Kounellis expects us still to be able to smell the aroma of coffee, if we stand beside *Untitled* (1969), a sequence of 'iron scales with

ground coffee' (illus. 73). He ensures the fresh grounds are replaced regularly throughout the period of each exhibition. A photograph that I have retained of a visitor standing beside this work in the Stedelijk Museum exhibition of 1990 still triggers the recollection of that particular olfactory stimulus. Yet the appeal of the work is not just a matter of replicating the experience that the visitor might already have had, while passing by the entrance to the museum cafe. It becomes memorable because that surprising aroma is dissociated from function, and newly associated with the act of pondering the mechanics of a carefully poised structure.

The Dutch context here invites us to compare the scales that appear in Kounellis's work with a famous conundrum in the history of Netherlandish painting. Admittedly, such a direct scrutiny of the heaped piles of coffee cannot strictly compare with the experience of viewing Vermeer's painting generally titled *Lady Weighing Pearls,* where we have to take into account a lengthy history of interpretations calling into question precisely what is being weighed, and what the symbolic meaning of the action might consequently be. At first sight, at any rate, Kounellis's work does not appear to involve any emblematic meaning, at least in the sense that the seventeenth-century painting might well have done.

It is no doubt important to our viewing of it, that we are familiar with the mobiles of Alexander Calder and their innumerable derivatives, which also exploit air currents and the forces of gravity to produce an unpredictable interplay between linked combinations of suspended forms. But Calder uses counterbalancing elements, which are specifically designed to react to random winds and draughts, and he dematerializes his metal parts through the application of strong primary colours. Kounellis provides a structure that embodies weight in the form of a kind of paradox. The weight of all the piles of coffee, and all the remaining scales, is borne by the top scale, whilst the bottom scale bears only its weight of coffee. Even if we do not rationalize our perceptions through making a calculation of this kind, there is no doubt that our normative experience of weight is slightly disorientated by the viewing of this structure, and the coffee itself, though unquestionably 'real' coffee, is distanced as a result.

This conviction that the experience of Kounellis's work is mediated, both by the perceptual conditions of its display and (as I shall argue in the next section) by the tradition of the Western visual arts in general, will be

sustained throughout my analysis. However it is also worth noting that there is a quite different kind of point to be made about the use of the 'real' in Kounellis's work, if we return to the historical context for the emergence of *Arte Povera* in the 1960s. Marco Meneguzzo, writing in 1997, recalls that *Arte Povera* was often seen at the earlier time as embodying 'unculture', a concept that seemed to be revolutionary in the second half of the sixties, but had already had its day at the beginning of the new decade.[26]

This seems a reasonable claim to make, at any rate in reference to the precise historical context that Meneguzzo is revisiting. A broad consequence of the events of May 1968, not only in France but also in other European countries, was the questioning of the validity of traditions inherited from bourgeois culture, and the decision to attempt a radical return to cultural foundations. This movement, represented in France by artists like Daniel Buren and the Supports/Surfaces group, echoed in many ways the rhetoric of the Productivist wing of the Russian avant-garde, with its slogan of 'Death to Art!' Even a Russian artist of the revolutionary period as committed to craft-based skills as Tatlin had seen the decisive shift from pre-revolutionary idealist art to the art of the revolution in terms of the need to explore new primary materials. Such industrially connotated materials as iron and glass were to be for him the vehicles of a 'new Classicism'. It is not coincidental that the first major show in the West that focused on Tatlin's work was held in 1968.[27]

Yet, even if there were clear comparisons to be drawn, at the time, between the 'materialism' of the Russian revolutionary avant-garde, and the attitudes of the artists involved in *Arte Povera*, it was (so Meneguzzo rightly argues) just for a period of a few years. The appeal of 'unculture' was not especially lasting. This is not difficult to accept. What is more deserving of debate in Meneguzzo's analysis is, perhaps, the ambitious counter-claim that Kounellis, in particular among the artists of the grouping, 'succeeded in making amends for the understanding of Arte Povera as "unculture"'. This he did, in Meneguzzo's view, by keeping alive throughout the 1970s a '"noble" concept of history' that pointed in quite a different direction:

> Kounellis's history is not even microhistory – that is, the sequence or presence of events that are significant only for the individual or a small community in a certain period of time. No, his is an epic

concept of history, heroic even, according to which a sack of coffee is a specific sack and, at the same time, all the sacks of coffee of all the underdeveloped countries of the world . . . The history of Kounellis is the history of mankind . . .[28]

Put in so direct a fashion, this seems a sweeping assertion to endorse. There is certainly no problem in switching from our absorbed attention before Vermeer's *Lady Weighing Pearls* to the broader interpretation of such a picture as emblematic of the Last Judgement. This is because we know, from the study of the emblem books of the early modern period with their attached mottoes and verses, that it was customary to draw broad inferences of a religious and cosmic nature from such visual motifs. The common world view of the period encouraged the construction of a public set of meanings, even if it placed a high premium on the initiative of the individual in proposing ingenious interpretations.[29] The question of whether Meneguzzo's statement is meaningful, or at all helpful, depends on a prior judgement about how far we still possess, in our own period, a common world view that is capable of supporting such an emblematic interpretation. As Meneguzzo himself readily admits, 'ours is an era that is anything but heroic, in which everything gets mixed up together, from Che Guevara to Lady Di . . .'[30]

I do not, however, want to rule out Meneguzzo's claims completely. In the earlier part of this section, I looked at Kounellis as a 'Mediterranean' artist. This was a judgement that certainly took for granted a transcendence of the dimension of the 'individual' or 'small community' that Meneguzzo sees Kounellis as having repudiated. If Kounellis can be seen as a Mediterranean artist in the sense of the *longue durée* that Braudel attributes to Mediterranean history, then it is not completely fanciful to see him as aspiring to be a world artist. In a context where the polarization of the world into rich and poor, developed and underdeveloped nations, is a universally acknowledged fact, the sacks of coffee used by Kounellis – with their clearly proclaimed geographical origins – may indeed contribute something to an interpretation moving along these lines.

Yet the rather facile character of this example, when taken out of context, provides a warning that Kounellis's historical significance cannot be based exclusively upon so simple an equation. If he has indeed kept alive respect for a 'noble' view of history, this is not because of one emblematic feature in his repertoire. It is because of the consistent

strategies that he has pursued from the 1960s onwards, to a great extent irrespective of the various fashions that have succeeded one another in the rapidly evolving world of the contemporary arts. The task of showing how his strategies are invariably embedded in a distinctive relationship to the history of Western art is, as I see it, the most important one of all. The balance of these arguments will finally be summed up at the end of this study. In the sections that intervene, however, it will be important to examine attentively the many clues that Kounellis himself provides, as he reconstructs the historical lines of ascent to which his work lays claim.

It should in any case already be obvious that there is no intention here of classifying Kounellis as a 'postmodern' artist – if by that is meant the deliberate avoidance of any identification with a continuous tradition. It is indeed quite surprising that such a claim could be made at all, in the light of his many public statements to the contrary. But Michaela Unterdörfer is perhaps carried away by her chosen title, *Die Rezeption der Antike in der Postmoderne*, when she writes that Kounellis's use of fragments of classical plaster casts bears no greater or less significance than his use of coal or other primary materials. All, in her terms, is material and nothing more.[31] The response to this assertion must surely be that every one of Kounellis's different materials is bound to have specific connotations, some of them more culturally determined than others. The fragments of plaster casts may not indeed be clearly identified in terms of their separate origins for the benefit of the viewer – and the viewer will not usually have access to Unterdörfer's painstaking research. But this is far from entailing that their meaning is restricted solely to their material condition as fragments of plaster. Even where such fragments are wrapped in wool blankets, as with *Untitled* (1980, see illus. 23), the knowledge that these anonymous lumps are in fact fragments of classical casts must surely play a certain role in our apprehension. The mysterious wrapped object, from the Surrealists to Christo, is a powerful device for activating the desire to see. But here the mystery is undoubtedly qualified by the knowledge of what sort of cultural object is under the wrappers.

In effect, Kounellis's use of classical casts is very different in character from that of a fellow artist like Paolini, but no less intimately connected to a sense of artistic tradition. For Paolini, the classical sculpture is often revealed in its full integrity, though caught up in the play of imitation and repetition that is epitomized by the symmetrically facing Medici Venuses

of his *Mimesis* series. For Kounellis, the cast is always fragmentary, but as a result often appears to have the character (and patina) of a freshly discovered archaeological object, recently retrieved from ruin. The hints of crude colour, however literally disfiguring, are suggestive of an original polychromy, just as much as they testify to the direct involvement of the contemporary artist. In the case of the previously cited *Untitled* (1978, see illus. 24), the effect is arguably no less powerful than if we had an authentic piece of classical statuary to gaze at. The earlier *Untitled* (1973) goes furthest, perhaps, in Kounellis's acceptance of the dispersal of the fragmentary objets, which are laid out on a table-top, with a stuffed crow to keep them company (illus. 74–5). In this case, however, a measure of unity was restored when he daubed the collection of fragments with yellow paint in 1977.

From a psychoanalytic point of view, disfigurement and fragmentation both undoubtedly accentuate the psychological drive that is termed (in Melanie Klein's vocabulary) 'reparation'. Drawing upon the aggression of the infant experience, these features observed in an object help to mobilize the drives deriving from our early guilt and foster their transformation into the desire to make good.[32] The painting of *Untitled* (1973) suggests a move towards reparation. *Untitled* (1978), with its crudely matched fragments of an Apollo and a Hermes, then embodies the imaginative challenge of what is neither intact nor perfect, and remains all the more powerful for not being manifested in its entirety. The eyes of Apollo are unseeing, and the finger of Hermes points nowhere. But the idea of an original plenitude of significance inherent in classical art, so integral a feature of Western visual culture ever since Winckelmann, seems not to have been entirely abandoned.

CONTEMPORARIES AND MODERNS

Kounellis has freely acknowledged his debt to many other artists, ranging from senior contemporaries to a long series of ancient and modern masters (not by any means exclusively painters and sculptors) whose names recur in his writings and interviews. This fact alone testifies to his special regard for tradition, and his straight rejection of the present-day axiom that the artist needs to achieve a defiantly personal brand image in order to survive. In the course of the previously quoted interview of 1979

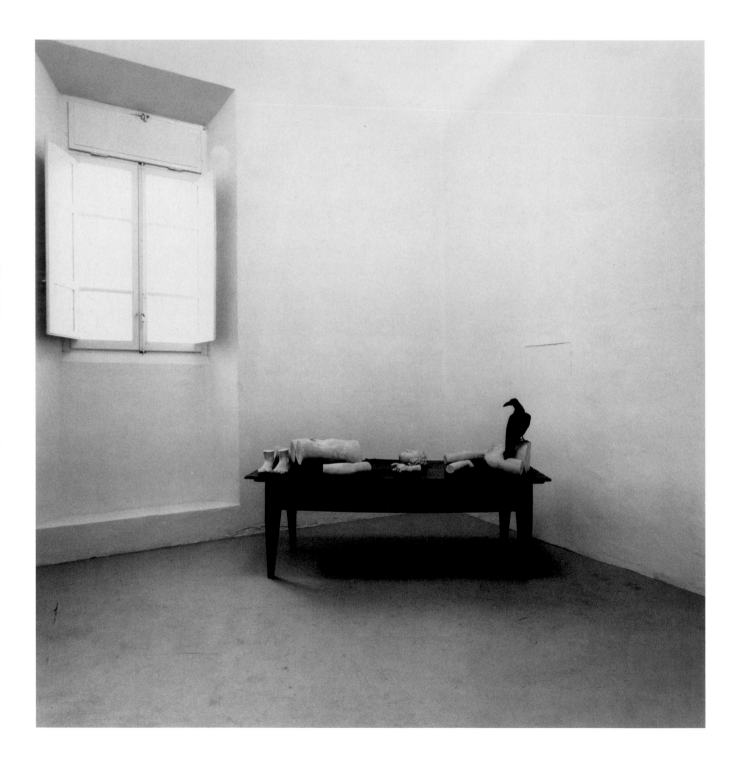

74 *Untitled*, 1973. Table with fragments of plaster casts, coloured yellow by the artist in 1977, and
stuffed crow, 170 x 200 x 70 cm. Table Crex collection, Hallen für neue Kunst, Schaffhausen (Crex
collection). Exhibition at Musei Communali, Rimini, 1983

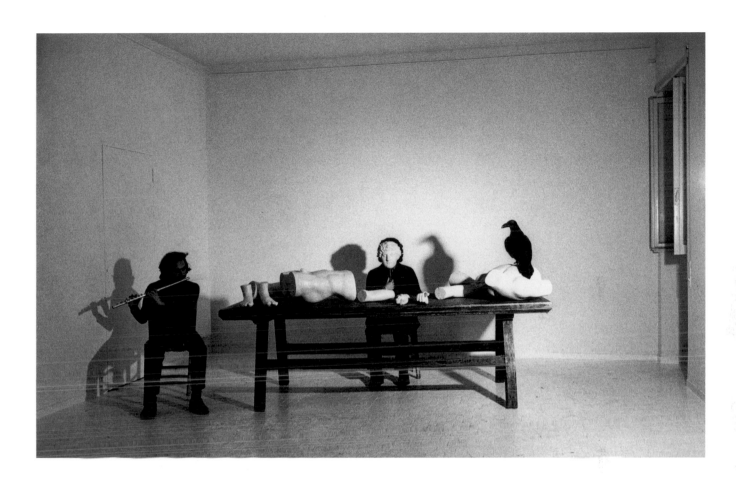

75 *Untitled*, 1973. The artist holding a plaster mask and sitting beside a table with plaster cast
fragments and a stuffed crow. A seated flautist plays a fragment from a composition by Mozart.
Exhibition at Galleria I a Salita, Rome, 1973

with the American critic, Robin White, he was asked what he thought of a 'European critic's' classification of his work in the category of 'personal mythology'.[33] This question was perhaps a little surprising to Kounellis. Although Harald Szeeman had made much of the category of 'individual mythologies' in his planning of the 1972 Documenta, he had (as explained previously) not seen fit to include Kounellis in this section, placing him instead in the more nebulous category of 'Prozessen'.

Kounellis does not, however, reply to this interviewer's question by arguing about critical categories. His reply takes the form of a memorable comment on one of his most celebrated works, indeed the very one that might appear to be most resistant to cultural reappropriation within a historical tradition. 'I do not know this critic', he replies, 'but I have always considered that my activity in putting horses on stage – for example the works presented at the Attico – was about the spirit of the Enlightenment.'[34] Kounellis's work involving live horses was his *Untitled* (1969), when twelve of these animals were tethered to the walls of an underground garage in Rome (illus. 76). Its notoriety was confirmed when the scenario was repeated in *Untitled* (1969/76) at the Venice Biennale of 1976. However this choice of a work to exemplify Enlightenment is further explained if we take into account another, related work in which Kounellis himself took a personal part: *Untitled* (1972), first performed at the Attico in 1972, and repeated at the Sonnabend Gallery in New York in 1974. For the latter piece, the gallery walls were painted yellow, and a small lamp hung from one of them. The centrepiece, however, was a horse, with Kounellis as its rider, wearing a mask in plaster taken from the so-called Kassel Apollo (illus. 77).[35]

Here the Enlightenment reference seems more accessible. Kounellis is juxtaposing two forms of lighting, the natural luminescence reflected off the brightly painted wall, and the light of the lamp which is stronger and hence casts it into shade. (*Civil Tragedy* of 1975, to be discussed in the last section, involves a comparable, but even more intense, opposition between forms of lighting.) The horse and rider refer to the tradition of the equestrian monument, dating back to Ancient Rome, as we are reminded by Kounellis's mask (in its original form dating back to the reign of Antoninus Pius, *c.* AD 150). But such a combination of horse and rider could also remind us of the revival of the equestrian image in the later eighteenth century, when the French painter David showed the Polish aristocrat Count Stanislaw Potocki, mounted on a fiery steed, as an

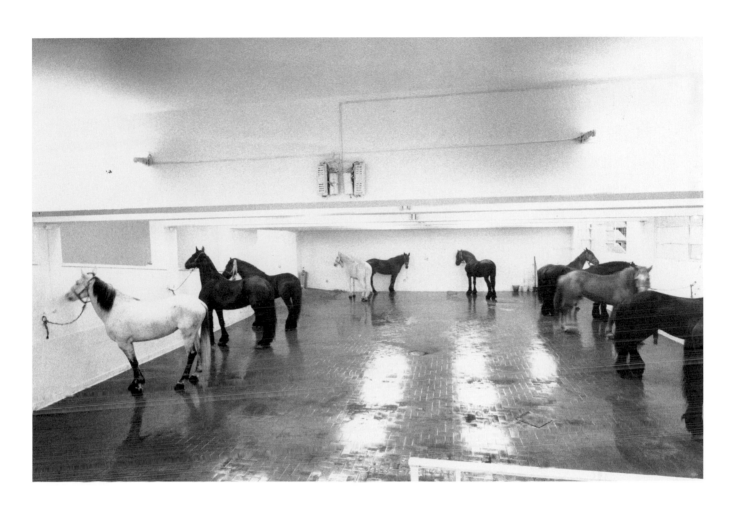

76 *Untitled*, 1969. Twelve live horses. Exhibition in underground
garage arranged by Galleria L'Attico, Rome, 1969

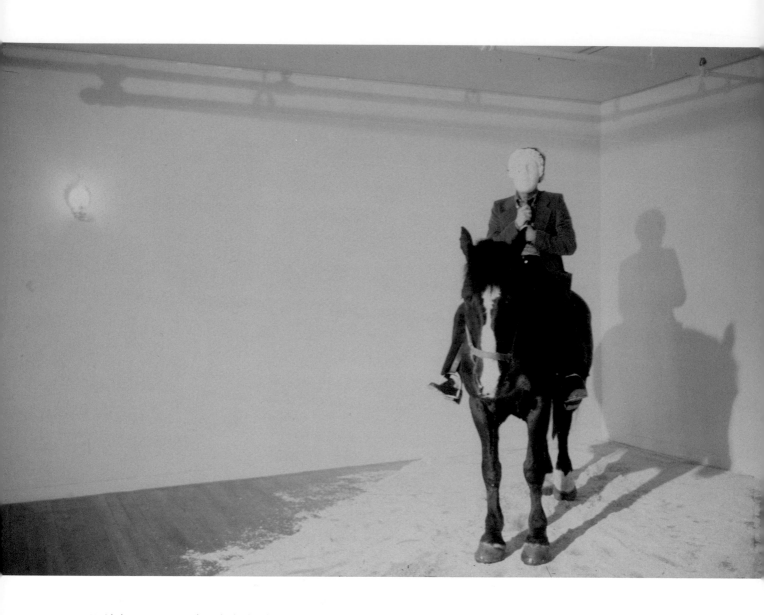

77 *Untitled*, 1972. Horse and masked rider, the artist, yellow-painted walls. Exhibition at
Sonnabend Gallery, New York, 1974

emblem of rationality subduing nature appropriate to the Age of Enlightenment (National Gallery, Warsaw, 1781).

Following up these different strands of association seems very much in the spirit of Kounellis's free and open development of motifs and themes. In this sense, his work takes for granted the existence of a public domain of reference in which the artist and the viewer hold an equal stake, in so far as they are products of the same history and culture. But more recent and precise points of reference should not be forgotten. Kounellis acknowledges the importance, particularly for his early development, of a select number of Italian and foreign artists of the post-war period. In the analysis that follows, I will pass from these close and acknowledged affiliations to some of his more remote connections, noting at the same time the considerable variations in the way in which these 'influences' and connections seem to have worked. This will anticipate the very different treatment of the historical resonance of Kounellis's work in the next section, when the argument will not move from the artist's domain outwards, but employ a number of different current interpretations of the history of Western art to focus attention on central features of his achievement.

Kounellis makes no bones about acknowledging, in the 1979 interview with White and elsewhere, the primordial importance for his early development of the Italians Luigi Fontana and Alberto Burri. Fontana (1899–1968) stands behind much of the advanced art that was produced in Italy during the two decades that followed the end of the Second World War. On returning to his native country after a stay in Argentina, he showed his *Spatial Environment* (1949) at the Galleria Naviglio in Milan, involving a darkened space with a suspended amoebic shape bombarded by neon light. This installation was remarkably influential, not least because it pioneered the custom of reconstructing such complex but ephemeral manifestations in other exhibition spaces, using photographs and other documents. Fontana's consecration as an artist, shortly before his death, took place when he received the major prize for painting at the Venice Biennale of 1966. The Kassel Documenta of 1968 contained an impressive section of 'homages' to his achievement by an international group of younger artists.

What particularly marked out Fontana's production in the 1950s and 1960s was the series of works entitled *Concetto spaziale*. These 'spatial concepts' involved piercing the canvas support, either by *buchi* (holes) or

tagli (slashes). The image was thus no longer an imaginary projection, bounded by the four sides of the support, but an opening into real space, which allowed the otherwise occluded back side of the picture to show through, and so dynamically transformed its relation to the wall. Monika Wagner has underlined the importance of this consistent experimentation in enabling Kounellis to conceive of the canvas in itself as his material, rather than simply taking it as a vehicle for paint.[36] A more general point could be made about his continual use, in more recent years, of structures which are permeable to light (illus. 78–82).

Burri (b. 1915) was probably no less important in awakening Kounellis, and many of his contemporaries, to the multifold possibilities of 'poor' materials. He had begun to add substances like tar, pumice and sand to his oil paintings as early as 1948, and from 1950 he had given worn sacking a primary role in his compositions and experimented with the effects of cutting and burning materials. It is, however, worth underlining that Kounellis does not imitate the distinctive sewing technique of Burri, which has been compared to the suturing of a wound. Moreover, when Kounellis himself began to work with burlap sacks in the mid-1960s, Burri was already turning to the use of coloured plastics. In the final analysis, what Kounellis seems to have derived from his knowledge of Burri's work was not a preferred material or technique, but an intimate sense of how he might aspire to develop as an artist. In the 1979 interview, he explains:

> I considered Burri as a fascinating person, very open for the period. His work helped me to understand the problems of Italian art, the way in which things originated, where they came from, the problems and contradictions that they posed. He opened my eyes to what was happening in Italy, to a whole series of fundamental issues.[37]

This is a significant tribute. What Burri stood for, in these years, was an artistic practice in which 'poor' materials were conceived as providing an alternative form of expression to the painterly surfaces of post-Cubist Concrete art. Burri strongly resisted metaphorical readings of his work, and was careful not to allow himself to be recuperated by the competing political discourses of the Left and Right, which had polarized in Italy in the aftermath of the Second World War, and continued to mimic the international clash of Cold War ideologies. The particular form of intellectual

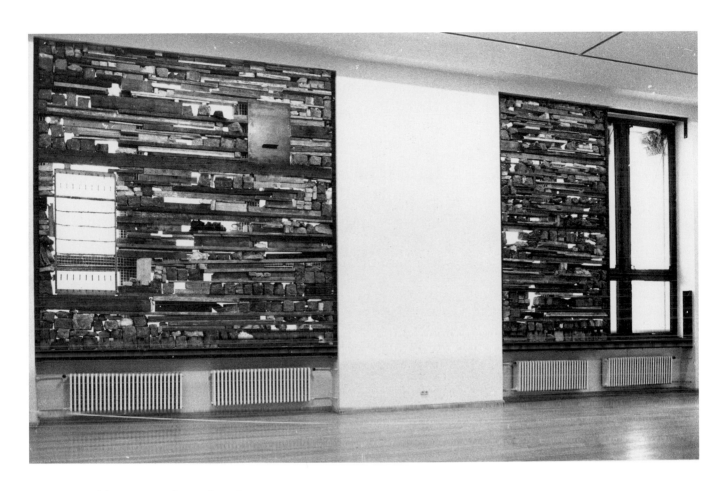

78 'Zeitgeist' exhibition, Gropiusbau, Berlin, 1982

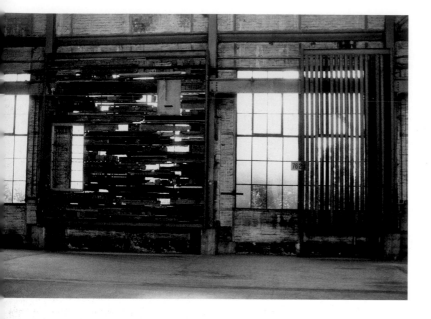

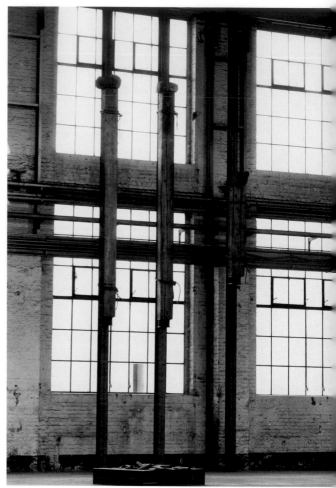

79–82 Exhibition at Museum Ludwig in der Halle Kalk, Cologne, 1997

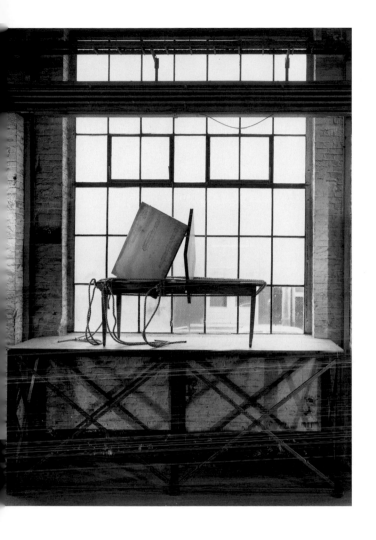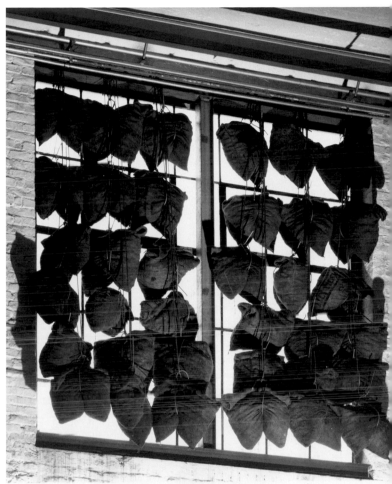

independence that Kounellis has sought throughout his career sems to have its roots in the form of the 'radicalism' that he credits to both Burri and Fontana.[38]

At least equal to the enthusiasm with which Kounellis acknowledges the importance of Fontana and Burri is his very high regard for Jackson Pollock. This may seem anomalous in the light of what has already been quoted from his negative comments on American culture as a whole. Yet, for Kounellis, Pollock's achievement was, precisely, to galvanize contemporary American art by taking it beyond its own self-imposed limits. 'Before Pollock, in the United States, art reflected the colonial attitude of the country . . . Pollock visited Mexico, he discovered mural paintings, Indian paintings, and he understood Mondrian; he lived all of that intensely. And that was his way of criticising the society.'[39] Pollock's 'radicalism' was clearly not a spent force for Kounellis when he completed the interview with White in 1979. By comparison, he was ready to consider Jasper Johns, and perhaps the rest of the succeeding generation of American artists as being 'conservative'.[40]

It was not just for his transcendence of American chauvinism that Kounellis valued the example of Pollock. As with Burri, it was a question of the work itself embodying a radically independent stance, and not the construction of any a priori ideological rationale. Here it must also be acknowledged that painting – rather than sculpture – is almost invariably the medium to which Kounellis refers when he speaks with admiration of his predecessors. He has more than once stated that he is in effect a painter, though his further explanation of the statement could suggest that he just refuses to accept the conventional, medium-based division of labour.[41] A brief passage from an interview quoted by Bruno Corà in 1993 evokes both the immediate attraction that Pollock's method of painting held for Kounellis, and the reason why it must also have served as a direct stimulus for his work in three dimensions. 'Look, it's because of the rhythm repeated a thousand times in the pictures of Pollock and his cosmic effect (*cosmicità*): so the mobility leading up to the point where there is a movement which takes me near to the ancients; in sculpture the maximum of mobility I have obtained is with the *Horses*.'[42]

As with the early paintings in the studio, Kounellis insists that it is rhythm and movement that enable him to occupy the given space. This applies clearly to the positioning of the original wall-mounted canvases, and it applies in an extended but comparable way to the installation that sites

twelve live horses, of varying colours, in a Roman garage. The lesson of Pollock, perhaps, is that the genre or medium which the art work adopts is not in itself a very significant matter. What is crucial is the creative process that takes it beyond the confines of static form, and so gives rise to new, hitherto unpredictable configurations. Having looked at Kounellis's *Untitled* (1968) in a number of early photographs, and several different exhibition spaces, I find this array of wooden sticks covered with wool curiously reminiscent of one of Pollock's last, and incidentally most contested works, *Blue Poles: No.11* (1952; National Gallery of Art, Canberra). This is not only because the material impact produced by the anarchic festoons of natural wool compares with the way in which Pollock's 'poles' structure the vaporous pictorial field as if they were gathering up the many-coloured skeins of paint. It is also because of the space-structuring effect that Kounellis has repeatedly sought to achieve across the sequence of different installations of the work. The sticks occupy, first of all, the central light well, and then the outer wall, of the Rome studio, in the photographs dating from 1968 (illus. 83). Then they reach right up into the ceiling beams of the CAPC, Bordeaux, in an installation shot from the '*Arte Povera, Antiform*' exhibition of 1982 (illus. 84). The latter image, particularly, which shows them distributed across two adjoining partition walls set an angle, provides an interesting example of Kounellis's dynamic interfusion of two-dimensional and three-dimensional space.

So Pollock's role as 'father and mother of American art' is primordial for Kounellis.[43] But if Pollock is deemed capable of bringing him 'near to the ancients (*antichi*)', one might ask what other reference points are necessary to establish this conjunction of the old and the new. Bruno Corà speculates on this point, with an evident commitment to a postmodern perspective, when he equates Kounellis's attitude to the past with Thomas Mann's metaphor of history as a 'deep well', perhaps 'unfathomable'.[44] To continue the metaphor, however, Corà aptly cites in connection with Kounellis the 'return to the surface', after two millennia, of the two extra-ordinary Greek bronze statues known from their place of discovery in the Tyrrhenian Sea as the 'sculptures of Riace'. The worldwide wonderment at this return from oblivion of the two figures – still retaining the ivory inlay that gives their eye sockets an intense impression of life – was indeed a cultural fact of some significance. At the very least, it demonstrated – the point that Kounellis himself has always insisted upon – the ancient art work's undiminished capacity to astonish us.

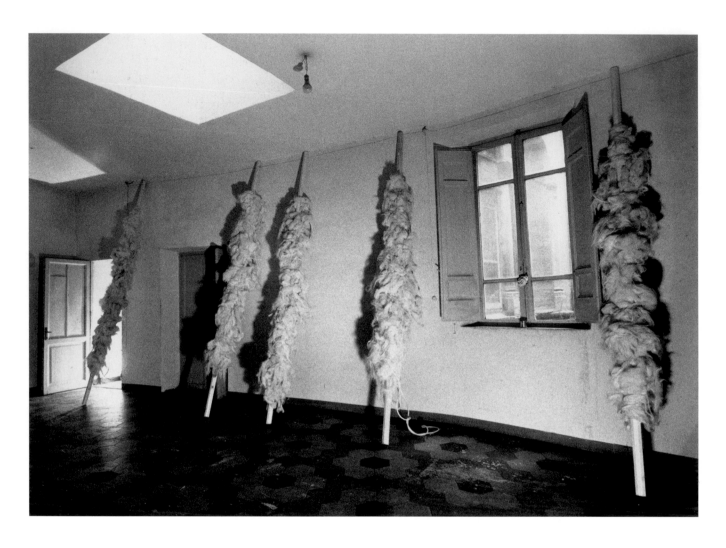

83 *Untitled*, 1968. Five wooden sticks with wool, 400 cm in
height, each stick. Photographed in the artist's studio, 1968

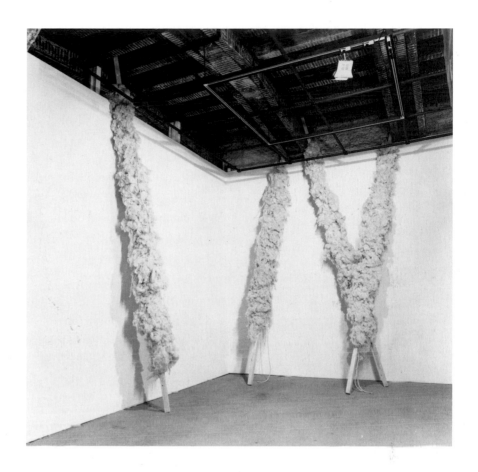

84 *Untitled*, 1968. Wooden sticks with wool. Exhibition 'Arte Povera Antiform', at CAPC Bordeaux, 1982

Corà is also well aware that Kounellis is a product of the Modern Movement, in common with all the other major Western artists of the late twentieth century. Kounellis himself knows that access to the past can only be achieved by way of the thorough-going revision of historical perspectives that took place during the rise of Modernism. At the same time (as Corà emphasizes) this does not mean that he subscribes uncritically to the myths of progress that were optimistically purveyed by the artists of the Modern Movement. Nor does it imply accepting that radical new theories of art (such as those accompanying the rise of Abstraction) should be taken at their face value when they claim to have achieved a definitive historical break. When Kounellis was reminded (in the 1979 interview with White) of his masked appearance on a horse in the Sonnabend Gallery, he brusquely rejected the idea that this was nothing but a satirical entry onto the New York scene, and spoke instead of a possible parallel with Kandinsky's *Blue Rider* motif. For Kounellis, however, it was not at

all Kandinsky's claim to have founded a new language of abstraction that was involved in this reference. On the contrary, it was the fact that 'Kandinsky's *Blue Rider* could without difficulty be seen as a St George on horseback.'[45]

A similar point can be made about the Russian Modernist probably most esteemed by Kounellis, and most relevant to the plastic characteristics of his work. Kasimir Malevich was regarded by contemporaries like El Lissitsky as having made a complete break with the past; he had created, through his mythic *Black Square* of 1913, the basis for a future art which would gradually permeate all areas of visual creation. Kounellis however hints, a little slyly: 'In Malevich's white there is a part of yellow because behind it is the memory of gold.'[46] Angel Gonzàlez, who also quotes this remark, glosses it by suggesting that 'the supplanting of gold by white is the same as the supplanting of a *material* colour by a *conceptual* one'. But the choice of the term 'supplanting' is surely not very exact in this case. Malevich has not in any way 'supplanted' the traditional values of Russian art, if 'memory' still enables the gold surface of the icon to shine through. Kounellis himself has no hesitation about reinstating 'real' gold surfaces, which thus point both to Malevich's own practice and to the earlier icon tradition that the Suprematist artist has not by any means succeeded in erasing.

In pointing to close personal affiliations such as this, Kounellis is not making any statement about 'style'. In fact, he explicitly dismissed 'the contradictions of style' when dedicating his Eindhoven exhibition of 1981 to 'the legendary Russian painter Andrei Rublov and his wonderful country'.[47] Icon painting therefore remains a living tradition to him, not because he wants to simulate its appearance, but because it was created by artists who were well aware, in their own times, that they were committed to the creation of something radically new.

This group of specific points relating to these two Russian painters also brings into focus the emphasis of Kounellis's more general relationship to Modernism. He values, in particular, that brilliant, but short-lived phenomenon which John Berger has described as 'The Moment of Cubism': that is to say, the moment of historical coincidence between a revolutionary artistic practice and a widely diffused sense that, in the new world that was then opening up, everything had suddenly become possible.[48] With respect to the group activity of his own lifetime, Kounellis can discern nothing of this exhilarating sense of common opportunity. Pollock

is for him an isolated figure, as are Fontana and Burri in their different ways. The typical model for group activity has become the Factory of Andy Warhol, a celebrity who, when asked about his knowledge of contemporary Italian artists, 'answered that the only thing he knew about Italy was the spaghetti'.[49]

Yet Kounellis is also fully wary of the dangers of romanticizing the pioneers of the Modern Movement. He recognizes that their sense of history was as complex as our own, and he also concedes that their strength lay in the determination with which they faced up to a difficult cultural predicament. They were the first generation to work with the overpowering sense that the legacy of the past could be accommodated only in the form of fragments: that both the literary and the visual arts would have to accept, and to a certain extent mime, this state of fragmentation in order to survive. 'These fragments I have shored against my ruins', writes T. S. Eliot in one of the last lines of 'The Waste Land'.[50] Bruno Corà points out that, for Kounellis, there is no essential distinction to be made between the achievements of the Cubists, and those of the major modernist writers and poets. Joyce and Kafka should be mentioned in the same breath as Picasso. All three were simultaneously engaged in a 'work of recomposition from the basis of fragments, in their vision of space, and temporal and literary memory'.[51]

Kounellis's own writings never fail to be interesting in this connection. He has not subscribed to a group manifesto, and, needless to say, such a public expression of collective purpose never came out of the *Arte Povera* grouping. Nonetheless, his statements at times adopt a form which compares and distinctively contrasts with the manifestos published by the pioneers of modern art. He gives us no hymn to the dynamism of the Machine Age, as Marinetti did in the First Futurist manifesto. He does not proclaim that the Winged Victory of Samothrace is the inferior of the modern racing car. As with the Pre-Raphaelites and the Vorticists in their day, the purpose of his declarations is partly to praise – and partly to blast – his precursors, and so to construct a personal pantheon that will implicitly challenge the conventional image of history and tradition that is current at the time. Yet Kounellis does not try to be in any way esoteric in his choices. None of his heroes could be said to be in the least undervalued. The transgressive quality of his statement lies perhaps in the very fact that he is not shy of associating popular favourites with his own individual quest. The 'I' who makes these assertions is demonstrably committed to

understanding the past in terms of the present, and gives us the measure of his commitment in the rhythmic urgency of his enunciation:

> I am against the world of Andy Warhol and of the epigoni of today. I want to restore the climate experienced by the Cubists.
> I am against the condition of paralyzation to which the post war has reduced us: by contrast, I search among fragments (emotional and formal) for the scatterings of history.
> I search dramatically for unity, although it is unattainable, although it is Utopian, although it is impossible and, for all these reasons, dramatic.
> I am against the aesthetics of catastrophe, I am in favour of happiness, I search for the world of which our vigorous and arrogant 19th-century forebears left us examples of revolutionary form and content.
> I am an admirer of Pollock, for his dramatic and impassioned search for identity.
> I am an expert traveler, I know all the tortuous routes of my land of Europe, the mountain paths and the big cities with their passionate stories and gossip.
> I like the pyramids of Egypt, I like Caravaggio, I like Van Gogh, I like the Parthenon, I like Rembrandt, I like Kandinsky, I like Klimt, I like Goya, I like the impetus of the Winged Victory of Samothrace, I like medieval churches, I like the character of Ophelia as Shakespeare describes her and I honor the dead, thinking of myself that I am a modern artist.[52]

Right at the end of this declaration from 1982 comes the most unexpected reference, which touches on the character of Ophelia as portrayed by Shakespeare. Maybe Kounellis is also aware (though he makes no acknowledgment) of the Pre-Raphaelite painting by Millais, *Ophelia* (1852; Tate Britain), which represents the drowned heroine from *Hamlet* in its own literally minded yet poignant way. For Kounellis – as indeed to a great extent for Millais – the task of conveying the pathos of Shakespeare's lines in visual terms is displaced on to the wild flowers that she listed in her final melancholy song. We can maybe see the stark flower form with burning gas flame of *Untitled* (1967) as, in some sense, Kounellis's reply to the designedly banal, silk-screened *Flower* series completed by Warhol and widely exhibited in the mid-1960s (illus. 85).[53] But the work of two decades later which evokes Shakespeare's Ophelia in lyrical terms is surely his *Untitled* (1987). An iron panel bears a long vertical strip that erupts with

85 *Untitled*, 1967. Cast-iron plate, Bunsen burner with collectors, rubber tube, gas bottle, flames. Height 150 cm. Exhibition at Galleria L'Attico, Rome, 1967

bunches of tiny, brightly coloured flowers. In his subsequent conversation with Germano Celant, Kounellis explains that 'for me the flowers are what remains of Ophelia . . . This is also a stone with an epitaph. The flowers certainly do not represent joyousness, which is not a motive for putting them in a picture. Rather they are dedicated to all the dead Ophelias.'[54]

In generalizing the aim of the work in this way, Kounellis must be implying that something more than this particular literary and pictorial reference is involved. What might this be? Arguably, what is at stake in

86 *Untitled*, 1987. Iron panel with flowers, 200 x 190 cm. Exhibition at Institute of Contemporary Art, Nagoya, 1987

Untitled (1987: illus. 86) – as perhaps in the rest of his work – is the continuing confidence that he holds in 'an innate narrative force'. Will people continue to tell stories? If so, will the stories that circulate still be capable of drawing creatively upon the archetypal models of narrative that once found expression in great literature and drama? Kounellis does not allow himself to doubt the answer to the first question. His own work is his way of responding positively to the second. Yet, as the next section will show, such a response always needs to be qualified by the historical conditions of representation. These have lost none of their constraining force in the contemporary world.

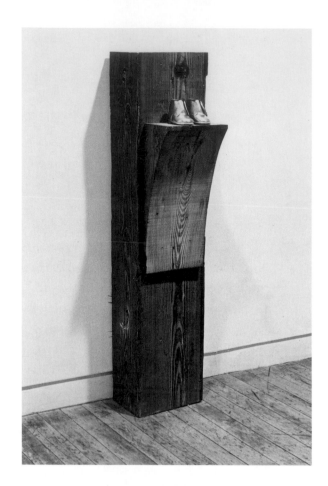

87 *Untitled*, 1972. Wooden structure with shelf, vertical shaft of a cross occupied by children's shoes in gilt, 125 x 50 x 25 cm. Private Collection. Exhibition at Sonnabend Gallery, New York, 1972

88 *Untitled*, 1975. Shoes with gold soles. Exhibition at Museum of Modern Art, Chicago, 1986

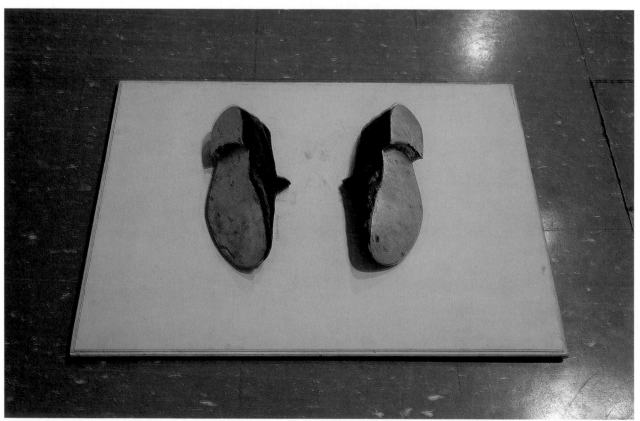

3 Alternative Histories of Art

Throughout his career Kounellis has insisted that he is a European artist, and that this implies a crucial difference from artists working within, or under the influence of, American culture. This issue inevitably came to the fore in the long interview of 1979 with Robin White, from which quotations have already been taken on several occasions. Intrigued by the fact that Kounellis had remade his piece involving twelve live horses, *Untitled* (1969), at the Venice Biennale of 1976, the American critic pointed out that European artists seemed 'to keep up a continuing connection with their former works'. This would not be the case in the United States, he explained, where 'the accent is placed on novelty'.[1] This is the cue for Kounellis to assert his article of faith: 'European artists maintain a relation to the past and nourish themselves from this essential source.' On being pressed to explain further what seems a difficult concept for White to assimilate, Kounellis then comes out with the concept of 'accumulation' to explain this relationship of the European artist to history, and illustrates it with a telling example:

> There is near the Pantheon (in Rome) a sculpture by Bernini which represents a little elephant carrying on his back a little Egyptian obelisk. Bernini combined the obelisk – which is a very ancient form – with an elephant for which he took his inspiration from a drawing by Raphael. That is an example of accumulation. In their work of the last fifteen years, American artists have by their own choice eliminated the idea of accumulation. They have chosen another sort of logic. The square totally eliminates the possibility of accumulation.[2]

In settling upon Bernini's sculpture outside Santa Maria sopra Minerva as the epitome of the 'logic' of accumulation, Kounellis has made an excellent choice (illus. 87). This example calls to mind an earlier figure for the European relationship to the past which was also expressed vividly in a work of art. John of Salisbury, writing at the time of the so-called 'Twelfth-century Renaissance', described his contemporaries as being dwarfs standing on the shoulders of the Ancients, with the implication that, despite their smaller stature, they could use the heights attained by their predecessors to see further into the future. A famous series of windows in the Cathedral of Chartres, where John was Bishop, is traditionally taken to have been a visual illustration of this proverbial farsightedness.

89 Facade of S Maria sopra Minerva, Rome, with Obelisk and Elephant designed by Gianlorenzo Bernini, unveiled in 1667

In Kounellis's example, however, the references are more complex, and the stakes perhaps higher. An ancient object, in effect an Egyptian obelisk from the sixth century BC rediscovered by a Roman antiquarian shortly before 1667, is borne on the back of a modern sculpture. And the modern sculpture itself derives its prestige not from an observation of nature at first-hand, but from an intermediate origin in the drawings of Raphael, who was himself the paragon of Renaissance artists, but also an inveterate copyist of the fragments left behind by the Romans in the imperial city. It is worth noting also that the idea of combining these two disparate elements significantly predates Bernini. The figure of an elephant bearing an obelisk is one of the most arresting woodcuts in that most mysterious and suggestive of all Italian Renaissance texts, the anonymous *Hypnerotomachia Poliphili*.

I would myself want to add yet a further layer of complexity to these instances of how the European sense of history might be defined (and visually represented) as having its basis in 'accumulation'. Bernini achieved his most spectacular adaptation of an Egyptian obelisk in his design for the Piazza Navona (itself derived from the pre-existing form of a Roman circus), where he erected a splendid specimen as the centre-piece of his vast Baroque fountain of the 'Four Rivers'. However, just a few years before, an English traveller called John Bargrave had chipped off a fragment from the base of the huge granite block as it lay in the Circus of Maxentius. At this stage in its history, the obelisk was well-known in Rome since it had been purchased by the English Earl of Arundel, who probably wished to transport it to the site of his new palace beside the Thames, but was prevented from doing so by the difficulty of dragging its immense weight as far as the Tiber. Bargrave felt himself free to remove this small token, and had it polished and carved into the form of a heart, to take its place ultimately as an exhibit in his Cabinet of Curiosities.[3]

Kounellis is thus quite right to agree (in answer to further questioning by White) that the notion of historical 'accumulation' is not a simple one. Certainly it is not one that may be comprised in the elusive notion of 'influence' as it has tended to be invoked in positivist readings of the history of art. Bernini was tempted to interpret a drawing by Raphael in three dimensions, rendering it as a solid object. But he also habitually incorporated pre-existing objects in his works, such as the large and small obelisks that have been mentioned here. The fact that these obelisks were moved only within Rome, being incorporated into the spectacular new scenography of the Baroque city, has now all but eliminated the sense of strangeness that they once must have possessed, in the centuries when they lay neglected amid the ruins of the ancient city. But what if we choose to imagine that larger obelisk on the banks of the Thames, as Arundel might well have wished to see it? And what if we turn our minds to the polished fragment of granite that Bargrave brought home, over three centuries ago, having imbued it with the intimate significance of a heart-like form, as an object to handle in common with his *virtuoso* friends in his study overlooking Canterbury Cathedral?

All of the prospects that are raised here in a speculative way relate directly or indirectly to the perspectives opened by the work of Kounellis. For 'accumulation' is, first and foremost, the trope that resists the entropic effects of time and decay. It is the strategic creation of composite new

entities which represent the layering, and thus the mutual intensification, of different historical strata. Hence it must matter enormously where, precisely, the work comes to be sited. An obelisk in the middle of Rome has a greater historical resonance than one which is placed beside the Thames, especially if the latter has come to be known by the half-jocular nickname of Cleopatra's Needle. A fragment of a prior object, however important this may be in itself, will need to be significant enough to call to mind, however indirectly, the form and material of its original. If it is converted to serve as a personal souvenir – like Bargrave's heart of granite – it is important that the narrative of its discovery and conversion should be placed on record.

In fact one of the special aims of a study like this is to encourage the process of 'accumulation', over against the process of entropy, and so to provide a deep historical context against which Kounellis's strategies can be reviewed and appreciated. To take a relevant example, I saw and hurriedly sketched *Untitled – À Damiano Rousseau* (1972), whilst it was presented in the Tate '*Arte Povera*' exhibition of 2001 (illus. 88–9). This is a work which was first presented in public in 1972, at Kounellis's first one-man show in the United States, at the Sonnabend Gallery. It consists of what appears to be the vertical shaft of a cross, with a shelf protruding from the shaft, and two children's shoes in gilt (as it happens, those of Kounellis's son) placed outward-facing on the shelf. When this work was recalled to him by Germano Celant in the wide-ranging interview of 1979, Kounellis instantly responded with a comment that picked up Celant's query about the symbolic role of gold:

> Verrocchio was a goldsmith, and so he paid the greatest attention to particulars; he was not only a sculptor but a goldsmith as well. In making the little shoes I thought particularly of Verrocchio and of his capacity for restoring particularity and his faith in artisanship.[4]

Kounellis goes straight into an explanation of the artisanal aspect of the use of gold, and its link with the craft-based workshops of the early Florentine Renaissance. What he does not have to explain any further, since the knowledge is no doubt already shared with Celant, is the fact that this work represents, on another level, a purely private appropriation of the form of his son Damiano's shoes. In the presentation at the Tate, this debt was recorded in a formal dedication of the work to the (now

grown-up) child whose shoes were originally borrowed: *À Damiano Rousseau.*

What also needs no further explanation, in this interview with Celant, is the obvious comparison betwen this truncated object and the omnipresent symbol of the Christian Cross. If Kounellis is thinking of Verrocchio, one might reasonably conclude, he is also thinking of Verrocchio's subject matter as a sculptor, which very largely consisted of biblical themes commissioned for the adornment of Florentine churches. One of Verrocchio's most celebrated works, *Christ and St Thomas* on the facade of Orsanmichele, was to become famous precisely because the more than life-size foot of the doubting saint, protruding from the niche, was successively stroked over many years by passers-by in the busy street, to the point where it gleamed bright and brassy. But Damiano's small shoes, striking because of their puny scale against the massive shaft, do not work their effect through any such incitement to fetishistic devotion. They are intricately made but empty, and they reinforce the awesomeness of the truncated cross. The emotion that Kounellis has captured is perhaps closer in expressive terms to a nineteenth-century painter like Ary Scheffer, who showed in a celebrated Crucifixion scene no more than the grieving figures at the *foot* of the cross, as we significantly put it. This implied cutting off the upper part and leaving it outside the limit of the picture frame, directing attention solely to the feet of Christ, and the ledge upon which they had rested.

In his interview with Celant, Kounellis moves directly from these comments on Verrocchio as a goldsmith to another work which involves the symbolic use of gold. *Civil Tragedy* (1975) can be singled out as a central achievement of Kounellis's career, not only because it is virtually the sole work to possess so specific a title, but because it epitomizes his desire to infuse a contemporary reference with historical depth. As he explains, the decision to make an exception to his rule of the Untitled in this single case was determined by the effect of the configuration of elements when it was first shown at the Modern Art Agency in Naples, under the direction of Lucio Amelio (illus. 90):

overleaf: 90 *Civil Tragedy*, 1975. Wall covered with gold sheeting, hanger with overcoat and hat, burning oil lamp. Exhibition at Modern Art Agency, Galleria Lucio Amelio, Naples, 1975

In the work for Lucio Amelio at Naples in 1975, with the gilded wall and in front the overcoat and hat, gold functioned as a kind of Brechtian panorama, and it is the only work to which I have given a title, 'Civil Tragedy', since what stands in front is conditional. Behind it

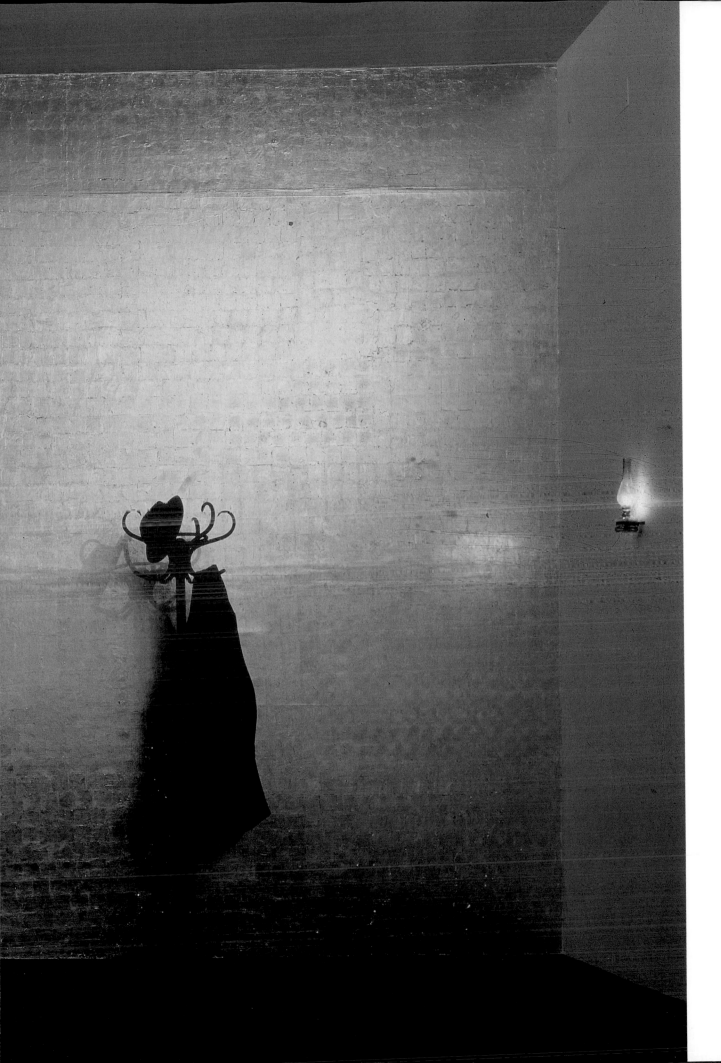

there is the recollection of the Sienese icons of the 14th century, which often have a golden background, but the figure in front is plastic. The background in Byzantine art is flat, as is the figure, it is both gold and sky. The overcoat is by contrast an image full of literature, a very direct image. Here the meeting between background and figure represents the double relationship between culture and identity, in a vision which is active and contemporary.[5]

Much that is important emerges from these comments on what is certainly one of Kounellis's most memorable works.[6] First we learn that the gilded wall is, on one level, a kind of *mise-en-scène*, like the stage sets of Brecht. But on a secondary level, it represents the historical point at which, in the Sienese art of the late medieval period, Italian painters began to

91 Christ the Warrior, mosaic in the vestibule of *c.* AD 500 Cappella Arcivescovile, Ravenna

draw away from the Byzantine influence. Kounellis wants the hat and coat to evoke 'plasticity', in the same way as the painted figures of artists like Duccio and Simone Martini began to acquire solidity and mass by contrast with the hieratic flatness of their Byzantine predecessors (illus. 91). A further point to note is that both hat and coat are devoid of their inhabiting bodies: they are empty containers, like the Malic Moulds signifying male presence (and absence) in Duchamp's *Bride Stripped Bare by her Bachelors, Even*. The hat rack itself also inevitably connotes Duchamp, with its reference to one of the most famous of ready-mades, and the oil lamp casts the shadow of the curved prongs onto the gilded wall rather in the same way as Duchamp's hat-stand projects a painted shadow image across his 'last painting' (mentioned earlier), *Tu m'* (1918).

When Kounellis produced a further version of *Civil Tragedy* in 1986, for a section of his Chicago exhibition held in a warehouse building at 401 West Ontario Street, some of these layers of ambiguity were deliberately stripped away (illus. 92). By comparison with the cavernous inner space revealed at the warehouse site of the CAPC, Bordeaux, in the previous year, Kounellis chose to expose the bare bones of the Chicago buildings, aligning his works with the long, multi-windowed walls. So *Civil Tragedy* lost its three-dimensional hat-stand, and the oil lamp that cast the Duchampian shadow. There is a kind of pathos here in the fact that *Civil Tragedy*, second edition, seems like a rather distant reminiscence of the Naples version, indeed a drastic reduction from three to two dimensions, though the 'plasticity' of the hat and coat against its gilded background is to some degree safeguarded. This is perhaps the kind of pathos that one could also feel, if one chose to imagine how far a Sienese altar panel has travelled from its original site to the walls of the Art Institute of Chicago.

Such issues of culture, identity and displacement will return in the Conclusion of this study, where *Civil Tragedy* will again be a central point of reference. But, for the moment, we need to look more intensively at the relationship with Renaissance art that Kounellis has claimed in commenting on the use of gold in both these works of the 1970s. Kounellis's staccato listing of favourite artists, quoted at the end of the last chapter, may seem at first sight a little arbitrary, and for that reason hard to relate to the details of his own working procedures. But the comments made in conversation with Celant, a fellow Italian immersed in the common visual culture, point to several subtle and precise distinctions: Verrocchio is cited as a goldsmith, and not just as a painter and sculptor; Sienese plasticity is

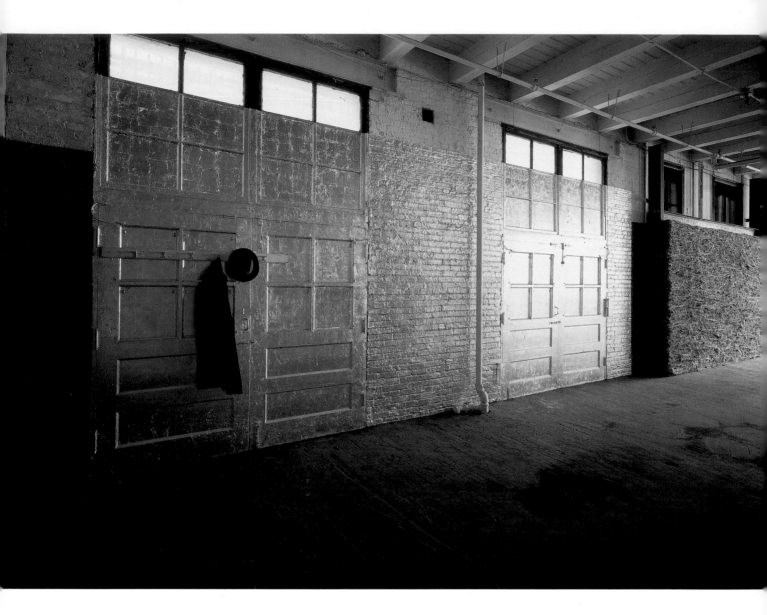

92 *Civil Tragedy*, 1975/86. Two doors and wall of bricks covered with gold sheeting; hat and over-coat on the hanger of one of the doors. Exhibition at 401 West Ontario Street, Chicago, 1986

preferred to the flatness of Byzantine icons. It seems that we can proceed a lot further in understanding the view of Renaissance art that Kounellis chooses to make his own, from the evidence supplied by the works themselves. But this must be through following in the steps of some of the most recent and adventurous readings of the Renaissance tradition, which will aid in dissolving the barriers between present practice and the understanding of the past.

MATERIALS AND THE LIMITS OF REPRESENTATION

It is a central argument of this study that Kounellis's work can be fully appreciated only if its claims for historical resonance are given their due. In the light of this criterion, I would hold, many of the elements that appear puzzling in assessing his distinctive way of working may be clarified and to some extent resolved. Such puzzling ambiguities can be expressed in the following questions. What is the particular mode of representation through which Kounellis exhibits his materials? Is he a painter, or a sculptor? Or if such a simple binary system does not seem to do justice to the case, then what is the historical basis for the particular types of presentation that he has chosen? Are his works most appropriately listed under the all-embracing contemporary term of 'installation'? If not, what significance can we attribute to the fact that he almost invariably tries to adapt his work to the new conditions of a given space? Is his way of exhibiting 'theatrical', given in particular the fact that (increasingly in recent years) he has begun to design stage-sets for opera productions throughout Europe? These questions may involve generic issues that are liable to arise in connection with the conventions and terminology of contemporary art. Or indeed they may indicate issues that come to the fore precisely because of the lack of any such binding conventions and the imprecision of the terminology that is currently in vogue. My claim would be that they nonetheless refer implicitly to the approaches taken by some of the most important revisionist studies of Western art history undertaken in the last few decades.

To take an example, Georges Didi-Huberman has consistently argued that one of the long-term consequences of Renaissance art theory was a devaluation of the material content of the work of art, and a consequent disparagement of the aesthetic possibilities of sculpture vis-à-vis painting.

Kounellis, as we have seen, singles out Verrocchio as a congenial point of reference because he is both painter and sculptor, and fully engaged at the same time in his craft-based technical skills as a goldsmith. As Didi Huberman points out, it is Verrocchio's pupil Leonardo da Vinci who later decisively repudiates this ethos of the workshop, and proclaims the superiority of painting as a '*cosa mentale*', a construct of the mind.[7] For Leonardo, the work of sculpture must be deemed 'less intellectual', and 'many of the aspects of nature escape it'. It cannot incorporate perspective, and the different points of view bearing upon objects that are achieved only through the use of perspective. In fact, it can offer only a few of the main conditions of corporeal representation, namely 'volume, figure, placing, movement and rest', while painting can offer in addition 'light, darkness, colour, distance and proximity'.[8]

This indictment is, as Didi-Huberman rightly points out, a piece of striking bad faith. Leonardo must have been well aware of sculptural polychromy, of light effects related to variation in materials and features like the veining of marble, let alone the perspective effects of a sculptor like Donatello in bas-relief. Yet this depreciation of sculpture is repeated, with even more specious elaborations, in the canonical text which is rightly taken as the ancestor of all Western art histories: Vasari's *Lives of the Most Excellent Painters, Sculptors and Architects*. Vasari is anxious to assert that painting and sculpture are like 'two sisters from the same father', which is the art of drawing (*disegno*). But having given sculpture a noble parentage which appears to relieve it of its gross materiality, he then goes on to contend that painting is incomparably the more versatile of the two. The painter can represent all the varied phenomena of nature through the resources of the brush. The sculptor, however, is barred from showing more than a small part of this marvellous repertory. As Didi-Huberman puts it, sculpture can only redeem itself from this stigma to the extent that it 'dissociates the image from the material'.[9]

Of course, it could be argued that these Renaissance exercises in the *Paragone* – that is to say, the competitive assessment of the different plastic arts against one another – belong to remote history and not to the present. Yet, as Didi-Huberman shows, they are certainly not without consequence as far as the development of art history has been concerned. As he argues, Aby Warburg was one of the first art historians who attempted to raise the taboo that had previously attached to a particular class of sculptural images, hitherto relegated as mere 'historical curiosities' by art

historians.[10] These were the *bòti* in the Florentine church of Santissima Annunziata, life-size effigies whose faces and hands were directly cast from the living bodies of their donors. Warburg persisted in attaching importance to these despised objects, which had first entered the corpus of art history only with the publication of Julius von Schlosser's *History of the Portrait in Wax* of 1911. But Schlosser's own pupil, Sir Ernst Gombrich, showed in his highly influential *Art and Illusion* (1959) that he, for one, was not willing to admit such disquieting images into the fold. In his own words, 'in front of the proverbial resemblance of wax images . . . we experience a certain malaise, from the fact that they are situated beyond the limits of symbolization'.[11]

What Warburg insisted on bringing to the fore, and what Gombrich then peremptorily excludes from the domain of 'symbolization', could be redescribed as the anthropological status of the art object. In other words, what the wax votive object gets into focus (and what Warburg also set about investigating through his interest in non-European, tribal artefacts) is the kinship between cultures, in respect of the values invested in types of material object that appear to transgress the norms of representation. In the case of the waxes, of course, it is not simply the fact that these images have been moulded directly from the features of donors who have long been dead. It is also a question of the intrinsic property of the wax itself, its troublesome viscosity (as Didi-Huberman expresses it). A material which so insidiously soft to the touch, and so easily takes on the form of whatever is impressed upon it, seems to violate the artistic condition of distance between the representation and the object (or person) being represented. This is not 'realism', so the art historian Horst Janson argues in respect of such votive objects, but a kind of 'resemblance by excess' that is contrary to all established traditions of artistry and style.[12]

I would not try to suggest that this debate about sculpture, materials and the limits of representation is a new one, let alone that it is being raised for the first time by the artists of Kounellis's generation. It was already raging in the nineteenth century, when Rodin, for example, felt that he had to defend himself against the accusation of using *surmoulage* – casting directly from the body – in the preparation of one of his most famous sculptures. But it is nevertheless the case that the wider issues connected with the 'limits of symbolization' have surfaced in a uniquely challenging way in the period from the 1950s onwards. Before this period, seemingly aberrant practices like Duchamp's taking of plaster casts from

male and female genitals were regarded as part of the Dada repertoire of shock tactics. Since that date, strategies involving different modes of 'resemblance by excess' have usurped the uncertain domain of 'realism', and the contestatory activity of previous years threatens almost to be the harbinger of a new orthodoxy.

So it is not surprising to find that the publicity hand-out for Kounellis's exhibition at Prato in 2001 places him at the centre of a wide-spread movement in which the *Arte Povera* artists took a leading part. We learn from the text that Kounellis develops his 'concepts of history and memory' through a return to 'the anthropological and mythical in his use of fire, of body cavities, and of space, of the form of the cross', also that he has broken 'with the linguistic conventions of art' by employing 'raw, natural and synthetic material such as bed frames, doors, shelves, cotton, wax, iron, lead and carbon (with) the involvement of vegetal and animal elements'.[13] This is indeed a suggestive list (though certainly not an exhaustive one) of the various objects and materials which Kounellis has imported into the gallery, ostensibly without paying much attention to the imperatives of 'symbolization' (illus. 93–4).

Yet to allow Kounellis's contribution to be defined by the terms set by such art historians as Gombrich and Janson – to admit the existence of 'limits' and characterize his work as going beyond them – is not in the spirit of this study. Of course, it is true that, in certain cases, Kounellis's use of materials exposes us to what Gombrich calls 'a certain malaise'. In front of *Untitled* (1989), a work involving haunches of beef hanging from hooks on iron panels that was recreated at Prato, we cannot fail to feel some measure of disquiet, if not a degree of revulsion (illus. 95–96). The yellow tint of the congealed fat and the red bloom of the muscle tissue look very differently here from when we observed such haunches of meat hanging in the butcher's shop. But to isolate a particular feature in this way is surely inimical to the spirit of Kounellis's procedures. Invariably, in all his gallery installations, there is a system of equilibrium at work. The haunches of meat are not only profiled against the smooth iron panels, but offset by the presence of the burning oil lamp, and the lateral effect of alternate blue and yellow panes of glass inset into the nearby windowpane (exhibition at the Espai Poblenou, Barcelona, 1989/90). Different states and qualities of material are, as a result, transmuted into contrasting effects of colour and light, within a space which is being dynamically transformed in the process.

93 *Untitled*, 1969. Bed-frame, wool, 33 x 190 x 80 cm. Photographed in the artist's studio, 1969

94 *Untitled*, 1998. Cast-iron construction, jute sacks, lead, hooks. Cast-iron construction, 3,540 x 782 cm. Exhibition at Ace Gallery, New York, 1998

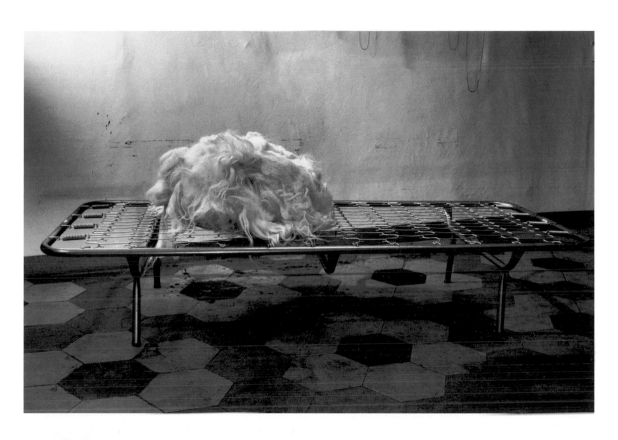

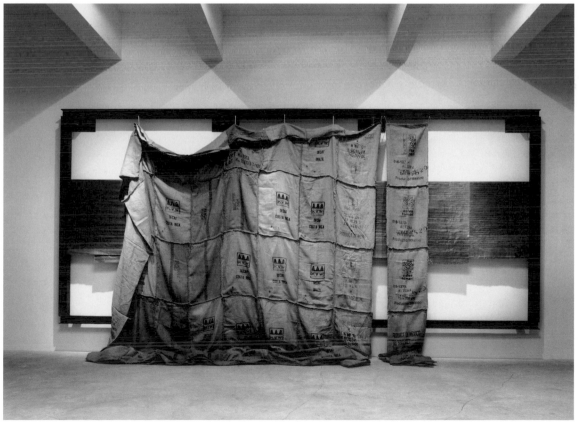

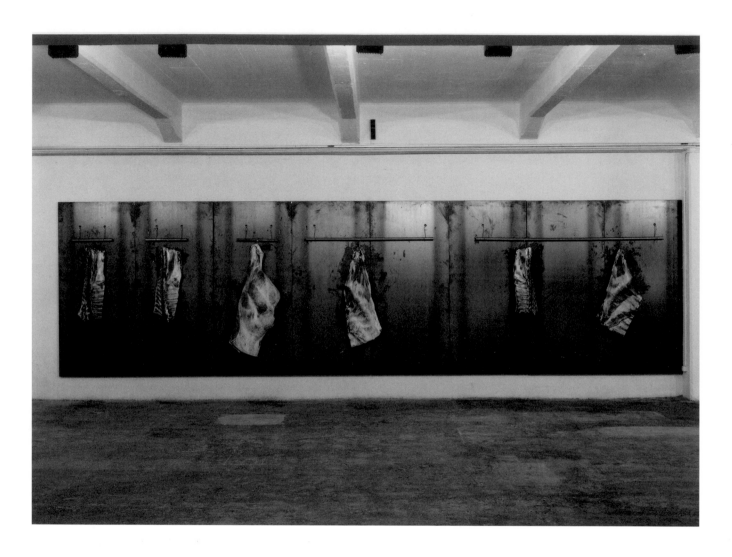

95 *Untitled*, 1989. Iron panels, pieces of meat and burning flame hanging by means of hooks
from metal tubes, propane gas bottle on the floor, 200 x 1330 cm. Part of the same work as 96.
Exhibition in Espai Poblenou, Barcelona, 1989–90

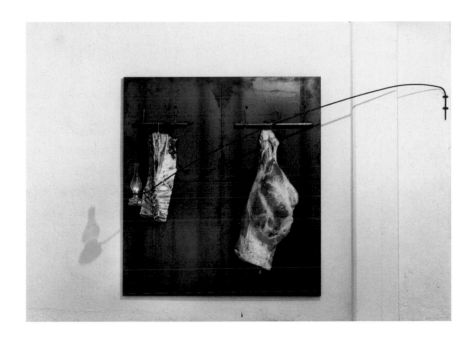

96 *Untitled*, 1989. Iron panel, two pieces of meat hanging by means of hooks from metal tubes, and burning oil lamp suspended from a metal rod

This aspect implies quite a significant difference from the approach of Joseph Beuys, one of Kounellis's interlocutors in the important conversation already quoted here, and undoubtedly a pioneer in the use of unprecedented materials for his art. Virtually all the new materials that Beuys employs belong to the register of substances that might be said to cause 'a certain malaise'. They include felt, with its dense, matted texture, corroded and rusted metal, and of course fat, which shares with wax, to a certain extent, the quality of viscosity, but presents in addition the disquieting feature of having been rendered down from animal carcasses. Even when Beuys uses stone, that most traditional of sculptor's materials, he shows a preference for the distinctive blocks of basalt that he came across in natural locations like Kassel and the North of Ireland: pre-formed miniature columns, plug-like in form, which have their mysterious origins in a primeval geology.

Beuys's works seem to epitomize the problematic character of a 'realism' that is conveyed by the disquieting marginality of the materials themselves, as well as by the artist's personal investment of mythical and anthropological themes. Very frequently, these materials proclaim their equivocal status through being stored in old-fashioned display cases, which would be more suited to showing items of natural history or archaeological artefacts. Yet this very fact demonstrates how very different in

character the work of Beuys is from that of Kounellis. In Kounellis's case, the conditions for understanding the work remain primarily aesthetic, and do not stray much outside the Western tradition of the fine arts. Whether Kounellis infringes the protocols of a particular reading of art history through 'resemblance by excess' becomes a decisive issue only if we accept that the terms of tradition and 'style' are definitively constrained by such a traditional point of view. In fact, the revisionist art history that has grown up since the 1950s (directly contemporaneous, as it would seem, with the artistic development of Kounellis) suggests a number of fruitful ways of opening up the question. One might argue that such recent initiatives have begun to reintegrate the contemporary art that Gombrich persisted in calling 'experimental', in the same way as it has been demonstrated that we can think differently about the whole course of art in the West from the Renaissance onwards.[14]

THEORY OF THE CLOUD

My first attempt to write at some length on a work by Kounellis sprang from a decision to combine three chronologically separate objects of study: Kounellis's frequently recreated combination piece, *Untitled* (1967), Degas's two associated paintings on the subject of the Cotton Office in New Orleans (1873), and a historical and semiotic piece of writing by Hubert Damisch, *Théorie du nuage* (1972).[15] The link between the contemporary work and the two nineteenth-century paintings was, on the surface, a clear and obvious one. Degas, on a visit to his family on the other side of the Atlantic, had determined to complete a painting which would enable his dealer, Agnew, to tempt the industrial magnates of Manchester into a purchase. He chose then to focus on the office in which the raw cotton was being displayed and viewed by a range of workers and bystanders. Kounellis included in the diverse array of elements that went under the general title of *Untitled* (1967) a separable object, officially described as a 'varnished iron structure containing cotton' (illus. 97). The 1967 work has been exhibited in its entirety by Kounellis on many occasions, such as *Falls the Shadow*, an ambitious group show held at the Hayward Gallery, London, in 1986, the large Amsterdam retrospective of 1990, and the recent 'Arte Povera' at Tate Modern.

97 *Untitled*, 1967 Metal construction, cotton, 120 x 120 x 120 cm. Raussmüller Collection. Exhibition at Galleria L'Attico, Rome, 1967

It is not hard to spot direct connections between the two Degas paintings and the Kounellis object, if only on a banal level. In what may be assumed to be the first of his paintings – the more finished and more saleable – Degas keeps the gleaming cotton well in the background. This picture (later to be sold to the Musée des Beaux-Arts, Pau) is very carefully constructed, in terms of traditional perspective, and when shown at the second Impressionist exhibition in 1876, it merited the comment that it 'revealed . . . the undeniable gift of a defrocked draftsman' (illus. 98).[16] The second work (Fogg Art Museum, Cambridge, MA) was intended, as one of Degas's letters recalls, to be 'less complicated and more spontaneous, better art', with little of the claustrophobic office furnishings but instead 'white walls, a sea of cotton on the table'.[17] Degas not only brought

98 Edgar Degas, *The Cotton Exchange at New Orleans*, 1873, 74 x 92 cm. Musée des Beaux-Arts, Pau

into the foreground the spectacle of a mass of raw cotton, but allowed it almost to bleed over the framing edge, with the roughly worked white pigment extending right up to the bottom left-hand corner of the canvas (illus. 99).

The transition between the two works by Degas can thus be seen as an index of where, in his own opinion, new and important art was moving. It was leaving behind the regime of perspectival realism, such as might appeal to a Manchester merchant, and approaching a condition where framing was no longer a matter of defining a box-like space, but merely of bounding a flatly designed area, that was enlivened mainly by the vigorous workings of the brush. Of course, there is still a crucial element of metamorphosis in the process of representation. The white pigment has to be interpreted as cotton. But Degas's metaphor, a 'sea of cotton', indicates perhaps how flexible a contract with appearances the modern artist has begun to negotiate. We seem almost to have entered the world of Proust's token modern painter Elstir, whom the narrator praises specifically for interpreting the sea as if it were land, and the land as if it were sea!

Kounellis's *Untitled* (1967) is worth another look in the light of this discussion. It is not simply that the cotton is now real cotton. That fact is of course undeniable, but it is a fact that figures only as one component in our experience of the work. The special property of the metal structure

99 Edgar Degas, *The Cotton Merchants*, 1873, 58.4 x 71.1 cm. The Harvard University Art Museums, Cambridge, Massachusetts (Gift of Herbert N. Straus)

in which the material is placed qualifies it to serve as a frame, in the literal sense that it prevents the cotton from spilling on to the floor, but also in the spectatorial sense, since it delimits a particular area for viewing. Since the corners of the structure are left open (as with the corner of Degas's canvas), we can register the fibrous and densely massed character of the cotton, which is retained strictly within the designated area. But we can also sense the buoyancy of the material, which is not massed to form a dense wedge (as in a mattress), but exposes its feather-soft surface to the light. The framing effect of the metal plates directs our gaze towards this surface. But the relative height of the piece, in relation to the viewer, means that all these other aspects are involved in our beholding of it.[18]

It is not just within the century or so between the rise of Impressionism and the *Arte Povera* movement that the significance of this connection should be sought. Damisch's 'theory of the cloud' suggests an overall view of the history of Western painting since the Renaissance that both clarifies the status of these works by Degas and Kounellis, and deepens the historical relationship between them. Damisch's argument is not iconographic but semiotic in character. That is to say, it is not concerned with the way in which a particular iconographic scheme – say, the hairy coat of John the Baptist – is employed in a succession of different works. That would be Panofsky's approach, broadly speaking, and it would take for granted the regular space of perspectival representation within which such a motif

would be located, when moving from one individual pictorial statement to another. By contrast, Damisch's 'cloud' is a differential element working within (and also transforming) the system of perspective itself. More precisely, it is what resists and expands the exact determination of the perspectival scheme, precisely by being essentially vague and amorphous rather than firm and clearly defined.

So the 'cloud' is not always, or necessarily, a cloud. It is whatever is chosen to perform that differential function. Nevertheless, in Damisch's account, it is the representation of clouds in the development of Renaissance painting that provides the best early evidence of how this differential element will progressively transform the scope of pictorial representation. The first clue to what may be happening can be found in one of Brunelleschi's founding experiments in perspective theory, traditionally reported to have taken place in Florence, at the corner of the Piazza della Signoria. Here Brunelleschi supposedly constructed a reduced, perspectivally correct view of the Signoria as seen from that particular viewpoint, and then placed it in the piazza, in such a way that the outline of the real building in the prospect was precisely repeated by the reduced image. Above the roofline of the building, however, the reduced image was cut off, and Brunelleschi permitted the real sky to appear. This was the aleatory feature that could not be captured by the linear schemata of perspective.

Damisch's illustrations retrace in a fascinating sequence the way in which this rogue element complicates, and progressively transforms, pictorial space. In Mantegna, for example, there is still a visible tension between a medieval vision of the material universe, in which objects are grasped in their literal proximity, and one in which distance from the beholder must be conveyed by diminishment and perspective. His *Agony in the Garden* (National Gallery, London) shows in the left top corner cherubs perching upon a fleecy platform that probably derives from the contraptions used in medieval street theatre. In the background, however, are carefully observed clouds that testify to a real knowledge of meteorological conditions, as well as being correctly diminished.[19]

With Correggio, at a slightly later stage, this inconsistency no longer applies. The clouds set up a dialectical dynamic, within and beyond the dimensions of the painted surface, and so manifest themselves in terms of dramatic innovation. Particularly in Correggio's large fresco projects at Parma, such as the cupolas of the Duomo and the Church of St John the Evangelist, the function of the encircling clouds is to create an impalpable

space beyond the literal dimensions of the architecture. As we look up into the cupola of St John, the witnesses clustering round the circular rim are part of our own dimensional system, despite their rigorous foreshortening. But the ecstatic saint has penetrated into another zone, perceived as an infinite prolongation of the literal surface of the ceiling.

For Damisch, then, the cloud is 'what marks the limit of a representation subservient to the finitude of linearity'.[20] Functioning as a limit, it can also transform the viewing conditions of represented space. In the case of Correggio, we find ourselves gazing up into a cloud landscape that has passed beyond the restrictions imposed by a rectangular frame, and so offers a visual experience which is no longer tied to the contrivance of a single vanishing point. Of course the story does not stop there. Damisch's proposition 'for a history of painting' (to repeat his sub-title) is potentially applicable to many future stages in the development of painting from the Renaissance onwards. That is why I have summarized it in connection with Degas and Kounellis. For Degas's table covered with cotton is, indeed, a 'cloud' that transcends its limits in its passage from the first picture to the second. And Kounellis's pile of cotton is, indeed, a 'cloud', that invites us to refer the idealized optical surface presented within the container to the mass, volume and weight of a real material.

This suggestion that a work by Kounellis may be interpreted in the light of a particular way of retelling the history of post-Renaissance art is not being offered as an open sesame. It is still only one line of interpretation among many. Nevertheless, I would hold that it is often helpful to take this kind of enlarged historical view in order to break out of the closed circle of contemporary avant-gardism. The further interpretations of Kounellis that follow will prove to have at least this feature in common. They start from the assumption that the history of art is not a seamless progression, marked only by repetitions and variations of iconographic material within the framework created by 'legitimate perspective'. On the contrary, it is a highly contested arena, in which different modes of representation and interpretation must constantly be brought into play. To appreciate why Kounellis's work takes the form that it does, it is useful to revisit some of the historical points of crisis at which new directions were emerging, and to observe their relevance to the issues that concern us here.

First of all, though, it should be borne in mind that *Untitled* (1967) is a complex work, consisting of a number of separate elements, only one of

100 *Untitled*, 1967, detail. Varnished iron receptacles containing earth and cacti, 140 x 100 cm (see illus. 101, 102). With the artist

which is the cotton container discussed above (illus. 100–02). The other components are a set of four varnished iron receptacles containing earth and cacti, and a wall-mounted iron panel with a perch occupied by a live parrot. It is important to note the detail of the live parrot, even though this was omitted from the '*Arte Povera*' (2001) exhibition at the Tate Modern, having been more enterprisingly supplied for both *Falls the Shadow* (1986) and the Amsterdam retrospective (1990). This prompts a comment not just on the increasing officiousness of government regulations (in Britain at any rate) but also on the overall connections and balances established by *Untitled* (1967). If the cotton in its container has a special semiotic function, along the lines that I have suggested, this is enhanced by being juxtaposed with the long, low trays of earth, punctuated by prickly vegetation, and the chattering, exotic, living bird. Clearly when we are faced with such a rich combination, it is not a question of the literal presence of the objects, materials and living things that the viewer registers one at a time, but of multiple connections and oppositions being put into play within a system: high and low, heavy and light, coloured and monochrome, organic and inorganic, with the ultimate, capital distinction between the mode of being alive proper to a succulent plant, and the less reticent self-advertisement of a sociable parrot.

We might perhaps get closer to understanding what underpins these distinctive systems that Kounellis employs – what is the unity underlying

101 *Untitled*, 1967. Work consisting of three elements: varnished iron structure containing
cotton; four varnished iron receptacles containing earth and cacti; varnished iron panel with
perch occupied by live parrot. Crex Collection, Hallen für neue Kunst, Schaffhausen. Exhibition at
Galleria L'Attico, Rome, 1967

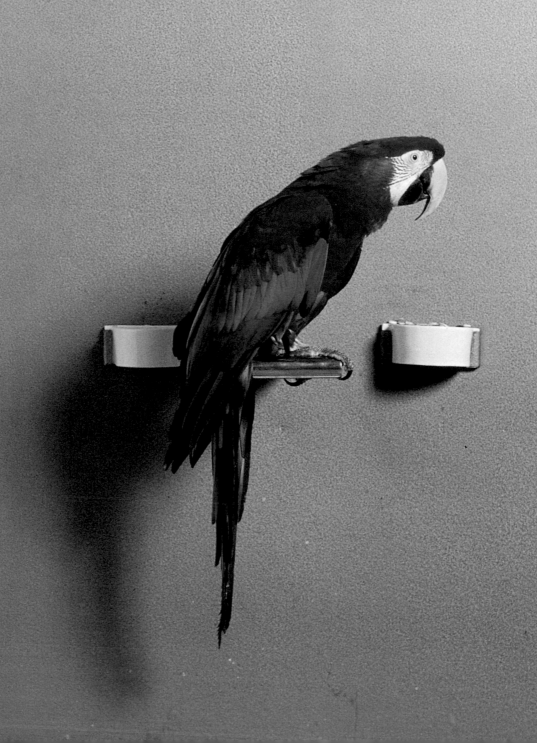

the panorama of elements – if we go back to one of the most stimulating passages in the previously quoted interview with Celant. The critic suggests that a considerable number of Kounellis's most interesting works, from the cactus trays and the charcoal piece of 1967 through to the array of amphoras (*Untitled*, 1989) could be classed under the general heading of a '"terrestrial" perspective'.[21] Kounellis responds directly by making a slightly different point. 'A grouping with a rectangular form creates a body.' He then goes on to suggest a directly historical context for the very general statement that he has made. 'So it is a body laid on the paving, as in cathedrals there are the laid-out bodies of rulers and saints.' This then prompts a surprising, but apt commentary on *Untitled* (1989), with its massed assemblage of earthenware containers, void of their original olive oil, except that a single one of them has been refilled with blood. 'They are all empty as with a carcass, only one is full.' (see illus.34)

PONDERATION

This unexpected reference to the way in which tombs are arranged in a medieval cathedral is of a piece with the apppearance of some of Kounellis's more recent work (illus. 103–4), and its implications will be considered further in my Conclusion. But in the context of this discussion on historical antecedents, it is worth recalling how Rudi Fuchs (one of the museum directors who has consistently supported Kounellis) approaches this central question of the body and the 'terrestrial'. For Fuchs, the issue turns around the role played in the transition from medieval to Renaissance (and modern) art played by Masaccio, a painter for whom Kounellis has several times expressed his deep regard. As with Didi-Huberman, it is Leonardo who strikes Fuchs as defining the hegemonic art of the future, and so initiating the tradition that Kounellis is reacting against. To use his precise terms, what finally emerges from the humanism of the Renaissance is 'an art of fluent flexibility', typified by Leonardo's achievement. To understand Kounellis, Fuchs explains, it is necessary to look back beyond this development:

> The humanist interest in atmosphere and anecdote and individual feeling led to a particular narrative aesthetic which for painting meant flexible structure and descriptive detail. Kounellis is obviously uncom-

102 *Untitled*, 1967. Varnished iron panel with perch occupied by live parrot, 120 x 30 cm. Crex Collection, Hallen für neue Kunst, Schaffhausen

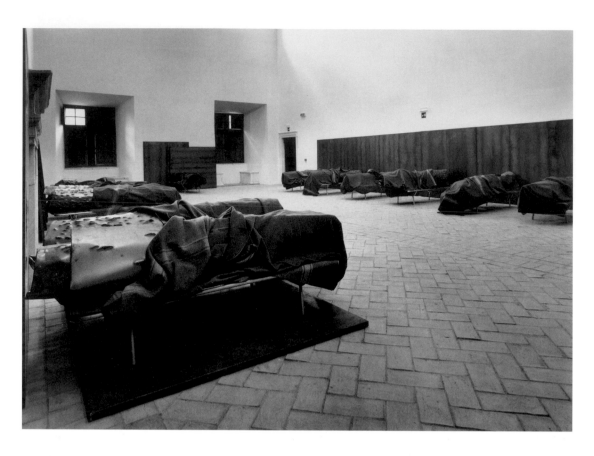

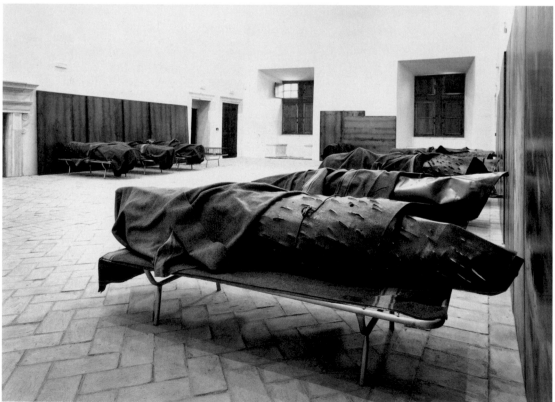

fortable in this realistic tradition which has been so dominant in western art. Commenting on its inevitable disintegration he has often referred to the art of Masaccio . . . The reference to Masaccio expresses a desire for what might be called an objective image – or an image which is more than an individual lyrical interpretation of visual circumstances and which aspires to an epic independence. This coincides with Kounellis's conviction . . . that an art-work must establish elements of a formal language which are valid also beyond the personal and accidental interpretation of the historical situation.[22]

The antithesis established here is an important one – and it is incidentally helpful to think of Kounellis, who titles all but a tiny proportion of his works *Untitled*, as being at variance with the tradition that valorizes 'anecdote' and 'visual circumstances'. Fuchs is providing a plausible point of reference for an art that seeks to counteract the long-term consequences of Renaissance 'history painting'. But we could pursue still further the question of what it is, on the positive side, that validates Masaccio's 'desire for . . . an objective image'. The answer can be found almost at source in the well-known passage in the life of Masaccio where Vasari singles out the specific feature that this Florentine artist repudiated in the work of his predecessors. 'He considered that the figures, which were not well planted and did not have their feet drawn in foreshortening on the ground, but were lifted up on their tip toes, were deficient in quality and style in the essential points, and that the artists who produced them proved their ignorance of foreshortening.'[23]

This, in Vasari's words, was the special intuition that impelled Masaccio to pioneer 'the good manner in painting'. Yet, as Étienne Jollet rightly remarks in his discussion of the previous passage, Vasari has chosen to put his stress on the cognitive aspect of Masaccio's revolution. He has interpreted Masaccio's move primarily as a shift from one form of visualization ('lifted up on their tip toes') to another, which the detached observer might recognize as being more suited to the position of a standing figure. But he has not chosen to underline the most important perceptual implication of such a change. This must surely be that Masaccio's figures are perceived as having weight – as capable of responding to the forces of gravity. The figures represented on tip toe by his predecessors – the Byzantine-influenced painters of the late Middle Ages – were not just standing in a different way. From a perceptual point of view, they would hardly appear to be bodies obeying the laws of gravity at all.

103 *Untitled*, 2000. Bed-frames (200 x 90 cm) with wrapped iron panels and military blankets and wall-mounted iron panels (200 x 180 cm). Exhibition at Castello Colonna, Genazzano, 2000

104 Exhibition at Castello Colonna, Genazzano, 2000

Etienne Jollet's study, *Figures de la pesanteur*, is in effect an attempt to redress this cognitive bias that has come into being partly through Vasari, and partly through the old tradition of interpreting works of art on the basis of their iconography, which has been strongly reinforced in the twentieth century. He succeeds very well in showing that one of the casualties of recent art historical scholarship has been the tendency to give serious attention to the observer's perception of weight, of *ponderation*. His thesis is in large part a historical one. He points to the general consensus that the appearance of the Greek *kouros* figures at the beginning of the fifth century BC, with their feet planted firmly on the ground, was a major event in the history of Western art. 'It implies a manner of affirming the existence around the figure of a space conforming to that of reality.'[24] But his argument is also philosophical in nature. Jollet recognizes that Bergson, for example, talks about the 'sensation of weight', and draws attention to the different modalities through which weight may be apprehended: stable equilibrium, unstable equilibrium and, in the most extreme case, the condition of falling.[25] While incorporating both the historical and the philosophical aspects, Jollet is also concerned to trace the intermittent appearance of a critical discourse of 'ponderation' over the last five centuries, and to mark its special relevance to the interpretation of a well-known eighteenth-century painting, Fragonard's *The Swing* (Wallace Collection, London).

The relevance of this approach to the understanding of Kounellis's work is not hard to appreciate. First of all, such an argument puts his veneration of Masaccio within the context of a vital, though somewhat neglected, reading of Western art history. Jollet clearly demonstrates that there has been significant acknowledgment of the perception of weight as a component in realistic representation, but that there has also been a frequent tendency to disparage it. In Panofsky, for one thing, the concern to assert the cultural determinants of pictorial representation over the presumed features of 'realism' entails a depreciation of all those effects that underline (or contravert) the laws of gravity.[26] By contrast, the work of Michael Baxandall pays close attention to the ways in which weight is associated with some of the most prestigious of pictorial motifs, from the Renaissance up to the eighteenth century. Baxandall reminds us moreover that weight is firmly associated with the terrestrial world from classical antiquity onwards. As a result, it becomes the ideal signifier to translate into visual terms the human nature of Christ. So the depiction of the

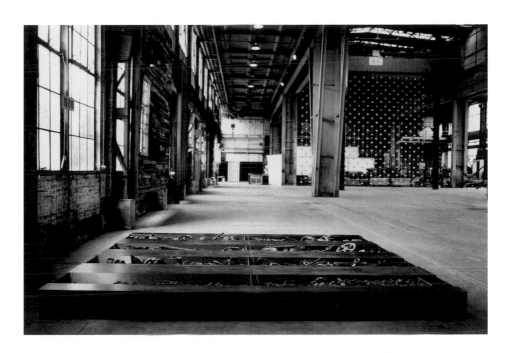

105 Exhibition at Museum Ludwig in der
Halle Kalk, Cologne, 1997

106 Cologne, 1997

107 Cologne, 1997

108 Cologne, 1997

109 Cologne, 1997

Lamentation over the Dead Body of Christ acquires a privileged place in the Western tradition. Alberti can state, with this theme in mind, that tackling such a subject is 'the most difficult thing, since it is as much the mark of a great artist to show the limbs in repose in all parts of the body, as to render them living and in the process of completing an action'.[27]

Recalling this tradition, we may well find a way of associating the discourse of ponderation constructed around the art of the past with our contemporary perceptions of Kounellis's work. The impressive installation that he created in the Museum Ludwig in der Halle Kalk, Cologne, in 1997, could plausibly be seen as transforming the structures and spaces of the former factory into a gigantic manifestation of the force of gravity. Hanging elements are either mysteriously packaged so as to mask their substance or transformed into shimmering screens of shining globes (illus. 105–9). But the process of foregrounding weight and balance is also apparent in Kounellis's less dramatic works. In *Untitled* (1988), for example, the attention that we pay to the placing of the eight superimposed iron panels, with their covering of sacks, is massively overdetermined by our assessment of their stability and equilibrium (illus. 62). First of all, we become aware of the construction of iron panels that forms the support, itself resting upon the floor and so substituting for the dematerialized white wall surface. The mass effect of these panels is, however, alleviated by the superimposed elements which set up a rhythmic movement on two levels. Their very slight upward inclination is enough to imbue this movement with a dynamic force that is directed to the right hand upper corner. But counteracting this dynamic tendency is the lower right element, singled out by the presence of a burning oil lamp suspended from a metal rod. The tense arc formed by the metal rod, which appears to be bending in response to the weight of the lamp, provokes a kind of interruption in the narrative logic of the work. Tempted to read the sequence from left to right, as Western convention enjoins and the stencilled lettering on the sacks provokes us to do, we are unexpectedly involved in a different logic of materials. Fire is lighter than iron, but forced to take a lower place in this connection, so it seems.

This description is not intended simply as a formalist description of the complex object that we see before us. On the contrary, it may suggest how the experience of a work by Kounellis provokes comparison with the experience of earlier artistic representations, in which such visual paradoxes of weight and weightlessness were not explored gratuitously, but

tied to precise doctrinal and philosophical concepts. Kounellis answers Celant's comment on the 'terrestrial' nature of his work by saying that a rectangular form creates a 'body', and then he goes on to invoke the *gisant* figures of rulers and saints in churches and cathedrals. In fact there is a very definite set of codes that governs the character and placing of such effigies. Recumbent figures representing dignitaries who have had a major part in the building of a cathedral are usually privileged both in the materials employed for the tomb and in its placing, as with the superb bronze effigies of bishops in the nave at Amiens, or the individual chantries devoted to William of Wykeham and other leading churchmen at Winchester. Sight lines and proximity to a noted shrine are also important, as with the two royal tombs of Henry iv and the Black Prince at Canterbury, which flank the Trinity chapel that originally contained the reliquary of Saint Thomas Becket. But it is still the case that the fundamental consideration underlying the creation of all these diverse types of monument is the paradox of the incarnation: that Christ possessed an earthly body, subject to earthly laws, and in consequence the materials of art, when representing the dead, must simultaneously acknowledge the claims of body and of spirit.

What counts as a limit case for the experience of ponderation is, as Bergson recognizes, our perception of a body falling. This has been

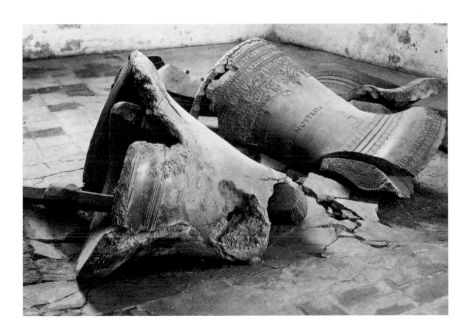

110 Fallen bells from the Marienkirche, Lübeck

portrayed in innumerable great Western paintings, and the subject matter of classical mythology as well as Christian tradition provides many congenial themes for the artist. But it is worth putting once again the question of how an artist can best represent falling bodies, in the definitive way that Masaccio represented the bodies of his figures firmly sited in space, with their feet planted on the ground. I know of one extraordinary example of a display of fallen objects, whose shattered state is so stark as to dramatize intensely the fact of their having fallen. But this is not an art work. It is the spectacle of the church bells that fell from the tower of the Marienkirche in Lübeck in 1942, when part of the building was destroyed by bombing (illus. 110). The pavement that lay beneath the tower is still in the same fragmented state as it was when the bells first crashed down upon it. The great bronze bells are mangled beyond repair, with great gobbets of metal gouged out of their noble rounded forms, and the Latin inscriptions recording their original dedication are only partly legible.

Kounellis has himself incorporated church bells in a series of works that readily connote their eccelesiastical origin, and most memorably so in an exhibition held at the Palazzo Fabroni in Pistoia, close by the Romanesque cathedral which could be seen through the gallery windows (illus. 111). However, he uses bells in order to enhance the pleasures of a maintained equilibrium, and not to convey the pathos of having fallen. On one level, at least, *Untitled* (1993) revives in an imaginative way the type of active participation that Jollet has persuasively outlined when he analyses the perceptual effects of Fragonard's *The Swing* (illus. 112). This work, when exhibited on the ground floor of the Anthony D'Offay Gallery, London, in 1994, made a playful intervention in the long, low space of the gallery at street level. Three massive wooden beams rested in the corner of the room, where they were furthest from the light of day. At the point where they met the wall, the three bells – two of them bearing Latin inscriptions recording their dedication – were tethered with knotted ropes. The size of the ropes, and the elaborate nature of their knots, testified to the substantial weight of the cohort of bells, which hung slightly at an angle, as if they were just on the point of sounding their respective notes.

There is certainly no direct connection, it hardly needs to be stressed, between such a work by Kounellis and Fragonard's Rococo vision of a careless maiden, whose immodest turn on the swing has exposed her legs (and maybe more of herself) to the gaze of an inquisitive young man. Yet, as Jollet has reminded us, the erotic aspect in Fragonard is, precisely, a lure to

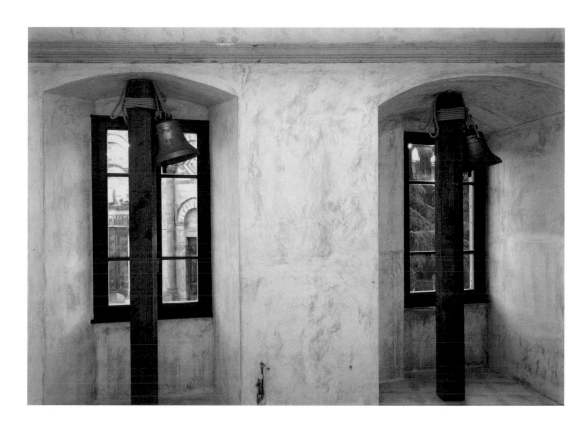

111 *Untitled*, 1993.
Wooden beams, rope,
bells. Exhibition at
Palazzo Fabroni,
Pistoia, 1993

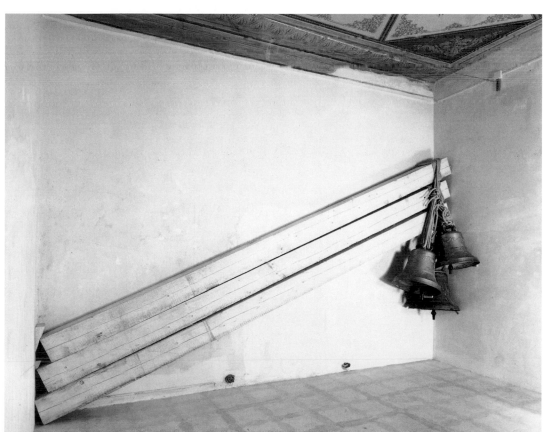

112 *Untitled*, 1993.
Wooden beams, rope,
bells. Approx. 420 cm.
Exhibition at Palazzo
Fabroni, Pistoia, 1993

tempt us further into exploring the mechanics of the picture. Retracing the movement of the swing, and engaging in the tantalizing spectacle of the secret that is never going to be revealed, we construct a synthesis of impressions from our successive perceptions of the work. We create a 'virtual body', which allows us to experience the 'sensation of weight', in the process of testing vicariously the voyeuristic pleasure of the onlooker. A work like Kounellis's *Untitled* (1993) operates not through energizing the erotic stimulus of seeing under the skirts, but perhaps through provoking the desire that these bells may make music once again. It will not happen, any more than the onlooker in *The Swing* will be erotically satisfied. But it is the pleasant fantasy of waiting to hear the bells sound their notes, as they swing from side to side, that captivates us while we assess the work's pondered equilibrium.

INSTALLATION, PAINTING OR SCULPTURE?

In the foregoing discussions, I have related particular works by Kounellis to some of the fertile revisionist histories that are currently modifying, in their complementary ways, the authorized narratives of Western art. In no case is it a matter of simply revising an old story with the use of new theoretical tools. Both the art theory of previous periods, and the actual practice of artists when considered in this fashion, reveal cracks in the official facade that call into question the whole structure. But we have not so far looked directly at a basic issue that underlies any appreciation of Kounellis's art if it is considered in the light of the Western tradition as a whole. This is the issue of whether it is to be regarded as 'painting' or 'sculpture'. It will hardly do to put off the dilemma by saying that this question is unprofitable, or meaningless, in the context of the eclecticism of contemporary art production. Against the evidence of Kounellis's own historical references, the very issue of such work being neither painting nor sculpture, but possibly something else that needs to be defined, becomes a historical problem to be explored.

One striking aspect of Kounellis's evocations of previous art, which have already been frequently quoted here, is his relative indifference to sculptural precedents, except in cases where the site itself is can be seen to have a special significance: such cases would include the Bernini elephant bearing an obelisk, or the recumbent effigies in medieval churches.

By contrast, he is only too ready to invoke the celebrated painters of the past, and the statement quoted at the close of the first section contains a lengthy list of them. In the case of Verrocchio, whom he mentions in reference to the work incorporating gilded shoes, it is specifically the Florentine artist's training as a goldsmith, and so his link with the medieval craft tradition, that is valued – rather than any possible contribution to a sculptural aesthetic.

This relative reticence could be explained by the very fact that anything resembling a specifically 'sculptural aesthetic' is quite late in emerging in Western art. As has been shown already, the 'Paragone' debates in the period of the Renaissance provided an occasion for painters like Leonardo to dilate upon the limitations of sculpture, *vis-à-vis* painting. Alberti's theoretical text on sculpture, *De Statua*, has justifiably been seen as a perplexing and rather confused document compared with the exegetical clarity and evangelistic zeal of his much better-known *De Pictura* (On Painting).[28] This is linked, of course, to the Renaissance view of the superior status of painting as an intellectual creation (*cosa mentale*), as opposed to the irreducible materiality of sculpture. But I have not yet raised the question of how far this prejudice, or (to put it less pointedly) this recognition of a crucial difference in status between the painted and the sculptural work, has been transferred into the recent debates about contemporary art and its different modes of display.

That it may have more than a lingering effect is suggested in a revealing passage from Alex Potts's recent study, *The Sculptural Imagination*. This is certainly a book that advances a strong intellectual case for the development of a modern sculptural tradition, beginning with the neoclassicism of Canova in the late eighteenth century, and continuing at least as far as the elder generation of American artists who continue to work at the present day. Potts's aim is, undisguisedly, to trace the emergence of a sculptural aesthetic, and he succeeds in doing so. But his advocacy is qualified by the frank acknowledgement that he has been, on at least one occasion, disturbed by the manifest dreariness of the ordinary run of modern sculptural production. So he describes in the following terms his visit to the sculpture hall that encircles the interior courtyard of the Hirshhorn Museum in Washington:

> I remember sinking into a state of vaguely irritated boredom as I
> scanned the various lumps and tangles of metal and bits of stone

sitting on pedestals or in display cases. Indifferent paintings at least do not take up so much space, they sit back on the wall, waiting to be looked at. Why all this stuff? It was as if most of the artists had fiddled away industriously to give solid form to some possibly intriguing looking plastic shape but had failed to take into account what the resulting object would look like as sculpture. How would it project itself when set in a public display space and hold the attention of a viewer drifting round a gallery? The cubistic forms, the vaguely primitivising shapes might have been fine in impromptu sketches, or enlivened by indeterminacy of depth and activated surface in a painting, but congealed into lumps of matter they too readily went dead.[29]

Admittedly this turns out to be a prelude, in Potts's argument, to the discovery of the one sculpture that stands out as special in the otherwise disappointing mishmash: Brancusi's *Sleeping Muse* (1909–10). Here he happens to have singled out one of the very few modern sculptors to whom Kounellis gives an accolade, describing him approvingly (and neoclassically) as 'antique'.[30] But this privileged single case does not entirely counteract the impression that, for Potts, something has gone very wrong with the condition of modern sculpture, if we judge it not by privileged exceptions but in the main. This problem appears to be rooted (as with the old Paragone debates) in the obtuse materiality of the sculptural object, compared to the capacity of painting to offer both illusory effects and material qualities in combination ('indeterminacy of depth and activated surface'). So there is a centuries-old resonance to the exclamation: Why all this stuff?

Although Potts's *cri de coeur* is directed at a typical range of modern and contemporary sculpture displayed in a major museum, it could perhaps be extended globally to the category of work now generally known as Installation Art. Modes of exhibiting have a habit of migrating from one category of work to another, and the visitor who deserts the dismal sculpture hall in search of something more vivid and contemporary is likely to come up against even more potentially disconcerting amalgams of heterogeneous material, sometimes occupying entire rooms, which pass under the general heading of 'installation'.[31] Since I have myself used the term on and off, in speaking of Kounellis's work – and since, with good reason, his site-specific productions have often been viewed against this context – I need to look closely at the question of how helpful, or important, the concept may prove to be in tracing his itinerary.

Jennifer Gonzalez has done an excellent job in summarizing many of the avant-garde currents that have contributed to the rise of the installation as a phenomenon in today's galleries, and in examining its possible theoretical underpinning. A broad and loose historical definition takes us back to the Wagnerian *Gesamtkunstwerk*, and by way of the 'performances, exhibitions, and working philosophies particular to Futurism, Dada, Constructivism and the Bauhaus', right up to 'Minimalism and conceptualism's dematerialization of the aesthetic object'.[32] Another, more restricted definition focuses instead on 'the hybridization of art media that can be traced to Pablo Picasso's and Georges Braque's incorporation of collaged elements onto the Cubist canvas'. The latter is the lineage chosen by the American artist, Allan Kaprow, in his influential *Assemblage, Environments, and Happenings*, published in 1966. Its salient feature is that it explicitly assumes a critical attitude to the museum as 'White Cube', and a consequent strategy of positive engagement by virtue of which 'the gallery space is transformed into the primary material of aesthetic encounter'.[33]

From a different perspective, Gonzalez points out, the installation artist is responding to the objection: Why all this stuff? with the answer that what we see is not stuff but signs. Indeed the philosopher Paul Crowther subtly argues that installation art has a mission 'to transform the complex excess of images and signs in contemporary industrial societies into a finite and rational form'. Its emphasis is thus on the production of meaning 'not simply "there in the world" to be perceived but rather (to) be decoded from an always shifting domain of social signification'. Through a range of site-specific strategies, the installation artist brings to the fore a relationship between 'perceptual and imaginative excess and rational containment' that recalls Kant's famous definition of the sublime. 'The audience of installation art', contends Crowther, 'is no longer lost in an excess of images and signs because it is able to enjoy a sensory overload that is sublime precisely because sensory and imaginative excess can be comprehended as an idea.'[34]

This is a bold, and in many ways illuminating, explanation of the contemporary vogue for installation art. It manages to salvage the critical function appropriate to the avant-garde tradition, whilst safeguarding the possibility of a primary experience of 'enjoyment'. But such a definition is surely no more convincing than Julia Kristeva's rather less euphoric comment: that installations reenact the condition of contemporary cultural malaise which derives from there being no longer any stable

centre. The best that we can expect from such displays, in her view, is that we will achieve a temporary transcendence of the present-day decentredness. 'Beyond the malaise of a lost foundation, (installations) would communicate this: the ultimate goal of art is perhaps what was formerly celebrated under the title of *incarnation*.'[35] The work that Kristeva selects in particular to illustrate this point is the memorable installation by Hans Haacke in the German pavilion at the Venice Biennale of 1995, when an entire concrete floor was torn up to form an uneven terrain, and loud-speakers relayed the sound of marching feet. The past history of Germany, and the place of the national pavilion in that history, was vividly manifested in this comprehensive uprooting of the past.

Like the shattered floor of the Marienkirche at Lübeck, this scene of disturbed foundations did no doubt achieve a transgression of the limits of aesthetic experience, which would justify the description of 'sublime'. As such comparisons go, however, Haacke's Venice work is at least equalled on the scale of sublimity by the continuing spectacle of the smashed bells at Lübeck. As Kant's definition of sublimity suggests, this is an area of experience in which the awe provoked by terrifying actions of God and Man threatens to dwarf the emotions elicited by a mere artist.

Kounellis's most sublime works, according to this principle, might well be those that erupt out of the aesthetic domain through their exploitation of forces that are harnessed directly from nature. From around 1969, it has been Kounellis's use of inflammable gas as one of his main materials that has taken him most forcefully in this direction. In *Untitled* (1973) he spent two days profiled against an iron panel in the Modern Art Agency, Naples, with a burning propane gas flame secured in his mouth (illus. 113). What Kristeva interprets as the artist's attempt to make good the contemporary default of 'incarnation' could also account for the many occasions throughout his career when Kounellis appears in person at the centre of his own installation. Characteristically, it is the searing force of the flame, rather than the uprooting of foundations, that propels Kounellis's performed works in the direction of the sublime.

It should also be borne in mind that the manifestation of Kounellis's own body is not so much in the spirit of a 'happening', but rather a necessary stage in the intense dialogue with the past that he consistently pursues. The particular works in which he bears a mask, usually of classical provenance, suggest that the elements of performance and reminiscence are closely interconnected. So the direct frontal address of

113 *Untitled*, 1973. Photograph of
the artist in front of an iron panel,
holding a burning propane gas
flame in his mouth, 100 x 70 cm,
panel. Exhibition at the Modern
Art Agency, Naples, 1973

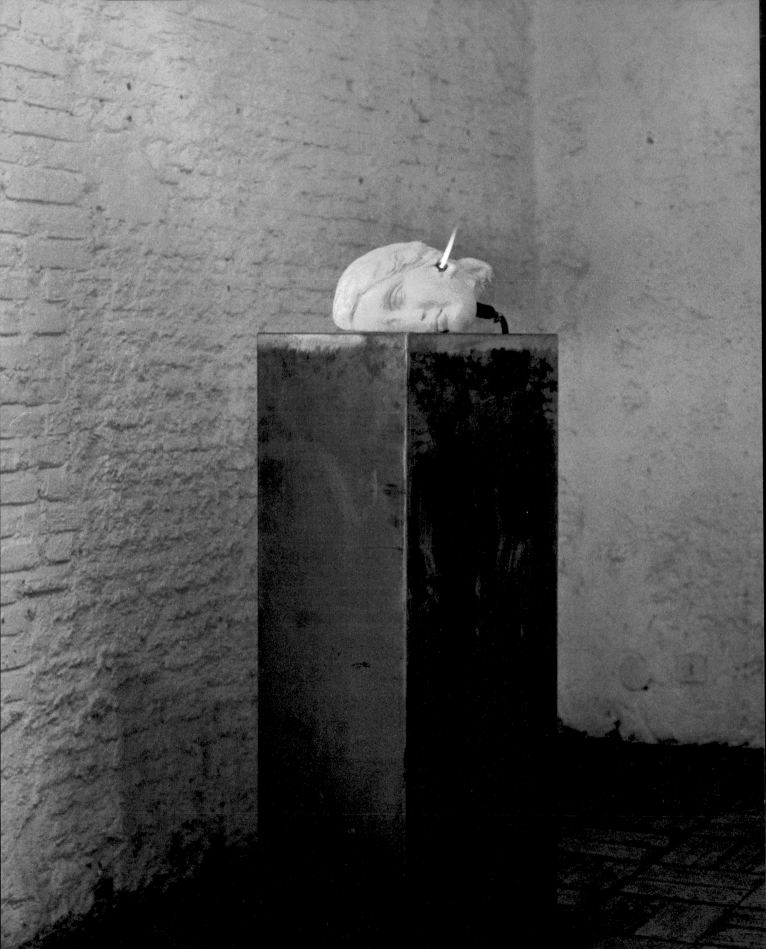

Untitled (1973) is followed not long afterwards by a spectacle of classical reincarnation. Dated two years later, *Untitled* (1975) embodies a fragmentary plaster head of Greek provenance, enlivened by a burning jet of gas that protrudes outrageously from its smooth white cheek (illus. 114).[36] The guttering, hissing flame shoots hungrily out of the fragile carapace, by the same token underlining, and enhancing with a new emotional pitch, the pathos of the fallen fragment.

It seems, then, as though there is no difficulty in relating different aspects of Kounellis's production to the various current interpretations of the significance of installation art, wide-ranging and disparate as they may be. But the different categories through which the phenomenon of installation art can be understood do not finally resolve the issue that lies at the centre of Kounellis's project. This is the possibility of a dialogue with the past, and a long-term involvement with the historical antecedents of the contemporary scene. Here we may come back again to the problem as it was posed by Alex Potts. The status of contemporary installation art is, of course, not the issue in his negative epiphany at the Hirshhorn Museum. He asks: Why all this stuff? And an important part of the answer is supplied straightaway. Much of the significant sculptural work of the early Modernist period was not, in its own time, intended to be sculpture. 'Such objects were mostly conceived as informal experiments in switching between painted form and sculpted object'. It was precisely this sustained experimental attitude, in Potts's view, that prevented such major works as Picasso's *Guitar* construction of 1912 (Museum of Modern Art, New York) from descending to the condition of obtuse materiality. The climate of informal experimentation 'enabled [these artists] to be true to the deconstructive and dematerialising imperatives of a modernist aesthetic, and to avoid having to engage with the expectations raised by full-blown sculpture'.[37]

For my purposes, this is indeed the relevant argument, but it is being seen from the wrong angle. If the tradition is indeed centred on 'full-blown sculpture', then the 'switching between painted form and sculpted object' must indeed appear as a form of experimentation, or perhaps equivocation, that compromises the tradition. But if the discrimination between painting and sculpture is not taken for granted – if the Cubist 'experiment' can be seen to be rooted in an alternative tradition where processes of interchange between two and three dimensions are commonplace – then there is much less of an incentive to stake everything upon

114 *Untitled*, 1975. Fragment of a plastercast head with a propane gas torch on a steel pedestal; fragment 28 x 28 x 12 cm, pedestal 125 x 40 x 40 cm. Collection of Peppino Di Bernardo, Naples. Exhibition at Studio d'Arte Contemporanea, Rome, 1975

the ultimately successful reemergence of 'full-blown sculpture' from the ferment of early Modernism.

For the understanding of Kounellis's work, and indeed of *Arte Povera* in general, this issue is not just an academic quibble. Potts's closely argued account comes up to date in the 1950s and 1960s, a period which he recognizes as having been fertile in generating new initiatives relating to sculptural practice, 'whether Pop, Conceptualist, Minimalist, Arte Povera, Neo-Dada, or performance orientated'.[38] He understandably chooses to focus on Minimalism, almost to the exclusion of these other currents, because the Minimalist artists continued to play an exemplary role in sustaining a discourse about the possibilities of sculptural form. 'Minimalist objects may not necessarily have produced more resonant or complex bodily responses than other forms of three-dimensional art, but they did more to provoke critical opinion into taking these levels of response into account.'[39] It could appear special pleading, from my own point of view, to justify the importance of Minimalism on the grounds that it has had more sustained critical attention (particularly among American artists and critics), than any of the other, more geographically scattered movements of the post-war period. But one cannot deny Potts's point that this critical commentary successfully directed attention to the 'sense of the work as physical presence', as much as to 'any form or image it presented'. European (including Italian) styles of art criticism have only rarely risen to the level of analytic rigour that distinguished the American debate.

From all that has been said here, it will be clear that Kounellis never considered taking the Minimalist route. In the quotation that began this chapter, he used the example of Bernini's elephant bearing an obelisk as a prime case of the European artist's strategy of 'accumulation'. Allowing for a very few exceptions, among whom Twombly (certainly) and Rauschenberg (possibly) might figure, he has surely here exposed a significant divergence in the basic attitudes of American and European artists. But we might ask again what it is, precisely, that the European artist 'accumulates'? Obviously it is not a question of primary geometrical structures, but of complex layers of signification whose physical structures do not deny their hybridity. Arguably it is also a matter of resisting the tendency to adopt an essentialist vocabulary When Kounellis goes on to assert that 'the square totally eliminates the possibility of accumulation', he provokes an immediate retort from the American critic Robin White: 'Perhaps. But it

also reduces these same complex forms to the essential.'[40] The dialogue proceeds no further from this crucial debating point.

Not much further attention has been given by Kounellis, since that interview was published in 1979, to revisiting the opposing cases presented in such an argument. Hybridity versus essentialism, accumulation versus repetition – these are hardly principles that might be reconciled through a simple exchange of views. Nor have there been many attempts by art critics to pursue a debate about difference which could all too easily end up in strident nationalism. With a few outstanding exceptions, critical comment on Kounellis's work has largely come from those who observe the distinctive ideology of Italian art criticism, and opening up the achievements of *Arte Povera* to a worldwide audience has never been foremost on the agenda. Perhaps understandably, the major emphasis in recent retrospective presentations of *Arte Povera*, now that nearly half a century has elapsed, has been on the investigation of the socio-cultural origins of the movement, within the specific context of Italian post-war history. This is a very different agenda from undertaking a major reappraisal of the place of *Arte Povera* in the global history of contemporary art.

At the same time, museums and galleries of contemporary art continue to produce their own broadly chronological displays, where a kind of attenuated historicism governs the juxtapositions. The lion lies meekly down in the company of the lamb, and fundamental issues of conceptual conflict are conveniently set aside. This is quite understandable, and perhaps no other possibility exists at present. To take one example, the splendid new display in the purpose-built underground space at the Kunsthalle, Hamburg, places Minimalism along one side of the long, rectangular room, and *Arte Povera* on the other, under the general rubric of 'Material in Art' (*Der Material in der Kunst*). Works by Kounellis (already mentioned here) predominate on the *Arte Povera* side, while the opposite wall features two of Robert Morris's large felt pieces, *Untitled* (1967) and *Untitled* (1978). A large part of the central floor space is allotted to Carl André's *The Voids Closed by the Square of Three Four and Five* (1967).

The chosen emphasis on 'materiality' does, of course, have a lot to be said for it. No one can fail to see that Morris's works do indeed foreground their material – the tangled loops of thick felt that are secured by nails to the wall surface but spill out chaotically on to the gallery floor. On another

level, however, the aesthetic strategy of these works is to advertise their origin in a single, presumably rectangular sheet of material, to which the ebullient chaos on a phenomenological level appears to be at least conceivably traceable. Felt is indeed an excellent material through which to communicate this arrested condition of having been permitted to follow the forces of gravity – but not completely so. The heavy folds, staid enough to guarantee virtual immobility, suggest a possible return to an origin that (we sense) might also have produced another, yet not dissimilar configuration. For Kounellis, however, the structure that informs the work is a wholly different one. There is no particular sense of a unified matrix dynamically related to its parts. The pieces of charcoal on their trolley, and the parallel metal ledges that support piles of used wood and indicate traces of candle flame, are conceived expansively, with a view to occupying the space, rather than as intrinsic parables of a process of integration and disintegration.

This might indeed be perceived as a structural weakness. But it has one special dividend. Kounellis's works, originally conceived for particular spaces (as has been often demonstrated here) and invariably retaining fugitive traces of such a primary installation, vividly enhance their part of the room and seem to make it their own. They materialize, as it were, in the form of gifts to the observer, rather than as autonomous collections of units reenacting the history of their generation. André's floor piece of lead squares offers itself to be walked upon by the visitor, while Kounellis's traces of candle flame are so delicate as to require a warning that they should not be touched. Yet it is the former, perhaps paradoxically, that is apt to come across as slightly forbidding. This is not to deny the importance, for his own development and for that of so many subsequent artists, of André's inspired recognition of the horizontal dimension of the gallery floor. The work in this instance, however, has an additional message. Its square lead units reenact the Pythagorean proof learned by every school-child: that, in a right-angled triangle, the square on the hypotenuse is equal to the sum of the squares subtended by the two remaining sides. Repeating its own axiom to itself, it pitches geometrical self-reference against the anecdotal indeterminacy of those ungainly driftwood fragments that Kounellis has piled up beside the sooty deposits of candle flame.

There is surely a case still to be made for the importance and centrality of *Arte Povera*, and one which has hardly begun to be heard. This case

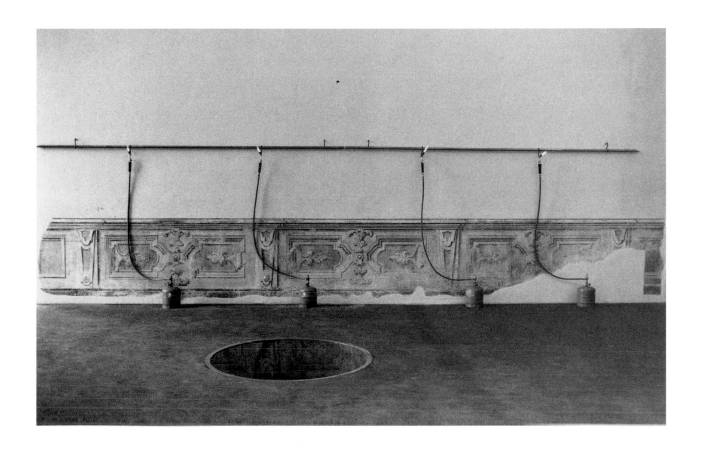

115 *Untitled*, 1969/85. Burning flames
hanging by hooks from metal tubes,
propane gas bottles on floor. Exhibition
at Castello di Rivoli, Turin, 1985

might take its starting point in the various kinds of alternative reading of
European art since the Renaissance that I have been using in this chapter.
It might take as its narrative thread not the evolution of painting and
sculpture as separate media, but the original imbalance in theoretical
weight to which I have referred, and its consequences for the ambition of
those working predominantly in two dimensions as well as for those using
three. It might pay attention to the mathematical aspects of perspective
theory, and to the remote but sustainable link between the formulation
of painting as a *cosa mentale* and the conceptualist turn in modern and
contemporary art. But it would also have to take account of the tradition
of giving attention to effects of weight and balance, to ponderation in all its
forms. Instead of conceiving the ideal visual expression of contemporary
art as the grand retrospective exhibition in a modern museum, it would
take time off to examine many of the impure locations – spaces and places
loaded with history – within which the *Arte Povera* artists have effected
some of their most memorable interventions. The Castello di Rivoli near
Turin, a late Baroque palace in which Kounellis and his fellow artists have
been encouraged to profile their work against the vestiges of a delicate
eighteenth-century decorative scheme, would be a prime case in point

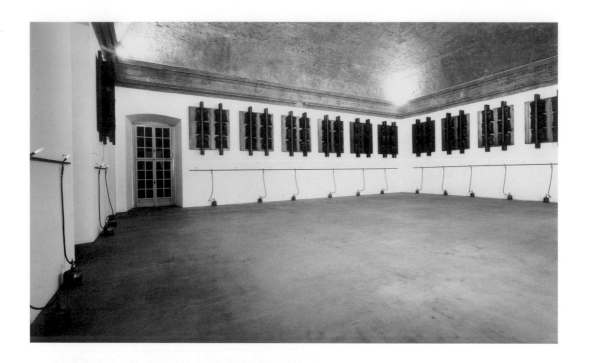

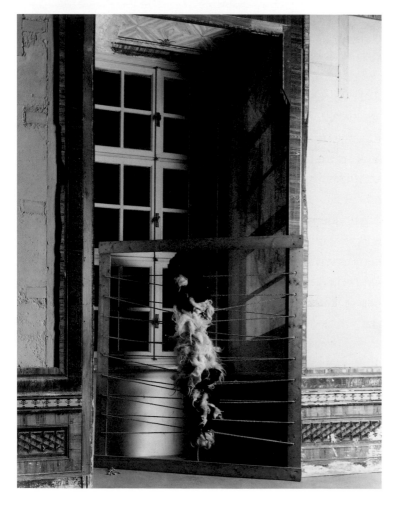

116 *Untitled*, 1969/88. Burning flames hanging by means of hooks from metal tubes, propane gas bottles on the floor, 178 x 3,780 cm. / *Untitled*, 1988. Sixteen iron panels, sacks of coal held in place by iron beams, 200 x 190 cm, each panel. Exhibition at Castello di Rivoli, Turin, 1988–9

117 *Untitled*, 1968. Wooden structure; ropes holding wool in place, 250 x 200 cm. Exhibition at Castello di Rivoli, Turin, 1988–9

(*Untitled*, 1969/85). Here the works which have previously been shown in a more neutral context acquire an unexpected and remarkable reinforcement (illus. 115–17).

Yet the countervailing claims of Minimalism and *Arte Povera* still need be seen against the historical and theoretical background that has emerged in recent discussions of contemporary art. As Potts recognizes, one of the most significant debates about the status of Minimalism began in the 1960s, when Michael Fried published his essay on 'Art and Objecthood'. This was, on one level, a response to the implicit claim of the new American sculptors that Modernist painting had already reached its furthest point of development, and that there was no alternative to the cultivation of the three-dimensional object. As Potts has reminded us, even Clement Greenberg appeared to take this view in his essay on 'The New Laocoon' published in 1949.[41] But Fried for his part lost no time in attacking the new minimalist practices as they were taking shape, on the grounds that such works substituted 'theatre' for art. The viewer was being invited to take stock of an array of objects that blatantly controverted the principle of aesthetic distance, in so far as they asserted their own literal and physical presence in space.

Here Potts is right to suggest that Fried's arguments about theatre being inimical to art involve a further discrimination between good and bad theatre, or theatre and mere 'theatricality'. This implicit distinction derives from Stanley Cavell's contention that drama works compellingly 'when we feel ourselves to be in immediate contact with the scene being enacted before us and at the same time situated physically in a sphere apart'.[42] In other words, the argument is not about the absolute dissociation of aesthetic experience and physical reality, but about the appropriate balance between the 'literal' and the illusory. Potts further identifies it in terms of 'a pervasive modernist anxiety that the autonomy or integrity of the work of art will be compromised, along with the viewer's critical autonomy, if the work impinges too directly at a physical level on his or her awareness'.[43]

In the recent edition of his critical writings, including 'Art and Objecthood', Fried has himself commented on the implications of his original, polemical distinction between art and theatre. He explained that this was an antithesis that required always to be understood in the light of a specific historical context, rather than as a factor recurring in an identical fashion throughout the history of Western art. His own extensive writings on the

Western tradition, from his study of French eighteenth-century painting (entitled *Absorption and Theatricality*) onwards, have of course given substance to this point. Indeed, 'art' and 'theatricality' often appear in these intricate and sustained analyses less as warring antagonists than as the systole and diastole powering the dynamic development of Western art from the Renaissance onwards. 'Theatre is now the enemy of art' – the phrase that was held to epitomize the polemical essay of 1967 – should thus be understood as implying a particular emphasis on the word 'now'. It could also be argued that 'here and now' would be a more appropriate specification for an essay that was essentially concerned with the art being produced at the time in New York.

In the light of this clarification, it makes sense to look again at the claim of *Arte Povera*, and Kounellis in particular, to have contributed to the revision of modernist practice, in a way that diverges illuminatingly from the strategies of the minimalists. The claim would be, essentially, that these Italian artists well understood the difference between art and theatre, but that they also appreciated the ways in which 'theatricality' could function as a dimension intrinsic to the structure of the art work, enabling their practice to integrate new elements within a progressively emerging and dynamic synthesis. As was seen in the case of the early works by Kounellis, the canvases incorporating musical notes do not claim to be music, any more than his performance pieces (even those involving an instrumentalist) are musical performances. In every case, the important aspect is the creative interfusion of one language in the sphere of another – the note sequence perceived in plastic terms but still apprehensible as a tune, or the fragment from Verdi's *Nabucco* that is played in an exhibition context, so that the piano remains as a mute token of the musical event.

This point is no less relevant in view of the fact that Kounellis has himself frequently worked on stage designs over the past twenty-five years. Yet, as he clearly explained in an early interview with Bruno Corà, this does not in any way imply that he sees no difference between his stage designs and his art. He explains:

> I have an idea of the theatre, I have an idea of theatrical space. I recognise, I see, I feel its problematics and its joys, which are fascinating. I am aware of it and I have always wanted to contribute to the inner theatre through my work. I would refuse categorically to make an adaptation of my work on the level of the theatre. When I am in the

theatre, I am a man of the theatre who has the experience of working with form and represents it, carries it with him in a certain manner, but I also recognise the specificity of theatrical practice. That doesn't mean that I have this idea and I try to adapt it to the theatre while still recognising its problems, that doesn't mean that I am a scenographer.[44]

What could seem to be no more than a casuistical disavowal of scenography is, in the light of the present discussion, entirely understandable. Kounellis's work for the stage is essentially different from the 'inner theatre' that he tries to cultivate in his art: that is to say, his stage designs have little to do with the creative process that fosters the illusion of dramatic action without having to incur the ambiguities inherent in theatrical performance. This is not merely a personal idiosyncrasy that is being vindicated, since (in Kounellis's view) history shows many examples of dramatic power being accumulated outside the conventional circumstances of dramatic performance. In his own opinion, Kounellis goes on to suggest, Piranesi's stage designs prove him to be the greatest dramatist in eighteenth-century Rome, and so superior to any playwright.

A similar point was emphasized in the 1992 interview, when Germano Celant began his questions precisely with the suggestion that Kounellis was aiming for a 'theatrical spectacularity' (*spettacolarità teatrale*). Again Kounellis insisted on stressing the difference between the narrative time of theatre and the 'unitary vision' of theatricality, for which Caravaggio provided a prime example in the history of the plastic arts.[45] The fact that Michael Fried's pursuit of the issue of 'absorption and theatricality' has led him back to investigate this nexus of aesthetic and formal effects in the work of Caravaggio is surely not irrelevant here. What Fried has consistently repudiated is the 'literalism' implicit in the minimalist position. This would amount, if carried to extremes, to the postulate that contemporary art has no history. All the evidence shows that Kounellis is also entirely aware that the dimension of 'theatricality' is profoundly rooted in the historical development of Western art.

Indeed, even in works that appear closest to performance, Kounellis and other *Arte Povera* artists invariably take care to incorporate a self-negating element that absolves them from the accusation of literalism. Giuseppe Penone's memorable image, *To Turn One's Eyes Inside Out* (1970), shows the artist's head with his eyes covered by mirrored contact

118 *Untitled*, 1972. Photograph of the artist with his lips covered with a gold mould. Exhibition, Incontri Internazionali d'arte, Rome, 1972: representation of an image in which the artist, with his lips covered with a golden mould, is seated beside a table while a singer, accompanied by a pianist, rehearses a fragment from Bizet's *Carmen*

119 *Untitled*, 1989. Photograph of the artist holding an iron plate with a burning candle between his lips. Invitation card to the exhibition at Espai Poblenou, Barcelona, 1989–90

lenses. The fact that the lenses thus display 'an immediate picture of the world' is thus qualified by our disconcerting discovery that we cannot make eye contact with the image of the artist.[46] The important sequence of photographic works in which Kounellis himself appears in person has the same property of distancing us from the biographical subject, who is ambiguously invested with the trappings of spectacle. In *Untitled* (1972), the large close-up of a part of the artist's face excludes the eyes, and focuses attention on the lips which are covered with a golden mould (illus. 118). In the previously mentioned *Untitled* (1973), the artist takes the place of the expected ledge on the hanging iron panel, and himself supports with his mouth the burning gas jet (illus. 113). More recently, in *Untitled* (1989), it is the artist's impassive face which performs the function of the background plane, with the ledge and its burning candle secured again by his mouth (illus. 119).

All of these pieces could be envisaged partly as allegories of the very act of enunciation. The foregrounding of the fact that the artist is physically prevented from speaking (or in Penone's case, from seeing) is integral to our reception of the image as a distanced artistic statement. There is, for this reason, also a close correspondence between the record embodied in such photographs and the actual performances that have taken place over the years, in which the artist is present not as a person, but as a *persona*, literally disguised with a mask. This was the case with the mounted appearance in Rome and New York discussed previously, and also notably with *Untitled* (1973), a work incorporating a flautist's performance, with the artist masked and seated behind a laden table, which was shown successively in Rome, Berlin and Athens (1973, 1975, 1977) (illus. 75).

Such recurrences in Kounellis's career always need to be seen in the context of the long-term development of his work, in order for us to appreciate their historical dimension. This chapter has been chiefly concerned with the ways in which revisionist versions of art history help to explain important aspects of his development that might at first sight appear to be disconnected from tradition. Given that the most memorable and persistent feature of his work for over thirty years has been the use of wall-mounted iron panels as a ground for varied object presentations, we should finally look at the special historical resonance of this usage. It begins around 1969, with a series of relatively small works involving standard panels of 100 x 70 cm, among which *Untitled* (1969),

120 *Untitled*, 1973. Black-painted canvas in wood frame with eight fragments of plastercast
heads, one blindfolded, 300 x 300 cm. Collection of Museum Boymans-van Beuningen,
Rotterdam. Photographed in the artist's studio with his son, 1973

presenting an egg, has been discussed earlier. In 1973, however, Kounellis partly reconciled this strategy of presentation with his performances using classical casts as masks, when he exhibited the much larger work (300 x 300 cm), *Untitled* (1973). Here the centre was occupied by a large canvas, painted black, and surrounded by an ample wooden frame (illus. 120). Upon the frame were mounted plaster masks of classical provenance, one of them possessing a black band that covered the eyes.

This is an arresting work, without any doubt – given special piquancy in one photograph by the appearance on stage of the artist's young son. Devoid of this humanizing touch, it seems to anticipate a kind of petrification of the process of picture-making. It is as if these classical personae had a part to play, in some historical or mythological account, but any access to a possible narrative is unaccountably barred to them – and consequently also to us. In fact, it has now proved possible to identify some of these masks that Kounellis bought at the Academy in Rome: the mask on the middle right represents the Roman emperor Trajan, and the one immediately above a philosopher, perhaps Heraclitus.[47] But the others, which are seemingly women's heads, have so far proved more elusive. The black band which, in the particular case, overdetermines the lack of sightedness of the masks is identified metonymically with the blankness of the central black canvas. Here, it seems, there might be prefigured a rendering of the empty scene of Western representation, one that evokes Malevich but travels back much further in time.

The French art historian and theorist Louis Marin put forward the persuasive argument that 'black' space enters the picture as the result of a particular parting of the ways in the development of European history painting, one that is concretized by the strong animosity expressed by Poussin towards the revolutionary works of Caravaggio. Félibien reports Poussin as saying that Caravaggio 'had come into the world *to destroy painting*'.[48] Marin goes on to provide his own explanation of 'Caravaggio's Paradox' in the following way:

> The paradox is a matter of presenting a 'black' space to be looked at. If it is valid to equate space, light, and whiteness, a black space is a contradiction in terms. If the space represented in the painting's frame is a cube 'open' on one side, a window on the world and a mirror reflecting the world, then we have to say that in Caravaggio's work the mirror has darkened, the window is closed, and the cube has no open side.[49]

The further implications of this apparent impasse are interesting to follow up. Let us suppose, suggests Marin, that the space defined by the frame is 'the simple and full surface of an infinitely dense black volume'. Then it will follow that 'a "black" painting is a represented space that expels the objects the painter wanted to include, forcing them outside of the painting and beyond its surface'.[50]

Kounellis's interest in Caravaggio is well attested. His first exhibitions in Rome, at the Galleria Tartaruga, took place at the corner of the Piazza del Popolo opposite the church of Santa Maria, where the side-chapel featuring Caravaggio's *Conversion of St Paul* puts on display its noble horse and capsized, ecstatic saint. To mention Caravaggio in the context provided by Marin, however, is to do more than argue that he should be valued as a great Roman artist and a remote precursor of modern art. Marin takes this radical difference in orientation between Poussin and his great predecessor as being a crisis that goes to the very heart of the Renaissance tradition of history painting. Indeed it opens up the possibility of a mode of visual representation that will finally prove to be profoundly inimical to the methods advocated by Alberti. For those who follow Caravaggio, it will henceforth be impossible to take as read the cubic extension of the picture plane, within whose orderly perspectival space the viewer is free to 'read or view the single represented moment as a diachronic series of narrative utterances, as a story'. What has replaced this traditional fashion of reading and viewing is the representation of a single instant. 'This instant is seized in the way a snapshot captures a flash of a second. In other words, the action is immobilized and made into a statue. It is *stupefied* in a Medusa-effect.'[51]

Seen from this point of view, the female heads around *Untitled* (1973) might well be ready to reemerge from the shadows as Heads of Medusa. The 'innate narrative force' that Kounellis evoked with regard to Ophelia might indeed be petrified by the very conditions of pictorial representation itself. In all events, the obdurate resistance of Kounellis's work to conventional story-telling, and the constant extrapolation of objects in front of the picture plane, could find their origin, both at the same time, in Caravaggio's abrupt reversal of the Renaissance tradition. Perhaps we need not spend too much further time on considering whether Kounellis's work is painting or sculpture, if the aspiration to the condition of a mute statue is so deep-seated an impulse within the history of painting itself.

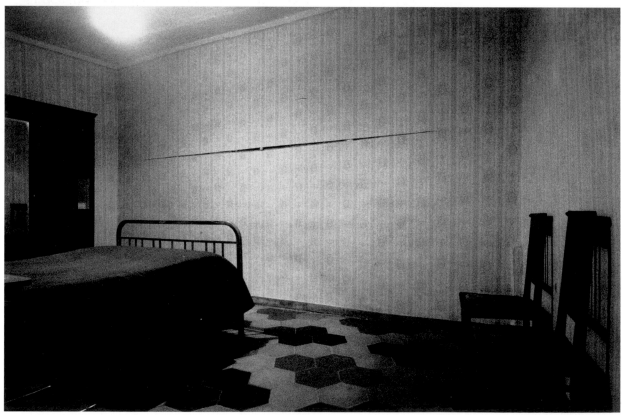

4 Conclusion: 'A Visible Language'

121 *Hotel Louisiana*, 1976. Overall view. Two adjoining rooms in the Albergo Lunetta, Rome, both with the door open and one of them with a ping-pong ball in the centre of a groove chiselled into the wall. Albergo Lunetta, Rome, 1976

In her searching critique of Kounellis's aesthetic objectives, Gloria Moure expresses her lack of faith in the socio-cultural situation within which the contemporary artist is obliged to operate. In her opinion, the 'effort of imagination' that Kounellis requires us to make has to be achieved in the context of a 'collective drifting' that implies both the 'use and abuse of the principle of representation'. Fiction, which has traditionally been 'one of our major instruments of individuality' has migrated from the 'inside' of the imagination, and turned into 'a specular "outside" which establishes the rules and either qualifies our actions and choices or simply ignores them'.[1] Against the background of what other theorists have termed the 'society of the spectacle', it is no longer possible to rely on the values of the Enlightenment, and to conceive of the artistic project as being part and parcel of a more widespread movement of socio-cultural progress. So Moure is forced to the bleak conclusion: 'Jannis Kounellis's artistic career is precisely a *peregrination without an itinerary.*'

This study has taken a rather different line of approach – and not only because it belongs in a series specifically devoted to the 'itineraries' of contemporary art. Instead of placing emphasis on the corruption of the public sign, I have tried to set Kounellis's strategies in the context of the history of representation in the West. Even if it were true that his work was implicated in the 'dialectical tangle' noted by Moure, his strategic moves would still lend themselves to being understood from the point of view of the dynamic interrelationship between the present and the past. What I have called a Mediterranean art implies the continuous attempt to reinvigorate a powerful myth of origins. Indeed Giuliano Briganti has suggested the most time-honoured of all Mediterranean precedents for the dialogue with the past that Kounellis has created in his art and in his writings. For him, it compares with the journey of Ulysses, whose protracted and eventful homecoming provided the fictional material for one of the aboriginal Western epics, as well as providing a structure for what is no doubt the definitive modern novel:

122 *Untitled*, 1976. Detail of ping-pong ball in groove. Albergo Lunetta, Rome, 1976

> I think that we should indeed interpret the voyage of Kounellis as a 'Return'. But not as a return to the obscure organic instinctive origins of life, nor as a voyage into the profound abyss of the unknown, preferred by the romantic instinct, but as a return towards the light of restored consciousness, towards the lost scale, unity and totality of man.[2]

Such an interpretation carries conviction, perhaps, if we agree that the artist's 'return' is a mythic reenactment of the very process of human communication, with its aim being not solipsism but the reaffirmation of culture and sociality. Briganti rightly observes that, if such a claim can be made at all, it has to be backed up by some evidence that the writer has also participated in the artist's voyage, and taken his cue (as it were) by commencing a parallel quest of his own. He dates his own first acquaintance with Kounellis's 'poetic message' to his viewing of the *Hotel Louisiana* installation of 1976, which was reached through a 'tortuous route' reminiscent of the mythical Labyrinth, but ended in the simple revelation of the two banal hotel rooms, intercommunicating through a chiselled groove containing a ping-pong ball (illus. 121–2).[3]

I have also chosen to present Kounellis's career partly from the point of view of my own experience. What I have tried to record (explicitly at the outset but implicitly throughout) is the sequence in time through which the majority of these objects and situations first presented themselves to me, and later became progressively assimilated into an unfolding story. This approach reveals curious temporal paradoxes, given Kounellis's method of recreating his works anew in successive exhibitions. I have not yet referred to one of the most strikingly memorable of all of Kounellis's works, *Untitled* (1969), which was exhibited for the first time (like several major pieces) at the Modern Art Agency, Naples (illus. 123). The more recent photographic images that I have of it, photographed at the Stedelijk Museum show of 1990, show a certain slight difference in the graphic inflections of the chalk-written script compared with the original 1969 photograph, as well as illustrating the obvious point that the lighted candle is always being consumed, and so never looks precisely the same. This work recording the Jacobin impulse in the French Revolution – acclaiming the message of 'Liberty or Death' and recording the names of two of the Jacobin protagonists – is therefore being remade over again for each showing, and also consumed progressively in the process of that showing. And indeed its message is also tied to the specificity of a historical moment, since when Marat and Robespierre were both alive simultaneously, the assassination of the former could not have taken place, and the Terror lay still in the future.

Briganti records in the account of his first reactions to the Albergo Lunetta: 'Naturally I thought of Fontana, but that was an obvious reference.'[4] In a similar way, we could say that relating *Untitled* (1969) to

123 *Untitled*, 1969. Chalk on steel panel with a shelf and candle, 100 x 70 cm. Two versions. Collection of Dr Speck, Cologne, and Grasslin Collection, Germany

David's painting of *Marat at his Last Breath* (1793) is both obvious and not specially necessary for the appreciation of Kounellis's work. But what is certainly germane, besides Kounellis's preoccupation with the Enlightenment that has often been noted here, is the concept of the artistic reinscription of the historical moment. David's painting, which was completed in the immediate aftermath of Marat's assassination, inevitably called for comparisons with the tradition of Christian martyrology, whether because of the fact that Marat's body was actually placed on view in a secularized religious building, or more generally because the artist's iconography recalled a deposition of the body of the crucified Christ. Kounellis's work is not in any direct sense a repetition of iconography, but, in its recreation through light and gesture, it at least mimes the immediacy of David's artistic reaction.

Another way of explaining the way in which this work conserves and renews its imaginative charge is by comparing it with the strategy of Ian Hamilton Finlay, who devoted much of his artistic production in the late 1970s and 1980s to reviving the texts and, to some extent, the iconography of the French Revolution. Finlay frequently works with pre-existing, highly recognizable images that are imbued with a strong historical message. His own transposition of David's *Marat* involves a return of the image in the form of a print, interpreted by an artist of the present day, and a new dedication that reverses the order of David's dedication and makes the artist himself the object of homage: not *À Marat, David*; but *À David, Marat*. Similarly, his *Saint-Just* (1991–4; Hamburg Kunsthalle) utilizes an imposing series of identical plaster copies by Annet Stirling of David d'Angers' bust of the revolutionary leader, in order to present the viewer with a sequence of exemplary political texts.

Yet this side of Finlay's activity, which belongs appropriately enough in a museum setting, would perhaps be less consequential if it did not have its counterpart in the garden installations that are the continuing centre of his achievement. At one level a writer who has gained widespread acceptance as an artist, Finlay is perhaps more fundamentally a poet who has resumed the poetic tradition of creating classical gardens, as did his eighteenth-century predecessors Alexander Pope and William Shenstone. His *Sacred Grove* in the park of the Kröller-Müller Museum, Otterlo, encircles the trunks of living trees with column-bases dedicated to French revolutionary heroes. It is the very context of the living garden, with its imperceptible growth and seasonal development over the years, which frames the dedication and ensures a constant renewal of its message.

For me, undoubtedly, the fact that Finlay and Kounellis are contemporaries has created a kind of mutual reinforcement between their positions, which is all the more significant in that such an insistence on the relevance of the past is relatively unusual at the present day. Yet of course the common references to the French Revolution – and indeed the fact that both have habitually treated the ship as a privileged aesthetic symbol – masks a very real divergence in their working methods. I would willingly concede that, on the level of practice, they have virtually nothing in common, while arguing that they share a sense of history almost universally lacking among their peers. Inevitably, the reference to Finlay's garden creations draws attention to the necessarily multi-faceted and often fragile

strategies of an artist like Kounellis, operating within the context of institutions whose institutional protocols massively predetermine the reception of his work. Kounellis has always made it his business to expand the possibilities of gallery display, from the modest early environmental pieces like *Hotel Louisiana* to the wholesale transformations of large buildings that begin in the 1980s. But such a commitment demands unremitting activity, and the need to reestablish the conditions of communication afresh, as each new context provides its own distinctive challenge.

That this is, however, no mere directionless repetition comes to the forefront if we bear in mind the implication of another of Kounellis's privileged symbols of tradition, which is the cathedral. It is interesting to note that the vast warehouse building of the Entrepôt Lainé, where he held his decisive Bordeaux exhibition of 1985, instantly suggests comparison with an ecclesiastical building, so that its curators customarily refer to the imposing central space bounded by arches as their 'nave' (illus. 124–7). Several of Kounellis's comments already quoted here indicate his awareness of the architectural ambiance of a historic cathedral, which features distinctive ways of integrating monumental sculpture within the surrounding space. He has also referred in passing to the hanging of a large-scale work like *Untitled* (1988), shown for the first time at the XLIII Venice Biennale, in terms of the clerestory of a Gothic church (illus. 128). Such a regular spacing of identical shining elements, placed high up on the wall, could indeed suggest the rhythmic progression and emphasis on measured verticality that the visitor experiences while walking along a cathedral nave. Equally, his various works incorporating church bells borrow some of the connotations of religious ceremony, whether they hang next door to Pistoia Cathedral or lie crushed together in the vicinity of a Gothic tower (illus. 129).

Yet it would be a mistake to take these affiliations as signs of religious belief. When presented with readings of his work that borrow specifically religious terms, Kounellis makes it clear that he is not a practising Christian. In answer to Celant, who had made a persuasive comparison between his omnipresent metal ledges and the concept of a 'sacrificial altar, on which the provisional and the fragile are "sanctified"', he is quick to underline: 'I make no reference to religion because I am an atheist, but I cite culture because it has come to me by way of religion.'[5] In fact, this hardly invalidates Celant's point, and it may be that he has put his finger on an essential difference between the effect of Kounellis's installations

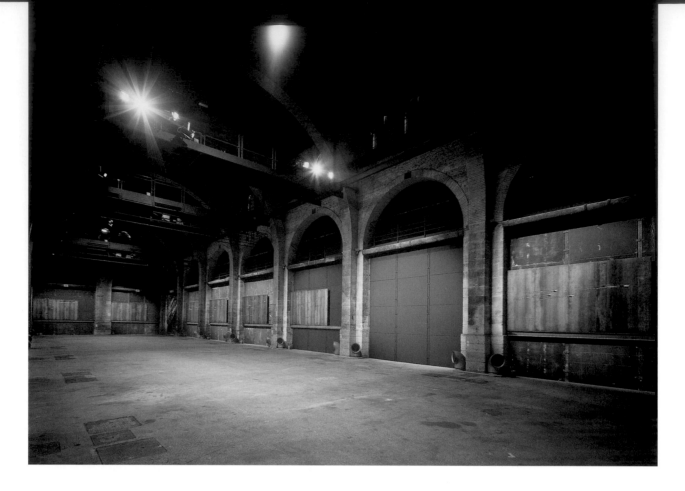

124 Exhibition at CAPC, Bordeaux, 1985

125 CAPC, Bordeaux, 1985

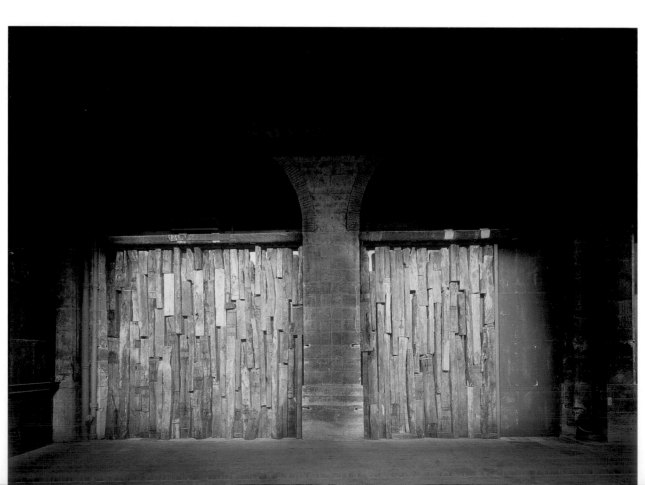

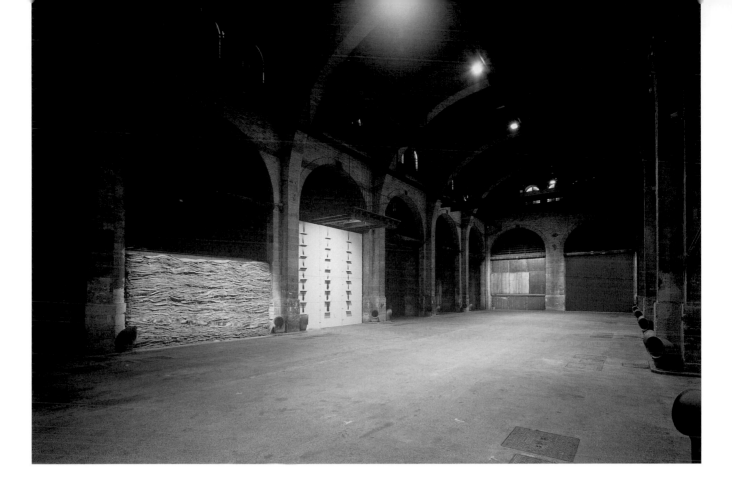

126 CAPC, Bordeaux, 1985

127 CAPC, Bordeaux, 1985

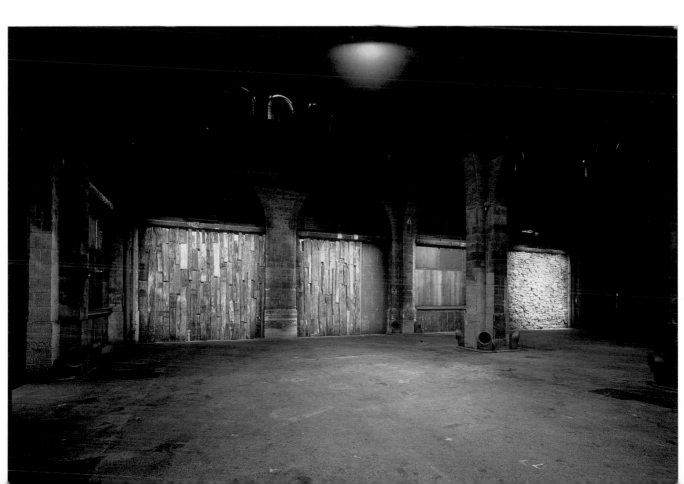

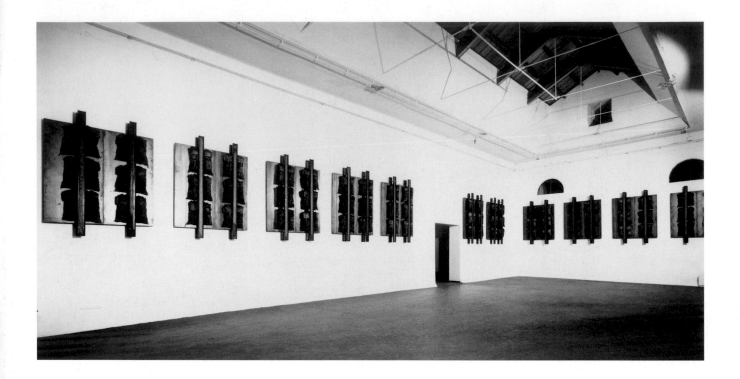

128 *Untitled*, 1988. Twenty-one elements: iron panels, sacks of coal held in place by iron beams. Exhibition at XLIII Venice Biennale, 1988

and those of the contemporary American artists discussed in the previous section. Nevertheless, the caution is worth bearing in mind in interpreting Kounellis's contribution to the Basel discussion of 1985 with Beuys and his fellow artists. It is particularly relevant since the significance attached to the Cathedral as a collective symbol plays a central role in this lively debate.

There can be no denying that the whole concluding passage of this exchange is dominated by different interpretations of this powerful image, which becomes crucial in establishing the distance between Kounellis's position and that of Beuys. Kounellis begins by putting forward the cathedral of Cologne as nothing less than the emblem of a common European culture: 'a monument like the Cologne Cathedral indicates a centralization, encompasses a culture, and points the way for future development. Without signs like this we would run the risk of becoming nomads.'[6] Beuys understandably demurs at the choice of the quite recently completed cathedral of Cologne, which he considers 'a bad sculpture' and more suited perhaps to swapping roles with the main railway station of the city which lies close at hand. But initially he is quite willing to accept the cathedral as an inspiring symbol, so long as it is the genuinely medieval achievement of Chartres that is selected. The symbol must, however, be brought up to date and made compatible with the realities of the present day. 'The old cathedrals were built in a world that was still round, but that

129 *Untitled*, 2001. Part of an installation at Kunst Station Sankt Peter, Cologne, 2001

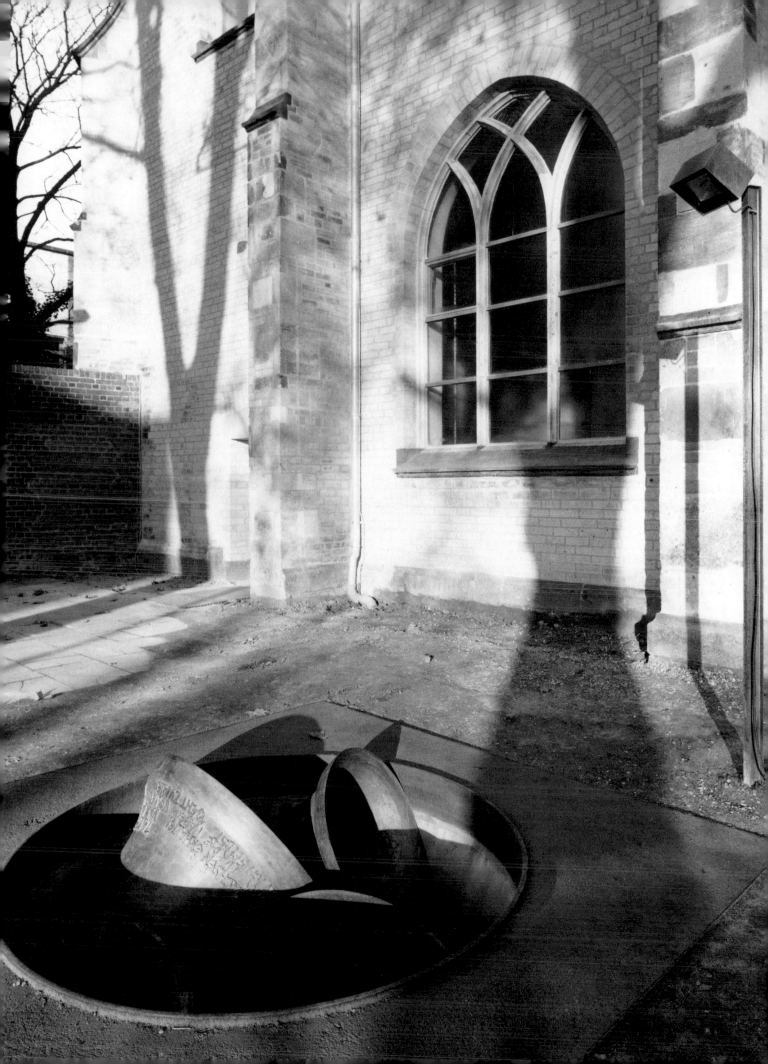

in the mean time has been constricted by materialism . . . Now we have to carry out a synthesis with all our powers, and build a new cathedral.'

Yet Beuys will not let slip the comment on the dangers of nomadism that Kounellis has made in passing. He spends the next stage of the discussion calling attention to peoples like the Basques, 'really the abandoned vestige of some nomadic people', and pointing out their plight in the new European Economic Community. His assertion that such local desires for independence throughout Europe are 'very positive' is the cue for Kounellis to return unrepentantly to Cologne: 'Yes, but it's also very positive to speak about the Cologne Cathedral. Not only those who wish to separate are positive.'[7] Beuys does not yet relinquish the image of the Cathedral, but he insists on pepping it up with the unlikely ideology of Heraclitus' 'permanent revolution' – something that he regards as being exemplified in the forces of contemporary terrorism. In reply, Kounellis once again reaffirms his position: 'But in order to build a cathedral you need a method and an understanding of the past. Otherwise you can't construct.'[8]

In this quite heated exchange of opinions, Kounellis is pressed to go further in defining his outlook as an artist than in his discussion with critics. It is here, for example, that he makes his forthright attack on Andy Warhol and American culture. It is here that he asserts – by way of contrast to Beuys's blithe endorsement of the 'ruminations' of art historians – that 'there aren't any art historians. History is of use only to artists and poets.'

We can gloss this point by stressing that many modern poets as well as artists (not to mention novelists) have been no less keen to revise and reinvigorate the symbol of the cathedral. They have done so partly because the cathedral epitomizes the collective cultural aspirations of pre-modern Europe, but also because it enshrines the hope of regaining a lost collective culture through art. This was specifically the message of Victor Hugo, who named one of his major works *Notre-Dame de Paris* and confidently exclaimed à propos of that colossal structure of imaginative prose: 'The book will kill the building' ('Le livre tuera l'édifice'). It was also the message of Balzac, who is said to have compared his life's work in the many novels of the *Comédie humaine* to the cathedral of Bourges. In terms of the critical approach of Julia Kristeva, it was also the central quest pursued unremittingly by Marcel Proust, whose message could be summed up in these basic terms: 'If you will only be so good as to open up your memories of felt time, *there* will rise the new cathedral.'[9]

Yet the very fact that Proust so explicitly devotes *À la Recherche du temps perdu* to the quest for a modern form of sociality centred in the text, is an indication of how differently Kounellis's artistic project has been conceived. As he states, almost at the end of his discussion with Beuys, Kiefer and Cucchi: 'The construction of the cathedral is the construction of a visible language.'[10] Here the emphasis lies, of course, on the word 'visible'. Where Hugo and Balzac felt that the mission of creating cultural community had migrated from the ritual function of worship to the reading of the mass circulation novel – where Proust believed moreover that the power of individual reminiscence was the only ground on which to build the collective structures of art – Kounellis aims to reinvest the visual arts with this all-important function. He is well aware that this can only be securely achieved by establishing a medium of visual communication that is held in common by both artist and public – that is, 'a visible language'.

Among Kounellis's most penetrating critics, Rudi Fuchs has shown himself specially aware of the implications of this goal. In his essay which takes for its subject the 'grey steel flower' (*Untitled*, 1967), Fuchs comments (as already mentioned) on the primary importance for Kounellis of the art of Masaccio, and his concomitant desire to achieve an 'objective image' (illus. 130). This goes hand in hand, in Fuchs's view, 'with the conviction that the art-work must establish elements of a formal language that are valid also beyond the personal and accidental interpretation of the historical situation.'[11] The argument then leads to a consideration of Kounellis's 'grey steel flower' in the context of Malevich's *Black Square*, and Mondrian's diamond-shaped paintings, 'generic forms' (according to Fuchs) which 'indicate or evoke the possibility of a formal language which is not entirely individual and which thus could be synthetic'. The quest here is for a definitive form which will affirm itself over and above the artist's 'speculative variations'. 'After being so formulated . . . , the form is final and iconic – like a word in a lexicon.'[12]

This is certainly a helpful way of evaluating Kounellis's search for an 'objective image'. Fuchs is careful to imply that the new language will not be conceived in the same fashion as the ambitious projects of the first generation of modernist artists. It will not, as Kandinsky confidently projected, be a matter of ensuring communication by basing the artist's vocabulary in the psychological effects of the various colours and geometrical shapes. Nor will it simply be a matter of establishing a lexicon of basic forms, as with the Neoplasticism of the De Stijl artists, who restricted their

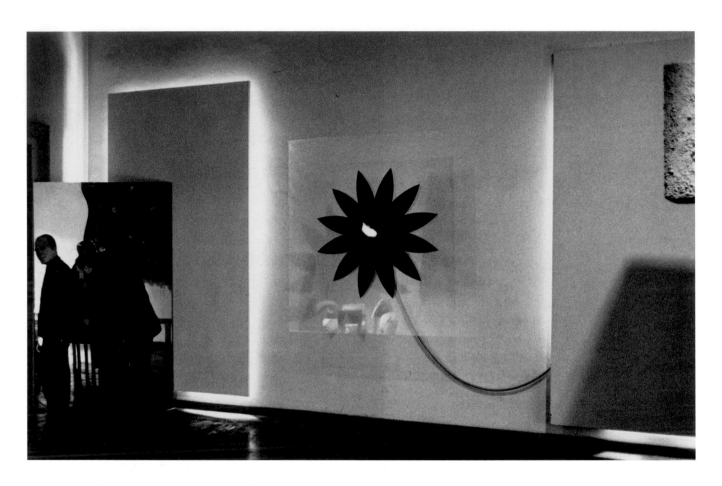

130 *Untitled*, 1967 (see also illus. 85)

artistic productions to right-angled lines and primary colours. These two examples that Fuchs cites are, however, by no means irrelevant to Kounellis's broader project of a 'visible language'. Both the *Black Square* series of Malevich and the sequence of diamond paintings by Mondrian began by being specific works, and if they also developed in the fullness of time into 'generic forms', this does not obviate the point that they were rooted in an individual act of creation. Bearing this in mind, we might well follow Fuchs in proposing particular works by Kounellis, such as the 'grey steel flower', for a similar status. This would imply a wager that they were destined at some point to become 'iconic', in the same way as the examples already mentioned.

Yet Kounellis surely implies more than this when he speaks of 'the construction of a visible language'. He is envisaging an 'iconic' status not just for certain works, but for the whole ensemble of syntactical connections that he puts on display, time after time, in the large exhibitions that repeatedly sum up the entire course of his work (at the time of writing, the most recent to have taken place are the Musée des Beaux-Arts in Ghent, April 2002, and at the National Gallery of Art, Rome, in the summer of 2002). This is his goal despite the fact that the circumstances under which such exhibitions are held make it difficult to evaluate their success as collective experiences. Patterns of visiting are inevitably distributed out over several months, and this makes it difficult for the casual visitor to pick up the social dynamic that is part of the artist's plan. Returning to the analogy of the cathedral, one has to agree that, if the sociality of the cathedral is epitomized by the congregation's participation in a common liturgy, the museum may be condemned to be a cathedral in want of a ceremony.

Here it is worth turning aside, briefly, to Kounellis's recent designs for the stage. This is not in the spirit of disputing his clear assurance that he does not see himself as a scenographer, but rather a way of showing how the context of a full theatrical performance accentuates the effect of the visual syntax that permeates all his work. At the performance of Wagner's *Lohengrin* which I attended on 26 February 2002, it was possible to see a whole series of Kounellis's most memorable motifs brought to bear in costumes, scenography and the many different aspects of stagecraft . This was indeed, for a follower of Kounellis's work, like being presented with a retrospective anthology on stage. The costumes of the performers stood out in rigid forms, recreating the cope-like, conical effect of Kounellis's draped canvases in the studio photograph of 1960. The back of the stage

was closed by a construction of iron panels, directly comparable to those in many of his large-scale works (illus. 131), and this background was also used to direct attention to superimposed motifs, like the bundle of shining oars that is gently lowered into place at the end of the third act when Lohengrin prepares to take off in his magical boat, led by a swan.

Even the mechanics of stage lighting and scene-changing in such a production could here be viewed as a demonstration, in the real time of performance, of some of the basic constituents of Kounellis's lexicon. Heavy cloths initially covered the counterpoised iron structures that occupied the front of the stage in the third act, until these were hauled up on high with a slow and ponderous movement. Kounellis once remarked in an interview that he saw himself as a sort of 'alchemist'.[13] Nothing more suggestive of alchemy could be imagined than the very gradual blossoming of the grey iron screens to an intense golden hue under the spotlights. This heightened sense of materiality was finally reaffirmed in the very last image of the opera, before the curtain fell: the child revealed as the new Duke of Brabant was momentarily acclaimed in a shower of golden dust.

An inevitable point of reference for this concluding image would be Kounellis's *Civil Tragedy*, with its background of gold leaf. Yet it is not a question of Kounellis repeating, or indeed revising this work, which has already existed in two main versions, being shown at Chicago in 1986 in a very different context from the original emplacement at Naples in 1975. What stays constant through all these different examples is the sense of a 'visible language' being constructed – one that is however integrally linked to the successive opportunities of exhibition and performance. With the help of this particular example, we can also appreciate how Kounellis seeks to remain true, not only to the cultural legacy of religious art but also to the fashion in which it has been continuously refined, in plastic terms, through the achievement of artists close in period and in sensibility to himself.

Among the painters celebrated in Kounellis's list of 1982, and coming straight after Caravaggio in order, is Vincent van Gogh. No better example could be imagined for a figure who was profoundly immersed in the culture of traditional religious practice, and managed to work through the psychological entanglements of his inheritance by means of the transformational energies of his art. In the catalogue of the recent exhibition, *Van Gogh and Gauguin* (Van Gogh Museum, Amsterdam, 2002), it is noted that, for an early 'manifesto' still life, Van Gogh used the image of

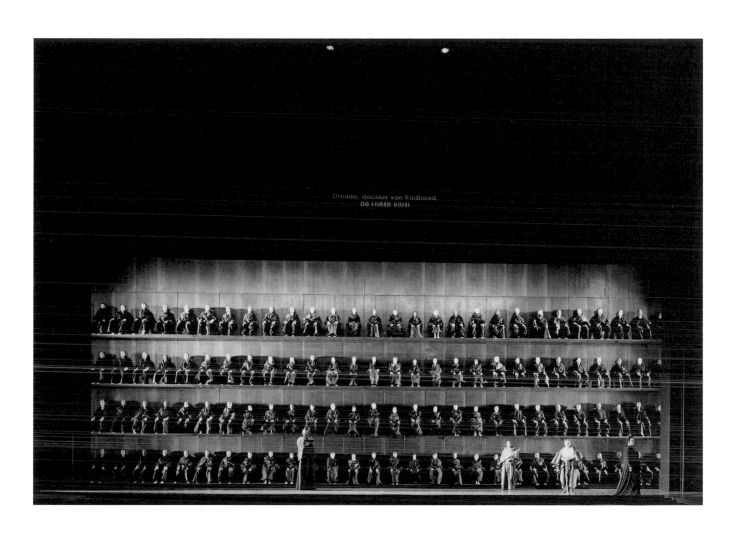

131 Scene from Wagner's *Lohengrin*, directed by Pierre Audi with stage design by Jannis Kounellis, De Nederlandse Opera, Amsterdam, 2002

the candle to signify his wish to distance himself from the evangelical religion so powerfully represented by his pastor father: 'the candle directly and oppositionally associated with his father is extinguished, alluding to the reverend's recent death and suggesting the inability of his religion to shed light on the experience of modern life'.[14] Three years later, however, in the painting of *Gauguin's Chair* that he completes in the Arles studio, Van Gogh features a lighted candle. This is positioned on his colleague's empty chair, where it competes with the flare of gaslight from the far side of the room. The catalogue entry further reads: 'Here the lit candle's symbolic significance as a source of illumination – art providing what his father's church could not – is underscored by its functional irrelevance in a room bathed in gaslight.'

It would be quite easy to quibble over this ingenious interpretation, and indeed to develop it in a different direction. The candle is certainly outshone by the gas light, but what outshines both (in the sense that it renders both sources of brilliant illumination simultaneously apprehensible to the viewer) is the luminous effulgence of the colours derived from Van Gogh's palette. The candle may now signify art as opposed to religion. But the chair functions both as his companion's seating place, and (so the catalogue reminds us) thereby as a reference to Luke Fildes's well-known print, *The Empty Chair*, a work commemorating the death of Dickens, which Van Gogh cherished because of his high regard for the English novelist. One type of traditional affiliation has thus been dismissed in the person of Van Gogh's father, but another is being welcomed in the guise of the moral authority achieved through contemporary literary creation.[15]

Civil Tragedy is just one of the many works by Kounellis which make use of the contrast between two sources of illumination. In the version of 1975, however, the effect of the presence of the oil lamp next to the glowing golden wall is particularly memorable (illus. 90). Kounellis has acknowledged that the oil lamp, borne aloft, is a feature that irresistibly calls to mind the striking iconography of Picasso's *Guernica*. But this does not stop the intersection of the different light sources from suggesting, in each of the new contexts, an internal metaphor for the power of art. 'The Mirror and the Lamp' is the name given to a celebrated study of Romantic poetics, which lays stress on the Lamp as an emblem of the power of the imagination, over against the classical doctrine of *mimesis*. But, as Louis Marin reminded us in a posthumously published essay, the notion of different qualities of light as having different aesthetic properties goes back much

132 *Untitled*, 1990. Windows partially blocked by iron sheets, each with four tons of anthracite installed in the space behind. Exhibition at CAPC Bordeaux, 1990

133 CAPC Bordeaux, 1990

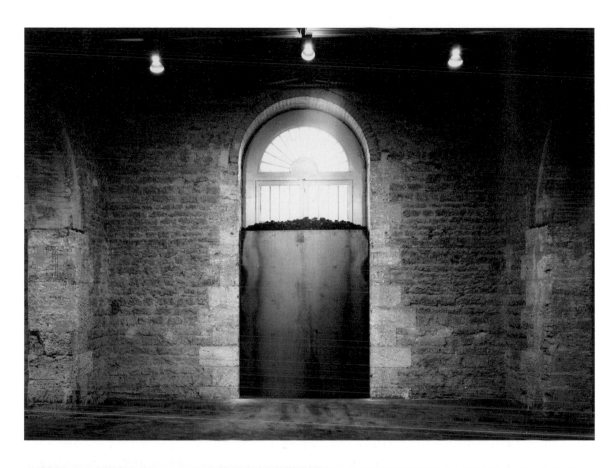

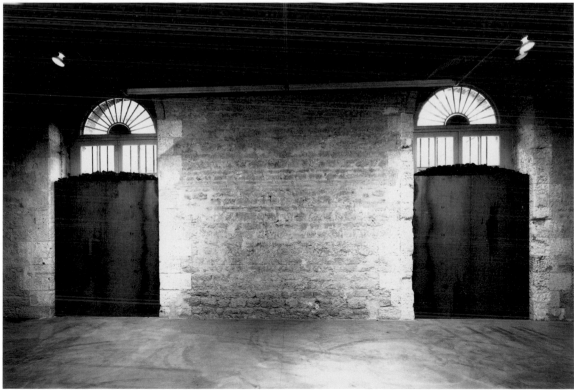

134 CAPC Bordeaux, 1985. Arch
partially walled in with fragments of
wood suspended diagonally: in the
background, an iron structure in the
form of a flower with a burning
propane flame

further. The aesthetic system of Abbot Suger of St Denis, the pioneer
builder of the first Gothic great church, was grounded in the assumption
that there were two forms of light, *lux* and *lumen* – what one might call
lighting and *illumination*. The one was the natural light of day, and the
other the means of the divine illumination of the intellect. Both however
were conjoined in the experience of the soaring architecture, coloured
glass and precious fittings of the Gothic interior, which functioned
precisely as a vehicle for transmuting the vision of *lux* into the power of
lumen (cf. illus. 132–4).[16]

It would be overstepping the mark to assert that Kounellis has
definitively established a 'visible language' of this kind. What counts at
present, however, is the single-mindedness with which he has pursued
his itinerary as a visual artist. From time to time, and through the precisely
tuned adjustment of material to place, the alchemy is triumphantly
achieved.

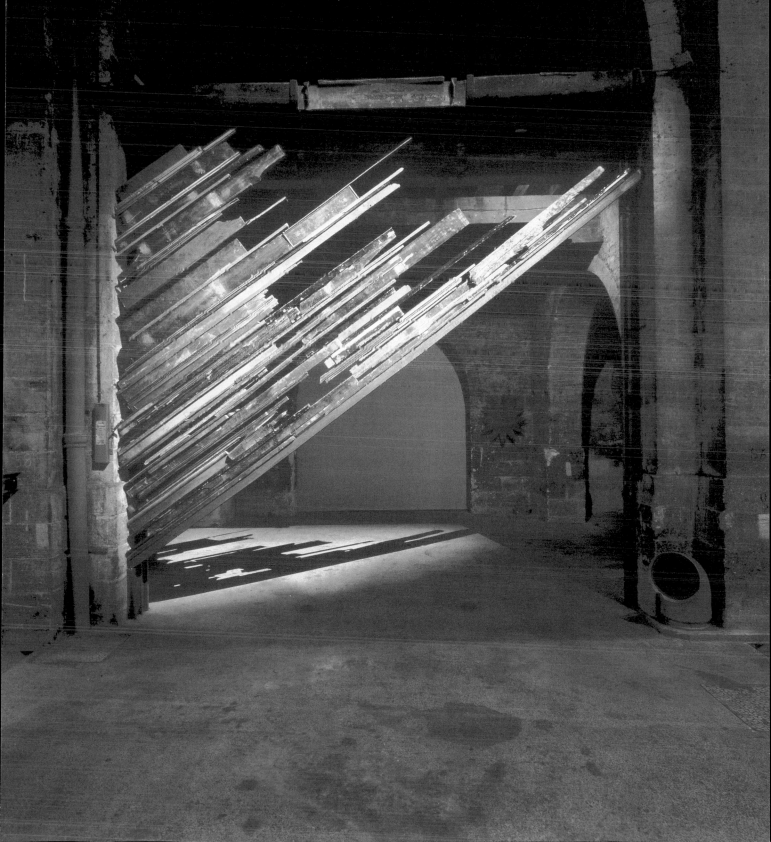

References

1 MEMORY, SPACE AND PLACE

1 For the distinctive opportunities and problems arising in this period, see my study *Parallel Lines: Printmakers, Painters and Photographers in Nineteenth-Century France* (London and New Haven, 2001).

2 Another example would be the remarkable recreation of a major exhibition of Rodin's works in the Galerie du Luxembourg in 2001. This effectively displaced the material hierarchy into which his works have been subsequently assimilated, giving pride of place to the plasters, which are now much less prized by comparison with carvings and castings.

3 See further discussion on pp. 158–79.

4 For some discussion, and illustration, of these works, see Bann, *Parallel Lines*, pp. 88, 102–3.

5 See Michaela Unterdörfer's thesis, *Die Rezeption der Antike in der Postmoderne* (Univ. Hamburg, 1998), p. 133.

6 *Ibid*. The study refers to Giulio Paolini, Claudio Parmiggiani, Vettor Pisani and Michelangelo Pistoletto, as well as to Kounellis. Of course this current was not confined to Italy. Ian Hamilton Finlay in Britain and Anne and Patrick Poirier in France should also be mentioned.

7 Bruno Corà, 'Burning is the image in the hour of the eclipse', *Parkett*, 6 (1985), p. 41.

8 See the photographic record of this work by Ugo Mulas in *Kounellis – Via del Mare*, exh. cat., Stedelijk Museum, Amsterdam, 24 November 1990–13 January 1991, pp. 128–9.

9 Jacqueline Burckhardt, ed., *Ein Gespräch: Joseph Beuys, Jannis Kounellis, Anselm Kiefer, Enzo Cucchi* (Zürich, 1986; republished Ostfildern, 1994), p. 162. This translation in English in *Flash Art*, 128 (May–June 1986), p.38.

10 See Robert Galitz and Brita Reimers, eds, *Aby M. Warburg ... Porträt eines Gelehrten* (Hamburg, 1995), p. 180. The *Bilderatlas* has recently been published in the complete series of Warburg's works: Aby Warburg, *Der Bilderatlas Mnemosyne*, ed. Martin Warnke (Berlin, 2000). See Tafel 55, pp. 100–1, for the montage under discussion.

11 The quote is from Warburg's journal entry of 3 April 1929, cited in Galitz and Reimers, *Aby M. Warburg*, p. 8. The phrases with which Warburg titles Tafel 55 are of course more open and suggestive in their evocation of possible connections between the images shown there: 'Plein air as substitute for Olympus', 'Borrowing Manet-Carracci', and 'Judgement of Paris with no entry'.

12 I am not, of course, claiming for a moment that the interest of Warburg's Atlas is exhausted by the particular use that I make of it in this part of the argument. For a full discussion of the implications of the loss of scale and concrete space in his montages, see Georges Didi-Huberman, *L'Image survivante* (Paris, 2002), pp. 480–81. Didi-Huberman's further comments on the significance of Warburg's legacy will be considered at a later stage in this study.

13 See Michael Fried, *Manet's Modernism, or The Face of Painting in the 1860s* (Chicago and London, 1996).

14 See Van Gogh, *Letters* ed. Ronald de Leeuw (London, 1997), p. 69.

15 See Georges Didi-Huberman, *Ninfa Moderna: Essai sur le drapé tombé* (Paris, 2002).

2 A MEDITERRANEAN ART

1 See Aphrodite Georgiou, *Die Dimension der Vergangenheit im Werk von Jannis Kounellis* (Cologne, 1998), p. 210. The passage concerning the 'trauma' is quoted from an interview with Germano Celant, published in 1983.

2 Jacqueline Burckhardt, ed., *Ein Gespräch: Joseph Beuys, Jannis Kounellis, Anselm Kiefer, Enzo Cucchi* (Ostfildern, 1994), p. 167: this translation in *Flash Art*, 128 (May–June 1986), p. 39.

3 See the bizarre account of a 'happening' held in a gallery in Athens in 1977, in Haris Livas, *Contemporary Greek Artists* (New York, 1993), pp. 90–93. 'But the artist himself

was GREEK! Yes, Greek, my friends.'

4 See Branislav Dimitrijevic's MA dissertation. 'Twentieth Century Art with the Byzantine Pictorial Tradition: Malévich, Gorky, Kounellis, Prodanovic' (U. Kent at Canterbury, 1994).

5 Gloria Moure, 'Jannis Kounellis: The Plastic Quality of the Human Condition', in G. Moure, ed., *Kounellis* (Barcelona, 1990), p. 11.

6 Burckhardt, *Ein Gespräch*, p. 14.

7 *Ibid.*, p. 148.

8 See Roland Barthes, 'L'Obvie et l'obtus (Paris, 1982), p.171.

9 See *Jannis Kounellis: Die eiserne Runde* (Hamburg Kunsthalle, 1995), pp. 9–16.

10 *Ibid.*, p. 28.

11 Giuliano Briganti, 'Kounellis', in *Kounellis: Via del Mare* (Amsterdam: Stedelijk Museum, 1990), p. 73.

12 'L'Epos contemporanea', dialogue between Germano Celant and Jannis Kounellis, in *Kounellis* (Milan: Padiglione d'arte contemporanea, 1992), p. 26.

13 *Ibid.*, pp. 25–6.

14 Kounellis's interest in typographical arrangement, which clearly ran parallel to production of the 'letter' paintings, was demonstrated in the catalogue for his exhibition at the Galleria Arco D'Alibert in 1966, where screen-printed pages featured details from early paintings, and the accompanying text involved typographical experiment on the page.

15 See his text, 'For Pascali', translated in Moure, *Kounellis*, p. 215.

16 *Jannis Kounellis: Die eiserne Runde*, pp. 12–13.

17 Quoted *ibid.*, p. 28.

18 The exhibition originated by Rudi Fuchs at the Gemeentemuseum, The Hague, under the title, *La Stanza vede*, and consists entirely of sketches of this kind.

19 Lucy Lippard, the well-known American critic and advocate of conceptual art, was a collaborator in the catalogue of this exhibition. Gillo Dorfles, the important Italian art critic, took up the question of defining the limits of the new movements in 'Arte Concettuale o Arte Povera?', *Art International*, XIII/3 (March 1969), pp. 35–8.

20 'L'Epos contemporanea', pp. 19–20.

21 Jannis Kounellis, *Odyssée Lagunaire. Écrits et entretiens 1966–1989* (Paris, 1990), p. 77.

22 *Ibid.*

23 *Ibid.*, p. 78. It is possible that the subsequent work involving the 'Port of Hamburg' (*Untitled*, 1975) relates to, or even reuses, material from this period.

24 Bruno Corà, 'Jannis Kounellis: l'Umanesimo del reale nel tempo della virtualità', in *Kounellis: Esposizione di paesaggi invernali* (Pistoia, 1993), pp. 16–17. I have changed the English translation of 'coal', which appears in catalogue entries, since the material is evidently charcoal.

25 See Michael Fried, 'Art and Objecthood', republished in Gregory Battcock, ed., *Minimal art – a critical anthology* (London, 1968), pp. 116–47.

26 Marco Meneguzzo, 'The Reality of the Real World', in *Kounellis*, exh. cat., Credito Valtellinese Galleria, 6 November 1997–4 January 1998, Milan, p. 30.

27 See *Vladimir Tatlin* catalogue (Stockholm: Moderna Museet, 1968). For Tatlin's reference to the 'materials of a modern Classicism', see the manifesto 'The Work ahead of Us', republished in the catalogue and also in Stephen Bann, ed., *The Tradition of Constructivism* (London and New York, 1974).

28 In Bann, *The Tradition of Constructivism*, pp.30–31.

29 See John Manning, *The Emblem* (London, 2002), p. 30: 'Yet even the most mundane or trivial aspect of everyday life could afford a useful moral to the curious and inquisitive eye. There was literally nothing under the sun that was not emblematic – at least potentially. The four elements, the heavens, four-footed beasts, birds, fishes, plants, stones and insects could all instruct the "eye of understanding". What made this symbolic universe different from the medieval "Book of Nature" was the active participation of the individual within the construction of significance.'

30 *Ibid.*

31 Michaela Unterdörfer, *Die Rezeption der Antike in der Postmoderne* (Weimar, 1998), p. 131.

32 See Peter Fuller's discussion of the Venus de Milo from a Kleinian point of view, in 'The Venus and "Internal Objects"', *Art and Psychoanalysis* (London, 1980), pp. 71–129.

33 Kounellis, *Odyssée Lagunaire*, p. 69.

34 *Ibid.*, pp. 69–70.

35 See *Die eiserne Runde*, p. 36 for a fuller description, drawn from Roberta Smith's article in *Artforum* XVI, 1 (September 1975), pp. 73ff. The identification of the mask, which was evidently described wrongly as the Apollo Belvedere by Celant, is given in Unterdörfer, *Rezeption der Antike*, p. 132.

36 Monika Wagner, '"Armes" Material als Hoffnungsträger', in *Die eiserne Runde*, p. 18.

37 Kounellis, *Odyssée Lagunaire*, p. 70.

38 Kounellis's vindication of the independent stance of the Italian artist is supported by his claim that modern Italy has a profound cultural continuity, but no political continuity. In the previously quoted debate with Beuys and other colleagues, he stresses that Italy is the only country in the world that has an uninterrupted urban history of three thousand years, but at the same time the late development of the Italian nation state in the nineteenth century and the delay in industrialization has resulted in the country having 'no structure'. See Burckhardt, *Ein Gespräch*, pp. 43–5.

39 *Ibid.*, p. 73.

40 *Ibid.*, p. 70.

41 See *ibid.*, p. 71. His answer to the question of why he 'effectively considers (himself) as a painter' is that 'For me, a good writer is also a painter'. See also Burckhardt, *Ein Gespräch* (1994), p. 106.

42 Corà, 'Kounellis', p. 16.

43 Kounellis, *Odyssée Lagunaire*, p. 71.

44 Corà, 'Kounellis', p. 13.

45 Kounellis, *Odyssée Lagunaire*, p. 68.

46 Reprinted from *A E I O U* (Rome), 12–13 January 1985, in Moure, *Kounellis*, p. 230. Quoted and discussed in Angel Gonzàlez, 'Janis Kounellis va in paradiso', in *Kounellis*, exh. cat. Museo Nacional Centro de Arte Reina Sofia, Madrid, 19 November 1996–19 February 1997, p. 231.

47 Reprinted in Moure, *Kounellis*, p. 222.

48 See John Berger, *The Moment of Cubism and other Essays* (London, 1969), pp. 1–32.

49 *Flash Art*, 128 (May–June 1986), p. 38.

50 T. S. Eliot, *Selected Poems* (Harmondsworth, 1948), p. 65.

51 Corà, 'Kounellis', p. 22.

52 *Ibid.*, p. 223.

53 Rudi Fuchs makes this work the focal point of his excellent brief essay, 'Vocation', in Moure, *Kounellis*, pp. 25–7.

54 Germano Celant, 'L'Epos contemporanea', interview with Kounellis dated February–March 1992, published in *Kounellis*, exh. cat., Padiglione d'arte contemporanea, Milan, 10 April–31 May 1992, p. 29.

3 ALTERNATIVE HISTORIES OF ART

1 Jannis Kounellis, *Odyssée Lagunaire. Écrits et entretiens 1966–1989* (Paris, 1990), p. 79.

2 *Ibid.*

3 See Stephen Bann, *Under the Sign: John Bargrave as Collector, Traveler and Witness* (Ann Arbor, 1994), pp. 6–7.

4 Germano Celant, 'L'Epos contemporanea', interview with Kounellis dated February–March 1992, published in *Kounellis*, exh. cat., Padiglione d'arte contemporanea, Milan, 10 April–31 May 1992, p. 28.

5 *Ibid.*

6　See also essay in Stephen Bann and William Allen eds, *Interpreting contemporary art* (London, 1994), pp. 47-66, where the connection with Byzantine mosaics is explored.

7　See Georges Didi-Huberman, 'L'image-matière. Poussière, ordure, saleté, sculpture au XVIe siècle', in *L'Inactuel – Psychanalyse et culture*, No 5, special number on 'Matière', 1996, p. 65.

8　*Ibid.*, quoted from Leonardo, *Trattato della pittura*.

9　*Ibid.*, pp. 68–71.

10　Georges Didi-Huberman, 'Viscosités et survivances: L'histoire de l'art à l'épreuve du matériau', in *Critique*, 611 (April 1998), pp. 144–5.

11　*Ibid.*, p. 140.

12　*Ibid.*, pp. 141–2.

13　See leaflet for exhibition *Jannis Kounellis: Centro per l'Arte Contemporanea Luigi Pecci, Prato*. 9 June – 9 September 2001.

14　Although the different art historians who will be cited here do not form a coherent group, it is worth noting that the majority are from France, and have had a close association with the École des Hautes Études in Paris.

15　The first publication of my article is in 'The Framing of Material: Around Degas' *Bureau de coton*', in Thomas W. Gaehtgens, ed., *Künstlerischer Austausch*, Acts of the XXVIII. International Congress for Art History, Berlin, 15–20 July 1992 (Berlin, 1995), pp. 511–24.

16　Quoted *ibid.*, p. 517.

17　*Ibid.*, p. 519

18　The particular characteristics of the cotton in Kounellis's work contrast strikingly with those in Giovanni Anselmo's *Untitled* (1968), where the material overspills the container, draws moisture from it, and hangs in dense skeins around it. This second work, close in time to that of Kounellis, suggests a conscious differentiation of effects between these two *Arte Povera* artists. For an illustration of the work by Anselmo, see *Jannis Kounellis: Die eiserne Runde* (Hamburg Kunsthalle, 1995), p. 20.

19　The suggestion that Mantegna copies the contraptions of street theatre comes from Pierre Francastel, *La Figure et le lieu: l'ordre visuel du Quattrocento* (Paris, 1984), pp. 54–7.

20　Hubert Damisch, *Théorie du nuage: Pour une histoire de la peinture* (Paris, 1972), p. 280.

21　Celant, 'L'Epos contemporanea', p. 25.

22　Rudi Fuchs, 'Vocation', in G. Moure, ed., *Kounellis*, exh. cat. (Barcelona, 1990), p. 25.

23　Quoted from Vasari, in Étienne Jollet, *Figures de la pesanteur* (Paris, 1998), p. 84.

24　*Ibid.*, p. 7.

25　*Ibid.* The discussion is in Henri Bergson, *Essai sur les données immédiates de la conscience* (Paris, 1889), p. 35.

26　Jollet, *Figures de la pesanteur*, pp. 14–15. Jollet uses as his example the significant discussion of Roger van der Weyden's *Vision of the Magi* in Panofsky's *Essays in Iconology*.

27　*Ibid.*, pp. 43–4.

28　See my discussion of the problems of Alberti's *De Statua* in relation to the work of a contemporary sculptor in Stephen Bann, *Stephen Cox* (London, 1995), p. 15ff.

29　Alex Potts, *The Sculptural Imagination: Figurative, Modernist, Minimalist* (London and New Haven, 2001), p. 104.

30　See Burckhardt, *Ein Gespräch* (1994) p. 156. The full comment involves a comparison with Duchamp, whose name had been raised by Beuys: 'Duchamp belongs to the 19th century. But Brancusi is antique.'

31　It would be a mistake to enquire too closely into the theoretical basis of 'installation art'. As Sven Lüttiken has acutely pointed out, the term acquires currency in the 1960s largely because the *captions* for illustrations of work shown in situ came to employ it. See Sven Lüttiken, *Allegories of Abstraction* (PhD. thesis, Free University of Amsterdam, 2002), pp. 129–30. Nevertheless, the rationalizations that follow upon the common use of the term deserve some attention here.

32　Jennifer Gonzalez, 'Installation Art', in Michael Kelly, ed., *Encyclopedia of Aesthetics* (Oxford, 1998), p. 503.

33 *Ibid.*, p. 504.
34 *Ibid.*, p. 507. See also Paul Crowther, 'The Postmodern Sublime: Installation and Assemblage Art', *Art and Design,* 10 (February 1995), pp. 9–17.
35 See Julia Kristeva, *Sens et non-sens de la révolte* (Paris, 1996), p. 28.
36 See Michaela Unterdörfer, *Die Rezeption der Antike in der Postmoderne* (Weimar, 1998), p. 133. In this case, however, the closest to an identification of the original sculpture has been a 'Roman heroine'.
37 Potts, *Sculptural Imagination*, p. 105.
38 *Ibid.*, p. 178.
39 *Ibid.*
40 Kounellis, *Odyssée Lagunaire*, p. 79.
41 Potts, *Sculptural Imagination*, p. 179.
42 *Ibid.*, p. 188.
43 *Ibid.*
44 Kounellis, *Odyssée Lagunaire*, pp. 117–18.
45 Celant, 'L'Epos contemporanea', p. 11: 'Il teatro ha un tempo differente, narrativo, mentre la teatralità prefigge un unica visione, porta avanti un discorso.'
46 See the brochure for the '*Arte Povera*' exhibition, Tate Modern (2001), unpaginated. This striking image was used on the cover of the brochure, and in publicity for the show.
47 Unterdörfer, *Die Rezeption der Antike*, p.133.
48 Quoted in Louis Marin, *To Destroy Painting*, trans. Mette Hjort (Chicago, 1995), p. 3.
49 *Ibid.*, p. 162.
50 *Ibid.*
51 *Ibid.*, p. 163.

4 CONCLUSION: 'A VISIBLE LANGUAGE'

1 G. Moure, ed., *Kounellis*, exh. cat. (Barcelona, 1990), pp. 9–10.
2 Giuliano Briganti, 'Kounellis', in *Kounellis: Via del Mare* exh. cat. (Amsterdam: Stedelijk Museum, 1990), p. 74.
3 *Ibid.*, p. 72.
4 *Ibid.*
5 Germano Celant, 'L'Epos contemporanea', interview with Kounellis dated February–March 1992, published in *Kounellis*, exh. cat., Padiglione d'arte contemporanea, Milan, 10 April–31 May 1992, p. 19.
6 *Flash Art*, 128 (May–June 1986), p. 36.
7 *Ibid.*, p. 37.
8 *Ibid.*, p. 38.
9 Julia Kristeva, *Proust and the Sense of Time*, trans. Stephen Bann (London, 1993), p. 7.
10 *Flash Art*, 128, p. 39.
11 Moure, *Kounellis*, p. 25.
12 *Ibid.*, pp. 26–7.
13 Quoted from a 1995 interview, in Aphrodite Georgiou, *Die Dimension der Vergangenheit im Werk von Jannis Kounellis* (Cologne, 1998), p. 54.
14 *Van Gogh and Gauguin: The Studio of the South*, exh. cat. (Van Gogh Museum, Amsterdam, 2002), p. 209.
15 The catalogue reminds us that, for Van Gogh, Fildes's print 'assumed the status of an article of faith'. It also points out that the candle shares a place on the chair with two yellow-backed books, symbolic of the artistic ambitions of the modern novel.
16 See Louis Marin, *Des Pouvoirs de l'image* (Paris, 1993), p. 224.

Select Bibliography

CATALOGUES AND WRITINGS

1966: *Jannis Kounellis*, 'alfabeto': artist's book/exhibition catalogue, ARCO D'Alibert studio d'arte, dated for private view 7 October 1966, with a text by Mario Diacono (screen-printed pages featuring details from early paintings, cf. *Senza titolo*, 1960, and accompanying text involving typographical experiment on the page), unpaginated.

1972: *Documenta 5*, exh. cat., Kassel, 30 June–8 October 1972 (contains entry on Kounellis, pp. 16, 145–6).

1977: *Jannis Kounellis*, exh. cat., Museum Boymans-van Beuningen, Rotterdam, 22 January–13 March 1977 (contains text by Maurizio Calvesi, eight black and white plates and list of exhibitions), unpaginated.

1978: *Jannis Kounellis*, exh. cat. as a cardboard box with multiple work, Städtisches Museum, Mönchengladbach, 11 May–11 June 1978 (edition of 400 containing a German translation of Aleksandr Blok, *Die Skythen*, and an insert by Kounellis).

1984: *Jannis Kounellis*, exh. cat., Krefelder Kunstmuseum, 26 February–29 April 1984 (contains text by Marianne Stockebrand, pp. 3–18, and photographs of work installed; epigraph by Kounellis: 'Alles, was ich von 1959/60 an bid heute in Angriff nahm, könnte man charakterisieren also einen kritischen Dialog zwischen den beiden Begriffen Struktur und Sensibilität'), 21 pp.

1985: 'Jannis Kounellis – Collaboration', *Parkett*, 6 (1985) pp. 18–50 (contains text by Bruno Corà, in parallel German and English versions, 'Jannis Kounellis: Burning is the image in the hour of the eclipse', pp. 21–43; photo-etching for *Parkett* by Kounellis; and Italian text, 'Ardente l'immagine nell'ora dell'eclisse', pp. 46–50).

——, '*Jannis Kounellis: Oeuvres de 1983 à 1985*, exh. cat., CAPC, Bordeaux, 10 May–8 September (contains essays by Jean-Louis Froment and Rudi Fuchs)

1986: Discussion between Joseph Beuys, Jannis Kounellis, Anselm Kiefer, Enzo Cucchi, organized by Jean-Christophe Ammann, excerpts in *Flash Art*, 128 (May/June 1986), pp. 36–9. (See also 1994 for full text.)

1987: *Jannis Kounellis*, exh. cat., ICA, Nagoya, 6 June–31 July 1987 (contains colour plates of installation), unpaginated.

1989: Maïten Bouisset, 'Jannis Kounellis, le voleur du feu', *Artstudio*, 13 (summer 1989), pp. 80–93.

1990: *Kounellis – Via del Mare*, exh. cat., Stedelijk Museum, Amsterdam, 24 November 1990–13 January 1991 (contains 'Kounellis', text by Giuliano Briganti, and 'Interview – Jannis Kounellis and Wim Beeren', in Dutch, Italian and English: 51 plates in colour and black and white: list of exhibitions, writings and publications by the artist), 124 pp.

——, Jannis Kounellis, *Odyssée Lagunaire: Écrits et entretiens 1966–1989*, Paris: Lelong, 229 pp.

——, Gloria Moure, *Kounellis* (contains texts by Bruno Corà, Jean-Louis Froment, Rudi Fuchs, Mary Jane Jacob and English texts of 'Writings by Jannis Kounellis', pp. 211–37), Barcelona: Poligrafa, 310 pp.

1991: Jon Thompson, 'A Deadly Prescription', *Artscribe*, 88 (September 1991), pp. 58–67.

1992: *Kounellis*, exh. cat., Padiglione d'arte contemporanea, 10 April–31 May 1992, Milan: Fabbri Editori (contains interview by Germano Celant, 'L'Epos contemporaneo', pp. 11–29, and text by Marco Meneguzzo, 'Cercare il nemico', pp. 233–9: 174 plates in colour, and black and white: list of exhibitions and biography), 247 pp.

1993: *Jannis Kounellis: Lineare notturno, Kunsthalle Recklinghausen*, exh. cat., 2 May–11 July 1993, Ruhrfestspiele Recklinghausen (contains 'Geschichtlichkeit und Gegenwärtigkeit', pp. 10–12, text by Ferdinand Ulrich, 128 plates in black and white: list of exhibitions and bibliography), 144 pp.

——, *Kounellis: Esposizione di paesaggi invernali*, exh. cat. Palazzo Fabroni, Pistoia, 24, October 1993–9 January 1994, Milan: Edizioni Charta (contains 'Jannis Kounellis: l'Umanesimo reale nel tempo della virtualità', text by Bruno Corà, pp. 11–30, and 'Rispondenze', text by Chiara d'Afflitto, pp. 31–4: black and white plates, pp. 37–162: list of exhibitions and bibliography), 182 pp.

1994: Jacqueline Burckhardt ed., *Ein Gespräch: Joseph Beuys, Jannis Kounellis, Anselm*

Kiefer, Enzo Cucchi. Ostfildern: Cantz Verlag, 170 pp. Reedition of text originally published in Zürich (1986). See also 1986.

——, Branislav Dimitrijevic, 'Twentieth Century Art with the Byzantine Pictorial Tradition: Malevich, Gorky, Kounellis, Prodanovic', MA thesis, University of Kent at Canterbury.

1995: *Jannis Kounellis: Die eiserne Runde*, exh. cat., Hamburger Kunsthalle, 17 November 1995–7 January 1996 (contains texts by Ortrud Westheider, Monika Wagner, Uwe M. Schneede and Kira van Lil: also Jannis Kounellis, 'Gedanken zur Zentralität', pp. 81–5), 99 pp.

1996: *Kounellis*, exh. cat., Museo Nacional Centro de Arte Reina Sofia, Madrid, 19 November 1996–19 February 1997 (contains Gloria Moure, 'Jannis Kounellis: Configuration as Resistance', pp. 75–124; Josè Jimenez, 'Revolutionary Melancholy', pp. 177–200 and Angel Gonzàlez, 'Jannis Kounellis va in paradiso', pp. 231–54).

1997: *Kounellis*, exh. cat., Credito Valtellinese Galleria, 6 November 1997–4 January 1998, Milan: Skira (contains text by Marco Meneguzzo, 'The Reality of the Real World', in Italian and English versions, pp. 13–16 and 29–32, extensive black and white documentation, mainly of work from 1990s; biography and bibliography), 138 pp.

——, *Jannis Kounellis: La stanza vede,* exh. cat., Haags Gemeentemuseum, The Hague, s.p. (introduction by Rudi Fuchs).

1998: *Kounellis*, exh. cat., Galerie Lelong, Paris, *repères – cahiers d'art contemporain No 98* (contains text by Jean Frémon, 'Le corps du délit', in French and English, pp. 3–11 and 17–19, photographs in colour and black and white), 24 pp.

——, Aphrodite Georgiou, *Die Dimension der Vergangenheit im Werk von Jannis Kounellis*, doctoral dissertation, University of Cologne, 249 pp.

——, Michaela Unterdörfer, *Die Rezeption der Antike in der Postmoderne*, doctoral dissertation, University of Hamburg, Weimar, 248 pp.

1999: *Jannis Kounellis: Il sarcophago degli sposi*, exh. cat., Österreichisches Museum für Angewandte Kunst, Vienna: Mak Art Society (contains text by Peter Noever, 'Zum Thema: On the Subject', pp. 7–10, and interview by Bettina Busse in German and English, pp. 43–6; black and white plates pp. 51–149; list of exhibitions and bibliography), 160 pp.

2001: *Jannis Kounellis*, exh. cat., Centro per l'Arte Contemporanea Luigi Pecci, Prato (edited and with a text in Italian and English by Bruno Corà), 324 pp.

2002: Nike Bätzner, *Arte Povera: Zwischen Erinnerung und Ereignis, Giulio Paolini, Michelangelo Pistoletto, Jannis Kounellis*. Nuremberg (based on doctoral dissertation, Free University of Berlin, 1993: covers mainly the early work in its socio-political context).

——, Mario Codognato and Mirta d'Argenzio eds., *Echoes in the Darkness: Jannis Kounellis – Writings and Interviews 1966–2002*, London: Trolley Ltd, (an invaluable English source for Kounellis's written work) 328 pp.

Photographic Acknowledgements

Thanks to the artist's studio for the generous supply of picture material. Claudio Abate: 1, 2, 3, 4, 5, 6, 13, 14, 15, 17, 18, 24, 25, 26, 27, 33, 34, 41, 42, 43, 51, 54, 55, 56, 57, 58, 59, 61, 65, 66, 67, 68, 69, 70, 72, 74, 76, 83, 85, 87, 93, 97, 100, 101, 102, 113, 114, 116, 117, 118, 119, 120, 121, 122, 123, 124, 125, 126, 127, 128; Aurelio Amendola: 12, 81, 82, 129; Mussat Sartor: 16, 64; Pellion di Persano: 29, 30; William Allen: 31, 32; Manolis Baboussis: 45, 46, 94, 103, 104, 131; Courtesy of Ace Gallery New York: 47; Mimmo Jodice: 50, 90; Giorgio Colombo: 52, 53; Photo Michelle Coudray: 78; Athina Ioannoy: 79, 80, 105, 106, 107, 108, 109; Aurelio Amendola: 81, 82, 129; Galerie Karsten Greve: 84; Alinari: 89; Piero Piersanti: 95; Réunion des Musées Nationaux, Paris: 98; Harvard Art Museums: 99; Verlag Schöning, Lübeck: 110.

Artist's Chronology

1936 Born in Piraeus, Greece
1956 Moves to Rome to study at the Accademia di Belle Arti; has lived in Rome since
1960 *L'alfabeto di Kounellis*, Galleria La Tartaruga, Rome
1964 One-man show, Galleria La Tartaruga, Rome
1966 *L'alfabeto*, Galleria Arco d'Alibert, Rome
 One-man show, Galleria La Tartaruga, Rome
1967 Group show, *Lo spazio degli elementi: Fuoco immagine acqua terra*, Galleria L'Attico,
 Rome
 Kounellis Il Giardino; I Giuochi, Galleria L'Attico, Rome
1968 One-man show, Galleria Iolas, Milan
1969 One-man show, Modern Art Agency, Naples
 One-man show, Galerie Iolas, Paris
1971 One-man show, Modern Art Agency, Naples
1972 One-man show, Sonnabend Gallery, New York
 Documenta 5, Kassel
 XXXV Venice Biennale
1973 One-man show, Galleria Lucio Amelio, Naples
 One-man show, Sonnabend Gallery, New York
 One-man show, Galleria La Salita, Rome
1974 One-man show, Sonnabend Gallery, New York
 One-man show, Galleria L'Attico, Rome
1975 One-man show, Galleria Lucio Amelio, Naples
 One-man show, Studio d'Arte Contemporanea, Rome
1976 *Hotel La Lunetta*, Galleria L'Attico, Rome
 XXXVII Venice Biennale
1977 One-man show, Kunstmuseum, Lucerne
 One-man show, Museum Boymans-van Beuningen, Rotterdam
 Documenta 6, Kassel
1978 One-man show, Städtisches Museum Abteiberg, Mönchengladbach
 XXXVIII Venice Biennale
1979 *V Premio 'Pino Pascali': Jannis Kounellis*, Pinacoteca Provinciale, Bari
 One-man show, Museum Folkwang, Essen
 One-man show, Salvatore Ala Gallery, New York
 One-man show, Galerie Konrad Fischer, Düsseldorf
1980 One-man show, ARC/Musée d'Art Moderne de la Ville de Paris
 One-man show, Sonnabend Gallery, New York
 XXIX Venice Biennale
1981 One-man show, Stedelijk Van Abbemuseum, Eindhoven
 (travels to Caja da Pensiones, Madrid; Whitechapel Art Gallery, London; Staatliche
 Kunsthalle, Baden-Baden, 1982)
 One-man show, Galerie Liliane and Michel Durand-Dessert, Paris
1982 One-man show, Galleria Anna d'Ascanio, Rome
 Documenta 7, Kassel
 Zeitgeist, Martin-Gropiusbau, Berlin
1983 One-man show, Musei Comunali, Rimini
 One-man show at Galleria Christian Stein, Turin
1984 One-man show, Galleria Lucio Amelio, Naples
 One-man show, Museum Haus Esters, Krefeld
 XLI Venice Biennale
1985 One-man show, CAPC Musée d'Art Contemporain, Bordeaux
 One-man show, Städtische Galerie im Lenbachhaus, Munich
1986 *Jannis Kounellis: A Retrospective*, Museum of Contemporary Art, Chicago
 One-man show, Anthony d'Offay Gallery, London
1987 One-man show, Artsite Bath Festival, Bath
1988 One-man show, Castello di Rivoli, Turin
 One-man show, Galerie Sparta-Petit, Chagny

XLIII Venice Biennale

1989 One-man show, Espai Poblenou, Barcelona
One-man show, Museo di Capodimonte, Naples

1990 *Via del Mare*, Stedelijk Museum, Amsterdam
La stanza vede, Haags Gemeentemuseum, The Hague; Arnolfini, Bristol; ICA,
London; Fundació Tàpies, Barcelona

1991 One-man show, Henry Moore Sculpture Trust, Dean Clough, Halifax
Frammenti di memoria, Kestner-Gesellschaft, Hanover; Kunstmuseum, Winterthur
One-man show, Sinagoga Stommeln, Pulheim, Germany
Metropolis, Martin-Gropiusbau, Berlin

1992 One-man show, Galleria Lucio Amelio, Naples
One-man show, Padiglione d'Arte Contemporanea, Milan

1993 Appointed Professor at the Kunsthochschule, Düsseldorf
One-man show, Belvedere, Gardens of the Castle, Prague
Kounellis, fumo di pietra, Galerie Lelong, Châtellerault
Lineare Notturno, Kunsthalle, Recklingshausen
Kounellis. Esposizione di paesaggi invernali, Palazzo Fabroni, Pistoia

1994 *Kounellis*, Galerie Lelong, Paris
Kounellis, Anthony d'Offay Gallery, London
One-man show, Cargo Ionion, Piraeus, Athens

1995 Monument in memory of Concetto Marchesi, Gigio Meneghetti and
Ezio Franceschini, Palazzo del Bo, Padua University
Kounellis, La Salara, Bologna
Jannis Kounellis Die eiserne Rund, Hamburger Kunsthalle, Hamburg
Palast der Kunste, Erzbischofliche Diozesanmuseum, Cologne

1996 *Jannis Kounellis*, Castelluccio di Pienza, Pienza
One-man show, Museo Nacional de Arte Reine Sofia, Madrid
One-man show, Piazza del Plebiscito, Naples

1997 *Kounellis. Die Front, das Denken, der Sturm*, Museum Ludwig in der Halle Kalk,
Cologne
One-man show, Ace Gallery, Los Angeles

1998 One-man show, Ace Gallery, New York
Jannis Kounellis. Il Sarcofago degli Sposi, Osterreichisches Museum für angewandte
Kunst, Vienna,
Jannis Kounellis: Iglesia de San Augustin, UNAM, Mexico

2000 *Jannis Kounellis. Ein Saal für die Sammlung*, Kunstmuseum Winterthur, Winterthur
Jannis Kounellis, Museo Nacional de Bellas Artes, Buenos Aires
One-man show, Castello Colonna, Genazzano

2001 *Kounellis*, Centro per l'Arte Contemporanea Luigi Pecci, Prato
One-man show, Kunst Station Sankt Peter, Cologne

2002 *Kounellis*, Galleria di Arte Moderna, Rome

NB The list of exhibitions given here is by no means exhaustive, and covers principally
those that have been illustrated or mentioned in the text.